O'Keeffe
Preston
Cossington Smith

MAKING
MODERNISM

EDITED BY

Lesley Harding
Denise Mimmocchi

Heide
Museum of
Modern Art
Heide

ART
GALLERY
NSW

Contents

v Sponsors' messages

vii Foreword

1 **Introduction**
 CODY HARTLEY

8 Georgia O'Keeffe
 Ram's Head, Blue Morning Glory 1938
 JASON SMITH

10 Margaret Preston
 Implement Blue 1927
 CODY HARTLEY

12 Grace Cossington Smith
 Sydney Harbour Bridge series 1928–30
 DEBORAH HART

17 **The modern art of painting flowers:
 reinventing the still life**
 LESLEY HARDING

36 Georgia O'Keeffe
 The Black Iris 1926
 KATHLEEN PYNE

38 Margaret Preston
 Banksia 1927
 ROBYN MARTIN-WEBER

40 Margaret Preston
 The Monstera Deliciosa 1934
 CAROLYN KASTNER

43 **Unveiling nature: landscape in
 the 'epoch of the Spiritual'**
 DENISE MIMMOCCHI

64 Margaret Preston
 Aboriginal Landscape 1941
 CARA PINCHBECK

66 Grace Cossington Smith
 Black Mountain c.1931
 ANN STEPHEN

68 Georgia O'Keeffe
 Storm Cloud, Lake George 1923
 DENISE MIMMOCCHI

70 Grace Cossington Smith
 Landscape at Pentecost 1929
 TRACEY LOCK

72 Margaret Preston
 Blue Mountains Theme c.1941
 REBECCA COATES

75 **Abstraction and the creation
 of national identity**
 CAROLYN KASTNER

90 Grace Cossington Smith
 Sea Wave 1931
 DEBORAH EDWARDS

92 Georgia O'Keeffe
 Blue Line 1919
 KYLA MCFARLANE

94 Grace Cossington Smith
 The Window 1956
 BRUCE JAMES

101 **Plates**

159 Artists' biographies
164 Timeline KIRA RANDOLPH
182 Notes
188 Further reading
191 List of works
200 Contributors
201 Acknowledgements
202 Index

Sponsors' messages

The Terra Foundation for American Art is proud to partner with the Art Gallery of New South Wales, the Georgia O'Keeffe Museum, Heide Museum of Modern Art, and the Queensland Art Gallery | Gallery of Modern Art to present O'Keeffe, Preston, Cossington Smith: Making Modernism, which examines the international languages of modernism through intersections and divergences in these artists' lives and careers.

When Georgia O'Keeffe moved to New York in 1918, she joined a group of artists committed to creating an American modernism that was both original and deliberately distinct from its European analogue. They concentrated their efforts on abstraction and quintessential American subjects, like the iconic New York skyscrapers. At the same time across the Pacific, Australian artist Grace Cossington Smith was painting another urban icon, the Sydney Harbour Bridge, as her compatriot Margaret Preston published an essay entitled 'Why I became a convert to modern art'. Though O'Keeffe and her Australian peers never met or corresponded, this exhibition reveals meaningful parallels, including each artist's identification with a specific and local sense of place, as well as positioning modern art as a vehicle for expressing a particular national identity.

By drawing attention to this rich international exchange, Making Modernism complements the Terra Foundation's global mission to foster the worldwide exploration, understanding, and enjoyment of the visual arts of the United States. It also amplifies the vision of our founder, Chicago businessman and art collector Daniel J. Terra (1911–1996), who understood that engagement with original works of art could be a transformative experience.

For nearly 40 years, we have been connecting people across the globe with American art. On behalf of the Terra Foundation for American Art, we congratulate the partnering institutions on this fine exhibition and for their dedication to inspiring new perspectives and cultivating a robust cross-cultural dialogue through original works of art.

Elizabeth Glassman
President & CEO
Terra Foundation for American Art

The Art Gallery Society of New South Wales is proud to be a partner in the exhibition O'Keeffe, Preston, Cossington Smith: Making Modernism. This major project presents an inspirational grouping of three leading modernists – American artist Georgia O'Keeffe, alongside Margaret Preston and Grace Cossington Smith, two of Australia's foremost twentieth-century painters. With the inclusion of outstanding works from across the careers of these innovative artists, the exhibition reveals important aspects of the modernist traditions in both the United States and Australia and illuminates some of the artistic and cultural parallels between the two nations. It also brings new light to bear on the synthesis and diffusion of modernism as it developed across the world in countries beyond its European source.

This exhibition will be of great interest to Art Gallery Society members and the wider community and is the second exhibition partnered by the Art Gallery Society of New South Wales. The first Society venture supported the acclaimed Sydney Moderns: Art for a New World exhibition at the Art Gallery of New South Wales in 2013. The opportunity to be involved once more in an exhibition that explores this ground-breaking period seemed like a natural progression.

Making Modernism is an important undertaking for all the art museums involved, including the Art Gallery of New South Wales, Heide Museum of Modern Art, and the Queensland Art Gallery | Gallery of Modern Art in partnership with the Georgia O'Keeffe Museum. The Art Gallery Society is privileged to support this important and timely project.

Brian Ladd
President
Art Gallery Society of New South Wales

The Art Gallery Society of New South Wales is the membership program of the Art Gallery of New South Wales.

Foreword

The Art Gallery of New South Wales, Heide Museum of Modern Art and the Queensland Art Gallery | Gallery of Modern Art in partnership with the Georgia O'Keeffe Museum are delighted to present O'Keeffe, Preston, Cossington Smith: Making Modernism.

This significant exhibition and its accompanying publication explore parallels in the development of Australian and American modernism through the work of three pioneering artists who shared approaches to modernist practice, even as their output reflected their individual and national tendencies. Each identified in their art a personalised sense of place, and in so doing developed a modern art that expressed something of the identity and culture of their respective countries. The project is the very first presentation of a major body of work by Georgia O'Keeffe in Australia, as well as providing an opportunity for audiences to view the works of Margaret Preston and Grace Cossington Smith with fresh perspectives and in the context of modernism internationally.

The exhibition, including around 30 works by each artist, has developed out of intensive discussion and research between the collaborating curators. We are indebted to Jason Smith, formerly director of the Heide Museum of Modern Art and now director of Geelong Art Gallery, Victoria, who initiated the exhibition concept. We also acknowledge the outstanding dedication and expertise of the other exhibition curators: Lesley Harding, curator, Heide Museum of Modern Art; Cody Hartley, director of curatorial affairs, Georgia O'Keeffe Museum; Carolyn Kastner, curator, Georgia O'Keeffe Museum; and Denise Mimmocchi, curator of Australian art at the Art Gallery of New South Wales.

We are most fortunate to have the Terra Foundation for American Art and the Art Gallery Society of New South Wales as our major exhibition partners. In addition to overall exhibition sponsorship, the Terra Foundation provided seed funding for the project which supported curatorial conferences in Santa Fe and Sydney in 2015. The Art Gallery Society of New South Wales, the membership program of the Art Gallery of New South Wales, has similarly played an essential role in enabling this ambitious project to come to fruition; we warmly thank both organisations.

We are very grateful to the Gordon Darling Foundation for providing a travel grant enabling Jason's initial research trip to Santa Fe in 2013, and for supporting the production of this publication. The Embassy of the United States of America, Canberra, has also kindly assisted with the realisation of the exhibition and its associated programs and events.

The National Gallery of Australia and the Art Gallery of South Australia, along with the National Gallery of Victoria and a number of metropolitan and regional galleries throughout Australia, have been extremely collegial in lending major works to the exhibition. We are most grateful to these institutions and their respective directors, Dr Gerard Vaughan, Nick Mitzevich, Tony Ellwood, Karen Quinlan, Dr Rebecca Coates, Jennifer Kalionis, John Cheeseman, Lauretta Morton and Dr Michael Spence, Vice-Chancellor, the University of Sydney, together with the numerous private lenders.

We hope that this exhibition not only provides new insight into the important modernist movement, but also serves as a model for future national and international collaborative partnerships.

Dr Michael Brand
Director
Art Gallery of New South Wales

Kirsty Grant
Director & CEO
Heide Museum of Modern Art

Robert A. Kret
Director
Georgia O'Keeffe Museum

Chris Saines CNZM
Director
Queensland Art Gallery | Gallery of Modern Art

Introduction

CODY HARTLEY

*Australia is a fine place in which to think ... You do not get bothered
with foolish new ideas. Tradition thinks for you, but Heavens!
How dull! To keep myself from pouring out the selfsame pictures
every year I started to think things out.*

— Margaret Preston, 1923[1]

*It was in the fall of 1915 that I first had the idea that what I had
been taught was of little value to me ... I had been taught to work like
others and after careful thinking I decided that I wasn't going
to spend my life doing what had already been done.*

— Georgia O'Keeffe, 1976[2]

*All form - landscape, interiors, still life, flowers, animals, people - has
an inarticulate grace and beauty: painting to me is expressing this
form in colour, colour vibrant with light - but containing this other,
silent quality which is unconscious, and belongs to all things created.*

— Grace Cossington Smith, 1969[3]

Making Modernism is about three remarkable artists. The joining of these artists
for exhibition is unusual in that they are not bound by any personal familiarity
or direct correspondence. If O'Keeffe and her Australian counterparts were
aware of one another, it was only in the most general way - in all likelihood
Preston and Cossington Smith never saw O'Keeffe's work in person and vice
versa. Nonetheless, across the great distance of the Pacific Ocean they were
kindred spirits. Innovative pioneers, each forged a bold, original, and independent
path for herself and for the art of her times and respective homeland. Embracing
an insistently 'modern' art capable of conveying the excitement, contradictions,
and complexity of life in the twentieth century, they rejected what they perceived
as the tired traditions of the past. In turning away from their training and from

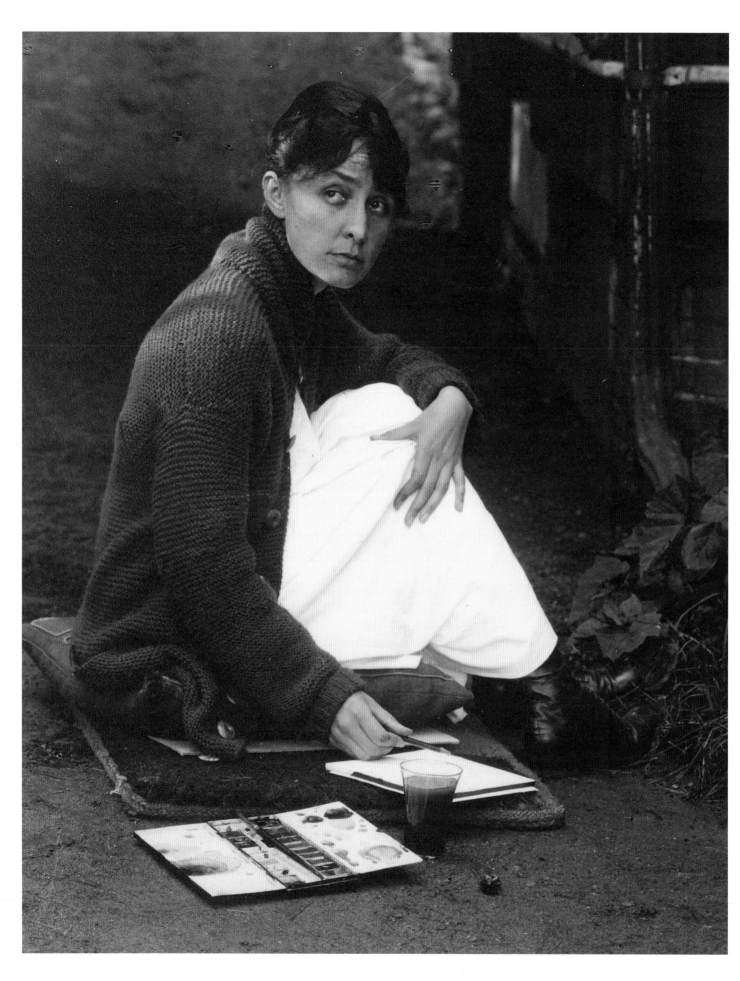

convention, they found new ways to communicate, new things to say, and new ways to make art significant to their national cultures. They left enduring legacies and have achieved a high degree of recognition within their respective countries. Yet their reputations and fame have only rarely eclipsed national boundaries. Georgia O'Keeffe is the best known internationally, but even she is only just now receiving the attention of important global institutions like the Tate Modern, which launched a major retrospective of her career in 2016, and few of her works can be seen outside of the United States. While celebrated as their nation's leading modernists, Grace Cossington Smith and Margaret Preston are little known and rarely exhibited outside of Australia.

Too often, calling these artists 'great Australian artists' or a 'great American artist' casts a slightly pejorative shade, minimising their importance, much as calling them 'great women artists' imposes an unnecessary distinction. As O'Keeffe herself remarked, 'the men liked to put me down as the best woman painter. I think I'm one of the best painters'.[4] While their understanding of the national spirit and desire to produce art that conveyed the distinct character of each land was an important factor in their careers, it should not limit our appreciation of their significance.

To be explicit, O'Keeffe, Preston, and Cossington Smith were not chosen for this exhibition because they are women, but because they are among the most distinct and influential modernists in their respective nations. That said, their biographies do illustrate the opportunities and obstacles faced by professional women artists in the early twentieth century. It would be disingenuous not to recognise that their experiences speak powerfully of the determination of women artists everywhere who have refused to accept conventional limitations – be they artistic or social. These artists were not just part of a broader artistic dialogue, they led the conversation.

At the core of this exhibition is a desire among the contributing curators in Australia and the United States to better understand modernism as a global phenomenon representing a set of reactions and artistic strategies that emerged around the world as a means of making sense of the conditions of modern life. Adapted to the particulars of each artist and nation, certainly, yet also part of an international dialogue. In this broader context, the achievement of each artist is brought into its full, brilliant clarity.

This project began with a phone call. In 2013, Jason Smith, then director of Heide Museum of Modern Art, called the Georgia O'Keeffe Museum to inquire about organising an exhibition of Georgia O'Keeffe's artwork for Australia. His request was elegantly direct. He wished to bring O'Keeffe to Australia. It was also unexpected. The idea was not simply an exhibition with the well-known American artist on the marquee (the O'Keeffe Museum receives many such requests). The fuller ambition was to bring O'Keeffe to Australia so that audiences could better understand the significance and importance of Australian modernism.

Alfred Stieglitz
Georgia O'Keeffe 1918 (detail)
gelatin silver photograph, 8.9 × 11.4 cm
Georgia O'Keeffe Museum, Santa Fe

As a scholar of American modernism, working at an institution dedicated to a pre-eminent modernist painter and explicitly committed to the study of American modernism, the very notion of an Australian equivalent elicited curiosity and excitement.[5] For myself, I sheepishly admit I had an embarrassing ignorance of Australian modernism. It is little comfort that many of our American colleagues, upon hearing about the project, have echoed my first thoughts, 'what is Australian modernism and why don't I know about it?' Such responses have brought into full relief how national bias has hindered the way that art historians in the United States, especially those under the sway of cold-war exceptionalism, interpreted the story of modern art, exaggerating the importance of their own nation and minimising the substantial transnational conversations that were such a common experience for artists who travelled frequently and corresponded globally. It seems as if an historical amnesia developed, obscuring the degree to which modernism was a global experience.

O'Keeffe, Preston, and Cossington Smith all travelled internationally, albeit at different times in their lives, and were fully cognisant of the artistic debates of their day, at home and abroad. They were citizens of their nations and the world at once, actively engaged with the ideas and work of their peers in many countries. Even as Georgia O'Keeffe and other members of the Stieglitz circle were seeking 'the Great American Thing', as she termed the search for authentically and uniquely American subjects, they were in contact with artists from many countries who were seeking similarly to create art reflecting distinct aspects of their national character. For those from former colonial states, long in the shadow of European artistic dominance, the desire to differentiate themselves from Europe and establish a valid national culture was strongly felt. Even as they sought distinct subjects, turning frequently to Indigenous cultures, unique flora and fauna, and the land itself, the ambitions and approach were often shared across national boundaries.

Australia and the United States are not just vast – roughly the same in terms of land mass – but might seem vastly different by many measures. At the same time, we are struck by some commonalities. Though the specifics vary, both are former British colonies overlaid upon a land with an ancient and continuing Indigenous presence inhabiting a diverse landscape of many geographies and climates. The lands are rich with abundant natural resources which fueled growth and expansion into the industrial age and beyond. Both nations preserve areas of unparalleled natural beauty, sites and locations that have become part of our respective national identities. Though Australia is smaller in population, both nations are highly visible and influential actors upon the global stage, through foreign policy but also as a result of being internationally recognised creative centres, producing vibrant art, music, cinema and television. To this day, both continue to wrestle with devastating legacies from the past, the haunting national traumas resulting from centuries of exploitation and the systemic impoverishment of Indigenous and minority populations. While our histories are distinct, nuanced, and specific to the conditions and peoples of each land, there are substantial shared experiences, pressures, and ambitions.

Margaret Preston in her garden
Mosman 1930 (detail)
Photograph: Harold Cazneaux
Art Gallery of New South Wales
Library and Archive, Sydney

4

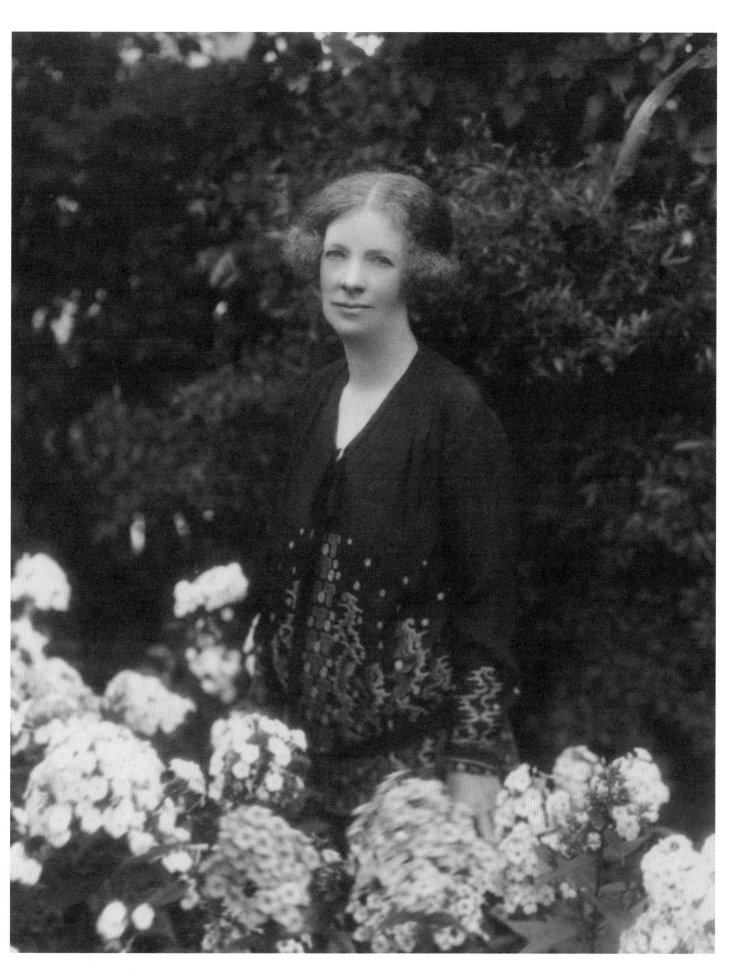

Such parallels continually energised the research and collaborative planning among the curators in Australia and the United States. Over the course of several visits and work sessions, including an initial visit by Jason Smith to Santa Fe supported by the Gordon Darling Foundation, and conferences in Sydney and Santa Fe generously supported by the Terra Foundation for American Art, the team repeatedly had moments of insight and recognition. If we did not always know the specific artists, we recognised the impulse and understood the motivation from our knowledge of artistic practice in our home countries. And for all the similarities, there were idiosyncrasies too, which served to bring into higher relief that which made each artist, and each country, unique.

This publication includes several extended essays investigating those aspects of these artists' careers where the curators found the most intense and revealing overlaps. Lesley Harding considers the ways in which the seemingly staid still-life tradition provided a productive 'laboratory' for radical explorations. All three artists used still-life paintings, and flowers specifically, to test out their ideas, to push their compositions and formal strategies to the extreme in the service of forging a new art. Landscape was equally a touchstone. Denise Mimmocchi reveals how landscape painting allowed these artists to actively generate meaning, to produce a sense of place overlaid with a deeply felt appreciation of natural beauty, an awareness of cultural history, and a lasting if sometimes obscured Indigenous presence. In painting the land, Preston, Cossington Smith, and O'Keeffe further tested the limits of representation while also defining distinct 'national' landscapes that continue to resonate. In distinguishing themselves from European precedents, they participated in a transnational conversation about modernism and abstraction even as they became proponents for unique and specific national identities, as Carolyn Kastner describes. Interspersed among the primary essays are a series of focused explorations bringing a variety of voices – from Australia and the United States – to consider specific artworks. The result is a bright tapestry of ideas, illuminating and rewarding for the reader and worthy of the artists that inspire this exhibition.

Bringing together three artists who might otherwise be considered an unlikely match has allowed us to better understand and appreciate Australian and American modernist practices, and to more fully appreciate the contributions of Preston, Cossington Smith, and O'Keeffe. In effect holding them up to one another as mirrors allows us to more clearly recognise the specific outlines of their ambitions, their careers and lives, and to fully trace their significance as great artists of the twentieth century. We can know their accomplishments better and in ways that would be impossible without lifting them from their usual context. Doing so reinvigorates our thinking, opens dialogue, and helps us better understand the richness of modernism. It reveals the shared contours of artistic experience even as it reiterates the uniqueness, the originality, and the enduring legacy of the individual artists.

Georgia O'Keeffe
Ram's Head, Blue Morning Glory
1938

JASON SMITH

Georgia O'Keeffe's first encounter with the vastness and stark beauty of the landscapes of New Mexico occurred when she visited Santa Fe en route to Texas in 1917. The territory embedded itself in her imagination and slowly began to become 'her country'.[1]

O'Keeffe's first extended stay in New Mexico was during the American summer of 1929. After arriving in Santa Fe she spent four months at the Taos home of art patron and writer Mabel Dodge Luhan, and explored and observed the ancient country by walking through it – an activity maintained throughout her life as an essential physical and spiritual connection to place.

O'Keeffe observed that there were no native flowers that summer, due to a lack of rain. Her eye turned instead to the bleached bones and weathered skulls of horse, cattle and deer littering the desert landscape. Wishing to retain something of the country that was providing such powerful new inspiration for her, O'Keeffe assembled a collection of bones and skulls and had a barrel of them transported to the Lake George farmhouse in upstate New York belonging to Alfred Stieglitz's family, where O'Keeffe lived and worked for part of each year from 1918 until the early 1930s. Arranging them with an assortment of fabric flowers also souvenired in New Mexico, O'Keeffe created a number of casual still lifes around the house and began to incorporate them into her paintings throughout 1930 and 1931.

The skulls particularly absorbed O'Keeffe, and her earliest paintings of them adorned with cloth flowers reveal a spirit of play with what was, for her, radically new subject matter with which she would continue to work into the mid 1950s. O'Keeffe first exhibited numerous skull pictures in 1931 and they found immediate critical attention but an unready market. The exhibition included the emblematic *Cow's Skull: Red, White and Blue* 1931 (p. 23), which O'Keeffe has explained as her response to an east-coast, metropolitan, heroic rhetoric and male-dominated ambition for 'the Great American Novel – the Great American Play – the Great American Poetry'.[2] This particular skull was only a half tongue-in-cheek joke on the cultural arbiters of the American scene, or on what the tastemakers thought their country *should* be. O'Keeffe's skull in red, white and blue was her

American painting: 'It was my way of saying something about this country ... better than trying to reproduce a piece of it'.[3]

In contrast to her prodigious output of skull pictures in the early 1930s, *Ram's Head, Blue Morning Glory* was the only skull picture painted in 1938. When it was shown in 1939, O'Keeffe – stung by recent criticisms of painterly and pictorial uniformity, and the corruption of her signature style to a formulaic 'mass-production'[4] – made possibly her most potent statement about her feeling for the paradox of the skulls, with their strange, residual life-force: 'The bones seem to cut sharply to the center of something that is keenly alive on the desert even though it is vast and empty and untouchable – and knows no kindness with all its beauty'.[5]

By the time *Ram's Head, Blue Morning Glory* was painted, the thematic and stylistic surrealist undertone of O'Keeffe's juxtapositions of skulls with flowers, or their hovering in landscapes, had been astutely observed by critic Lewis Mumford to be 'more unexpected than those of the Surrealistes [sic]', though he thought she used the skulls 'in a fashion that makes them seem inevitable and natural, grave and beautiful'.[6]

Gravity is counterpointed by O'Keeffe's lightness of palette and the enduring vitality of her painterly mark. The forms in this restrained composition are defined through studied observation and the elimination of all that is superfluous, and the picture is a quiet but emotionally penetrating meditation on the cyclical nature of which we are a part.

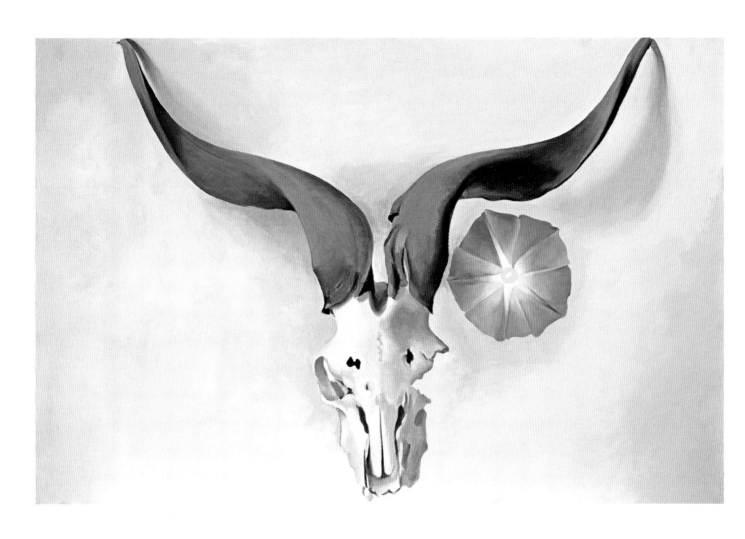

Margaret Preston
Implement Blue
1927

CODY HARTLEY

Margaret Preston rarely exhibited *Implement Blue* 1927 during her lifetime. After an initial presentation at Grosvenor Galleries shortly after its creation, it was displayed as part of the Burdekin House exhibition organised in 1929 by Roy de Maistre. The fact that Preston kept the artwork in her possession until her last years, giving it to the Art Gallery of New South Wales in 1960, surely suggests the painting held great meaning for its maker. Georgia O'Keeffe, likewise, kept many of her most personally significant artworks until the end of her life.

In subsequent years, *Implement Blue* has been shown with increasing frequency. It has appeared in eight major exhibitions in Australia since the mid 1990s, including the definitive Sydney Moderns exhibition in 2013 and the Margaret Preston retrospective in 2005, as well as being on regular display as part of the collection of the Art Gallery of New South Wales. Over the course of the past two decades, the painting has become iconic, among the most recognised and beloved examples of Australian modernism, and written about elegantly and insightfully by numerous of Australia's brightest art historians and critics.

One might assume there is little left to say, perhaps even less so for an American art historian lacking cultural context. Of course, transcending national distinctions and exploring artistic practice from an international perspective is a key objective of this exhibition. To this art historian trained in the United States and specialising in American modernism, *Implement Blue* was a discovery and revelation. My experience seeing the work at the Art Gallery of New South Wales was epiphanic and uncanny, revealing the national bias of my training and understanding while exciting a sense akin to precognition.

I knew this art. I did not yet know the artist or the specific artwork, but I recognised immediately a kinship with the innovations and ambitions of many of the artists in the United States I most enjoyed and valued. It was a catalyst, making evident how modern artists shared a passionate commitment to innovation across distances and beyond various nationalist projects.

Implement Blue demonstrated the boldness of an artist knowing but consciously departing from tradition. To do so requires confidence and determination. The painting is a fusion of observation, interpretation, and artistic creation. Preston is not replicating the visual but constructing the artistic. As a result, the still life becomes something of lasting interest, able to engage generations of viewers far more powerfully than the humble simplicity of the subject suggests. The composition is masterful, an arrangement so confident, so certain, it seems that no other presentation of these objects is possible or desirable. This degree of mastery – true as well for O'Keeffe – reflects a habit of careful observation and, I suspect, pre-conceptualisation, that is to say the ability to see the canvas completed in the mind before brush ever touches canvas. Preston's husband described how the artist 'carried what she wanted in her head, and then when she got home committed it to paper'.[1] O'Keeffe too seems to have had a preternatural visual memory, resolving her work entirely in her mind before beginning to paint.

Preston blends careful observation with abstraction. She emphasises the interaction of forms, lines, and shapes to provoke a response. Dynamic diagonals and contrasting geometric shapes add drama and visual tension, as does the play between illusion and abstraction, creating intrigue. A suggestion of rounded forms and reflected light is balanced against the flatness of other surfaces, resisting the illusion of depth. Much more than a simple image of cups, cut glass, and a manufactured pitcher, the painting's visual power is the result of Preston's perception and creative act.

Lasting art is endlessly interesting because its meaning is constantly remade by each generation, by each individual viewer. *Implement Blue* invites and fully rewards such reconsideration. With inventive design, such pictures interpret and record the changes of modern life, and express an urgent insistence that art be an essential voice in defining and understanding the contemporary spirit. Little wonder the artist held the work close. Lucky we are that she left it for our contemplation.

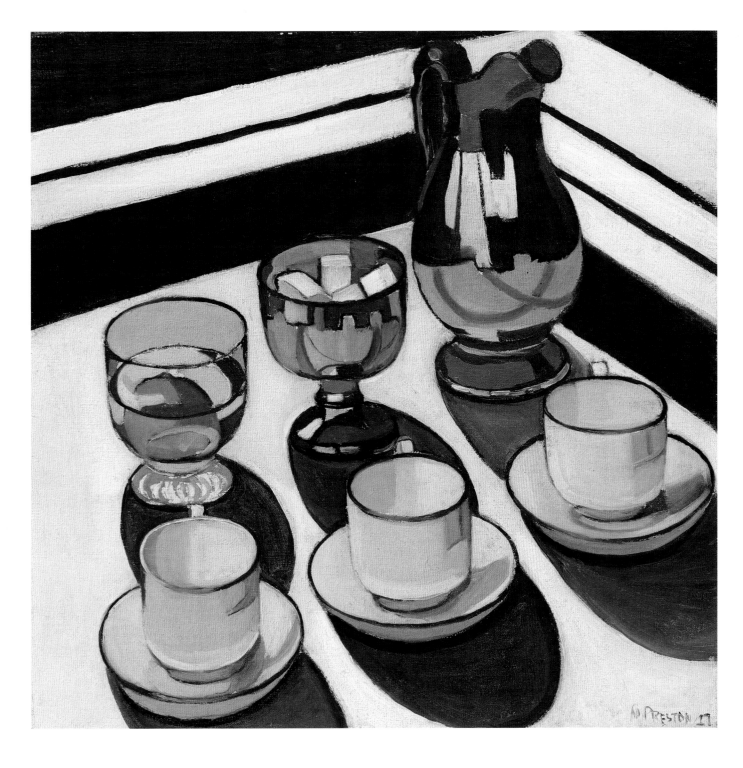

Grace Cossington Smith
Sydney Harbour Bridge series
1928–30

DEBORAH HART

Late in her life Grace Cossington Smith remembered the evolution of the Sydney Harbour Bridge with great fondness: 'I loved it, you see'.[1] The building of it took place when she was coming into her own as one of the great modern Australian artists of the twentieth century, even though it would take time for her significance to be widely recognised. In the wake of World War I and into the Depression years, the bridge was a symbol of hope for Cossington Smith and many artists. Linking the south and north of the city across the harbour, it was a triumph of engineering and significant to the revitalisation of a modern metropolis. Cossington Smith made many drawings and a small number of remarkable paintings of the bridge, most of them when the construction was well underway towards the end of the 1920s. Having travelled regularly by ferry from Sydney's North Shore to the city across the harbour since building commenced in 1923, she was able to witness the structure gradually forming; from grounding ballasts of granite pylons to the steel arches soaring up into the sky. For her the bridge-in-progress represented a merging of the secular and the sacred. It was a revelation of energy and passion made visible.

Cossington Smith liked the bridge best before it was finished. Her favourite place for viewing its construction was at Milsons Point on the North Shore. In those days she would take her sketchbook and drawing materials down to the Point, wearing a long skirt, large sunhat, sturdy boots, and carrying a gentleman's black umbrella. Once there she strapped herself to her equipment in order not to lose it in blustery winds coming off the harbour. As she said, 'My father gave me a lovely Winsor & Newton sketching umbrella but unfortunately I could never force it into the ground enough and the wind always blew it over, so I had to end up ... using ... an ordinary black [umbrella] which I fixed onto my painting box and to myself and it worked extremely well'.[2] Her drawings of the bridge range from sketchbook notations, to sketches for later finished drawings, to detailed pencil studies for paintings with written notations.

Back home in the garden studio that her father Ernest built for her, Cossington Smith readied herself for painting in oil or tempera on cardboard. In her study for *The Curve of the Bridge* 1928–29 (p. 15) she had circled the words 'rhythm of the bars', and its interlacing web of steel bars and interplay of straight and curved lines corresponds with the modernist passion for dynamism and rhythmic structure. *The Curve of the Bridge* 1928–29 (p.14) was one of the largest and most impressive paintings she had undertaken at the time, revealing the construction from an unusual, dramatic close-up viewpoint. Having transposed the map of the drawing, the painting took on new life as she applied small touches of vibrant colour across the entire surface, while retaining a sense of the impact of the structure itself. The interaction of the bridge with the harbour is amplified by details like the ferry in the steep 'V' between two pylons, moving towards us over the blue water.

Cossington Smith was not afraid to engage with the mechanisms and building blocks that brought the structure into being, as *The Bridge in Building* 1929–30 reveals. Again the viewpoint and composition is daring and unexpected. The cranes in the foreground are dynamic structures like the bridge itself, the tripod akin to a makeshift pyramid pointing directly to the sky in the gap between the arches above. The toughness of the building site is counterpoised by the radiant palette of the orange-yellow crane, the deep purple and rose of the arches and the gentle, soft yellow of the towering pylon. Yellow was the artist's favourite hue: 'the colour of the sun'.[3] Characteristically the skies in Cossington Smith's bridge paintings are filled with light. As she said: 'I'm always so anxious to get the feeling of penetrating light ... Nothing to me is solid colour. There must always be light in it'.[4]

The Bridge in-Curve 1930 (p. 15) captures her delight in the bridge coming into being. Its curving structure moves over buildings and a verdant landscape, and is given release in the steel arch surging up and across towards its counterpart on the opposite shore. The two facing cranes at the apex are like spires of a cathedral, with the whole surrounded by auras of light. It is a paean to modernity, to ingenuity and the human spirit. A great colourist, Cossington Smith was deeply interested in colour theories prevalent around the time of World War I. Like her peer, Roy de Maistre, she was interested in the emotive, spiritual and

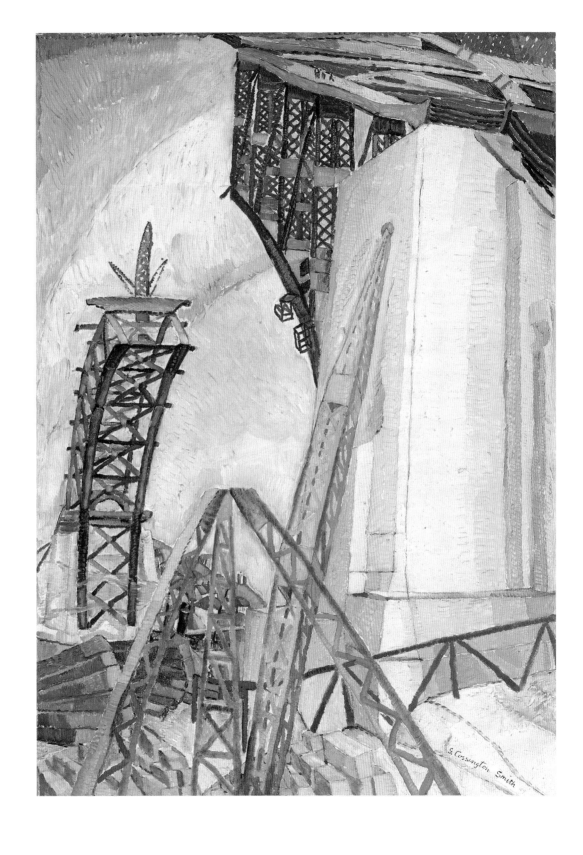

Grace Cossington Smith
The Bridge in Building 1929-30

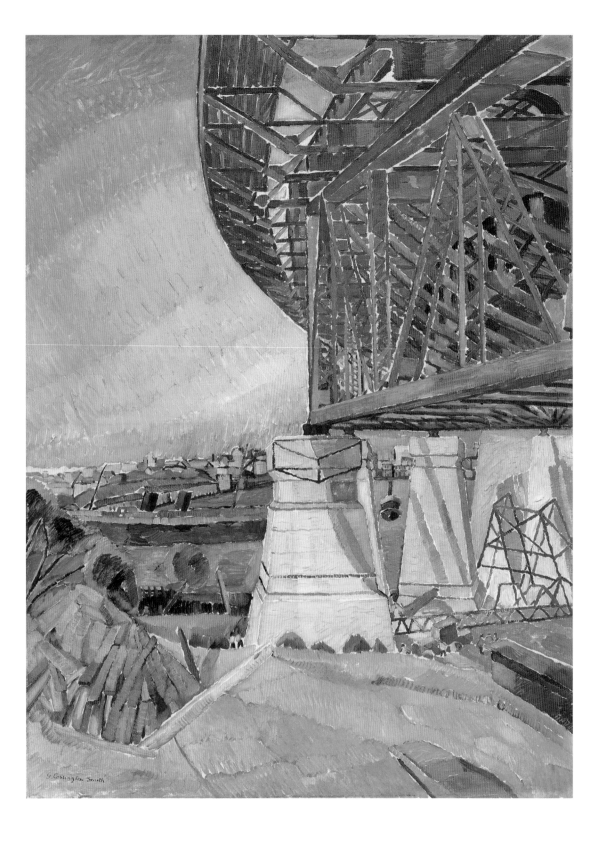

Grace Cossington Smith
The Curve of the Bridge 1928–29

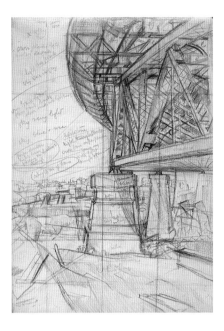

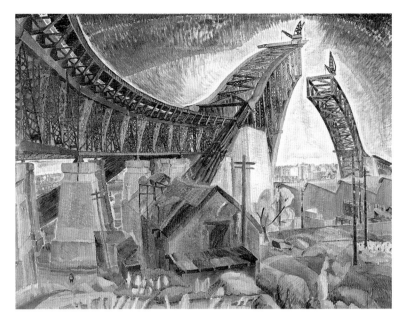

Grace Cossington Smith
Study for *The Curve of the Bridge* 1928-29
pencil and colour pencil on paper, 36.8 x 25.4cm
National Gallery of Australia, Canberrra
Purchased 1976

Grace Cossington Smith
The Bridge in-Curve 1930
tempera on cardboard, 83.6 x 111.8 cm
National Gallery of Victoria, Melbourne
Presented by the National Gallery Society of Victoria 1967

recuperative potential of colour and she read and even transcribed Beatrice Irwin's *The New Science of Colour*, first published in 1915.[5] Irwin, who has been described as a colour-poet and performer, 'the Laurie Anderson of her day', advocated meditating on a scene to allow an intuitive, felt response to colour to come through. She wrote of radiating colour: colour waves, auras and vibrations, and the capacity of colour to transform our states of mind.[6]

While Cossington Smith would have drawn selectively from Irwin's ideas, always endeavouring to be true to herself, there was a sense of excitement of implementing new discoveries when she was painting her Sydney Harbour Bridges. Around this time she received a visit from Ethel Anderson, a great supporter of modern artists. Anderson's daughter, Bethia, recalled her mother's rapturous response after her first encounter with the work: 'My mother's eyes were sparkling with excitement. Gracie's too were alight ... "And who knows?" Mother encouraged Grace, "With your unique brushstroke, with your grasp of colour, you may be about to give an expression to a quality of life, more moving than beauty alone, more intimate than infinity. You may find a fourth dimensional emotion as yet unfound, un-named"'.[7] Anderson was outraged when Cossington Smith's

The Bridge in-Curve was rejected from the Society of Artists exhibition in 1930 and she showed it the following year with works by other artists at her home in Turramurra, singling it out for special praise.[8]

The flamboyant Irish-born collector Gladys MacDermot was another keen supporter of the young moderns, and recognised Cossington Smith's achievements when others had passed them over. Although *The Curve of the Bridge* was shown in the Australian Art Quest in 1929, organised by the State Theatre, it was not selected for acquisition. Instead it was bought by MacDermot, who took it to London and loaned it to an exhibition in Walker's Galleries in 1932. Decades later, after the work had returned to Australia, it was described as 'probably the greatest modern painting of its period'.[9] Along with the breathtaking *The Bridge in-Curve* and *The Bridge in Building*, it is now a treasure within an Australian public collection.[10] The three paintings confirm Cossington Smith as an artist of considerable daring and sensitivity, capable of revealing the physical presence as well as the passion and energy implicit in the bridge coming into being in the modern world.

The modern art of painting flowers: reinventing the still life

LESLEY HARDING

When Margaret Preston determined as a twenty-one-year-old art student that still life painting held sufficient challenges and variations to sustain a career in art, she demonstrated the type of resolve and disregard for convention that would come to characterise both her personal and professional lives. It soon became evident she had found her *métier*, and shortly thereafter that she could construe the genre as a 'laboratory table' upon which her converging interests in Western modernism, Eastern art and colour theory might be tested.[1] Unexpectedly, it would also play a part in her later ambitions for a new national culture.

It was this fortitude and willingness to experiment that would eventually see Preston bring the original and remarkable achievements of *Implement Blue* 1927 and *Western Australian Gum Blossom* 1928 to the Australian canon. Her creative ideas and spectacular art 'ushered in the era of Australia's new modernity', as the curator of her retrospective, Deborah Edwards, has observed.[2] But in 1896 her prospects as a cultural inventor and path maker must have appeared questionable to those in artistic circles. In Australia, as in other colonial outposts far from Europe's *fin de siècle* advance guard, the subject of still life was largely the resort of amateurs or an occasional and benign diversion for serious painters of the landscape and nationalist narratives. Noble images of masculine labour and sun-drenched idylls of the so-called Heidelberg School or 'Australian impressionists' resounded, while the still life, an essentially domestic genre, was firmly entrenched in its customary low position under history, religious, portrait, and landscape painting.[3] That flower painting, in particular, was stereotypically a feminine subject further diminished its esteem. Preston's contemporary, the reactionary artist Lionel Lindsay, regarded such art as the 'apotheosis of Useless Beauty'.[4] It was just this sort of condescension that led the art historian Norman Bryson to associate the persistent downgrading of the still life with the historical oppression of women.[5]

As it was, Preston's initial forays into still life scarcely challenged tradition at all. Like her fellow students Hugh Ramsay and Violet Teague at the National

Gallery School in Melbourne she had worked her way from the cast room to the number one studio, where conservative painter Bernard Hall, the school's director, drilled his pupils in the Munich system of structured picture-making based on rigorous observation, accurate drawing and tonal realism. Sourcing her subjects from the kitchen, Preston went on to paint eggs, onions, pots and domestic tableware in her early years as an artist, depicting a humble, everyday reality in the historical style of the eighteenth-century French painter Jean Baptiste Siméon Chardin.

Yet at the time of Preston's decision to specialise in still life, Western art was entering a period of huge transition. Vincent van Gogh had died prematurely and retrospectives of his work in Paris and Brussels revealed to the public the astonishing veracity and independence of his painting. Paul Gauguin had recently commenced a second spell living in Tahiti, producing his flat and high-keyed 'primitivist' pictures that merged Polynesian and Western paradigms. Meanwhile Paul Cézanne was dividing the European art scene with his anti-naturalist paintings that appeared to be, as his contemporary Maurice Denis described, 'a sumptuous sequence of resounding harmonies', his process more like a Persian carpet-weaver than a painter from the past.[6] Among other innovations, these artists had begun developing new procedures for uniting colour and form and offering alternative ways of picturing the familiar world. Modernism would from hereon become an evolving, iterative series of movements and styles characterised by technical manoeuvres and philosophical diversity rather than by any sustained political or aesthetic homogeneity. Those at the vanguard turned their backs on the past and looked towards potential futures.

Arguably, one of the connecting threads of the various movements that comprised the broad church of modernism is the exigency of this future view; its proponents were united in their pursuit of a modernity not yet fully in place. These conditions saw a host of new possibilities for art, some responding to social changes and aspirations such as Constructivism, others looking inwardly at modes of representation and illusionism like Cubism, with its multiple viewpoints and conceptual type of realism. The art historian T.J. Clark explains: 'Some avant gardes believe they can forge a place for themselves in revolution, and have real truck with languages in the making; others believe that artists can be scientists'.[7] Margaret Preston and fellow Australian Grace Cossington Smith tended towards the latter camp, painting spirited descriptions of their private visual domains and looking into ways of picturing imagery specific to the local culture. Across the Pacific the American painter Georgia O'Keeffe was similarly expressing the newness of her times and personal interests, with a view to creating a modern, relevant, national art.

As this exhibition attests, though the three artists forged independent approaches to painting within the modernist idiom, they all used the still life, and more specifically the painting of flowers, as a testing ground for their modernist arguments. A forbearing subject, it provided scope for devising new tactics and stylistic constructs that could then be applied to their broader oeuvres. They could rehearse and research, see what survived the extremes

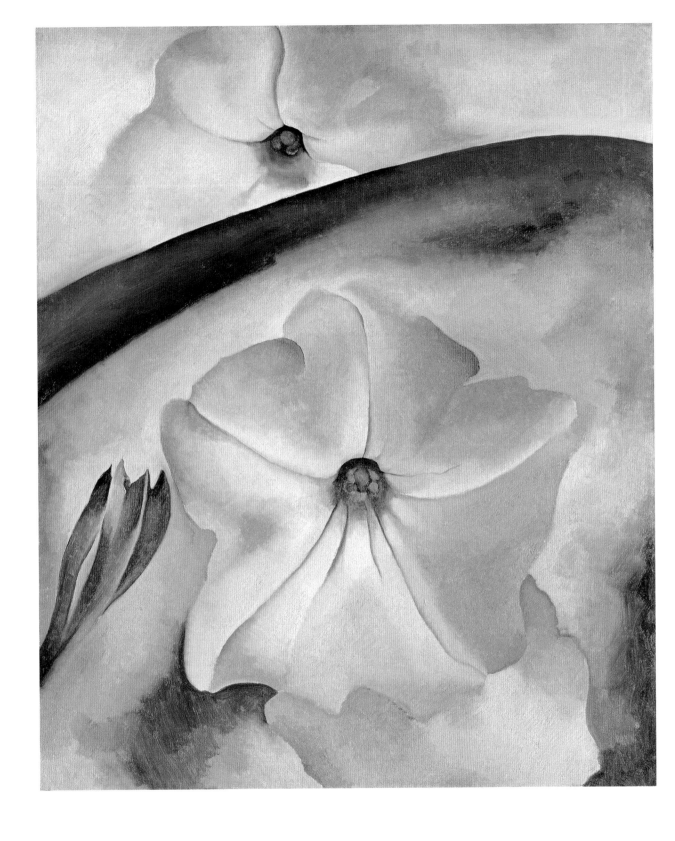

Georgia O'Keeffe
Petunia No. 2 1924

of dispersal, emptying, flattening or abstraction,[8] or exercise their curiosity for other art forms and philosophies. For each the still life was much more than a static tableau of nostalgic or convenient accoutrements and comestibles. Instead it comprised natural things real to their worlds, perennially alive and demonstrating a form of truth. And for all three, this reinvented form of still life was a vehicle for their abiding interest in nature.

Such a motive was not unusual among modernist artists, and indeed a whole stream of modernism was devoted to a more organic art in Europe in the interwar years. This 'rusticization of the modern',[9] as the art historian Romy Golan calls it, was part response to the trauma of World War I and part reaction against the machine age. Philosophically it can be traced to the Back to the Land and Back to Nature movements of the nineteenth century, which were accompanied by the political treatises of the art commentators John Ruskin and William Morris in England and the transcendentalist writers Henry David Thoreau, Ralph Waldo Emerson and Walt Whitman in North America. These observers held in common a faith in the capacity of the natural realm to fulfil spiritual as well as social requirements: contact with nature, in their eyes, had a liberating, metaphysical corollary. The philosopher Henri Bergson helped revive such thinking in twentieth-century France, where a wistfulness for *le retour à la terre* saw major modernists, including Henri Matisse, Pablo Picasso, Fernand Léger and Amédée Ozenfant, along with André Derain and Maurice de Vlaminck, shift their focus towards organicism in the late 1920s.

Under the watchful guidance of the photographer and gallerist Alfred Stieglitz, Georgia O'Keeffe and others in the Stieglitz circle, such as painters Arthur Dove and Marsden Hartley, also came to align their modernist project with nature's quintessential forms. The foundations for a true American art, they believed, were derived from the land itself and its vernacular qualities. Bergson's concept of *élan vital* or 'life force' as an experiential creative principle appealed to the group, especially the prospect of 'holding a moment' and translating the direct experience of the artist through the visual medium of art, so the viewer could relive an equivalent sensation.[10] Stieglitz had grasped the concept quickly, publishing extracts of Bergson's influential 1907 text *Creative Evolution* in his journal *Camera Work* as early as 1911. That such thinking would be used as a departure point for the Stieglitz circle's nationalist project underscores the evolutionary character of modernism as it was dispersed and rethought beyond the wellspring of Europe.

O'Keeffe was newly influenced by the theories and teachings of the artist and educator Arthur Dow when her formative work, unusual for its formal abstraction and emotive qualities, was first brought to Stieglitz's attention in 1916. Dow's theories of composition impressed upon her the importance of structure, design and colour as well as the Japanese concept of *nōtan* (light-dark harmony), but it was his mentor Ernest Fenollosa's insistence on the democratic, organic integration between art and society that saw her turn her eye to motifs that were unceremonious and commonplace. Fenollosa garnered some of his ideas from the texts of Emerson and Thoreau, reinforcing

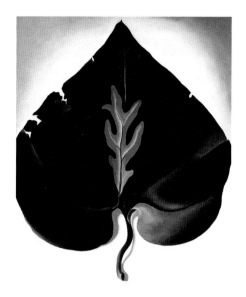

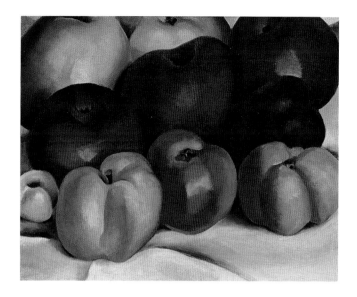

Georgia O'Keeffe
Dark and Lavender Leaves 1931
oil on canvas, 50.2 x 42.1 cm
New Mexico Museum of Art,
Santa Fe
Gift of the Georgia O'Keeffe
Estate 1993

Georgia O'Keeffe
Apple Family - 2 1920
oil on canvas, 20.3 x 25.7 cm
Georgia O'Keeffe Museum,
Santa Fe
Gift of the Burnett Foundation
and the Georgia O'Keeffe
Foundation 1997

O'Keeffe's reading of their work when she was young and the inspiration
to be found in the 'nature religion' they espoused. Thoreau's observation
that 'Nature will bear the closest inspection. She invites us to lay our eyes
level with her smallest leaf, and take an insect's view of its plain',[11] summons
immediately O'Keeffe's close-up views of shells, bones and leaves, and
especially her famous flowers.

The earliest of these paintings were created in 1918, around the time that
she began joining Stieglitz at his parents' property on the southwestern shore
of Lake George in upstate New York. They would spend part of each year
there until 1934. Although there were reportedly consternations attached to
the summer months she 'endured' with the wider Stieglitz family and a sense
of isolation and confinement,[12] it is also apparent from the variety and depth
of O'Keeffe's Lake George paintings that she gained pleasure and inspiration
from the inherent beauty of the vast waters, surrounding wooded trails and
groves of abundant plant life. Her arresting series of watercolours and oils
featuring the crimson canna lily found in the flowering gardens of the Steiglitz
estate shows a melding of her previous organic abstraction with myriad
investigations of the blossoming plant. A thorough enquiry into form and
colour, the suite culminated in *Red Canna* 1925–28 (University of Arizona Art
Museum, Tucson), wherein the flower's nuanced interior folds are ablaze with
a vital and animated force. Significantly, O'Keeffe largely dispensed with the
conventional bouquet or vase arrangement and the contrived, static arena of
the studio still life and instead filled her compositions, often from edge to edge,
with images of magnified blooms.

The contemporaneous and persisting view that her flower paintings are
sexually charged – a product of Stieglitz's positioning of her work and their
personal relationship – is a frequent touchstone in the vast literature on O'Keeffe.
With their luxurious colours, soft surfaces, flowing imagery and close examination
of form and structure, pictures like *Red Canna* and *The Black Iris* 1926 (p. 37)

readily lend themselves to metaphoric interpretations and Freudian associations. That they could be about more than their overt subject, and allude to the flush of romance or the ecstasy of physical love, admittedly made for easy conjecture after Stieglitz made public his ongoing and intensely intimate photographs of O'Keeffe. For her part O'Keeffe alternately resented the inference and played on its implications. A woman artist painting feminine subjects was to her a detestable stereotype, yet it also presented an advantage, enabling her to say things in her art that men could not.

One of three flower paintings included in this exhibition, the soft and ethereal *Petunia No. 2* 1924 (p. 19) may have helped consolidate O'Keeffe's reputation as a painter of the female experience, but it also marks an interesting development in her practice. During the extended periods spent at Lake George she had become increasingly involved with the property's garden, and that year had planted beds of petunias in blues and purples. Her cultivation of flowers to paint, as opposed to representing those found opportunistically in nature, allowed her to study the plants as they grew and adopt the critical eye of the gardener. O'Keeffe chose cultivars developed by the botanist Luther Burbank, connecting not only to the popular culture of American horticulture (Burbank was by now a national hero and renowned 'plant wizard') but to science, advancement, experimentation and the 'garden of invention'.[13] It was the beginning of what would become a self-conscious program. A true American art, she now understood, could be elaborated through seriality and visual acuity rather than grand and isolated artistic statements.

O'Keeffe lent her telescopic focus to a range of items collected at Lake George. Among these her bold and reductive paintings of apples (America's national fruit in Emerson's view) hold an important place in the lineage of still life painting, though not so her many pictures of leaves gathered on walks around the Stieglitz property. Now regarded as an innovation in the genre, the leaf paintings, many of which are magnified like the flowers, are often interpreted as markers of O'Keeffe's autobiography – representing the passing of seasons and nature's phases of growth, decline and regeneration, and thus symbolic of events and changes in her life. As intrinsic to the living, breathing ecosystem of Lake George, the leaves perhaps more accurately speak to the artist's desire to get to the heart of things, to represent the elemental and the everyday. As the academic Bruce Robertson has pointed out, 'For O'Keeffe, Lake George was not the Lake George of Revolutionary War history, or even of contemporary nature tourism, but the more abstract essence of the region's natural patterns. Where other artists heard the history and rich associations ... O'Keeffe screened out those voices and heard only the bass note of the land'.[14] Repeated contact and deep experience of some small piece of America had become central to her philosophy and aspirations, as it had for her immediate colleagues.

But it was in the landscape of New Mexico that O'Keeffe truly felt a kinship with country. It was here, starting in the summer of her first sustained visit in 1929, that she found her second signature motif, again a modern

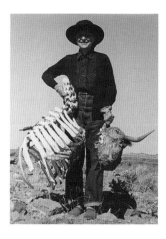

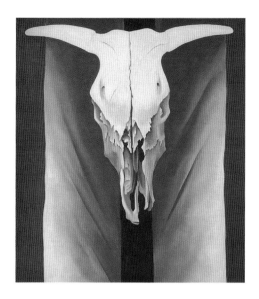

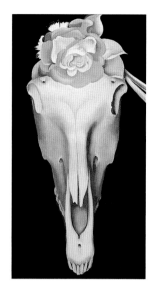

variation on the still life theme: the weathered and bleached bones of the desert. Initially wanting something of New Mexico to paint after returning to New York, she collected a barrel full of these organic souvenirs of the Southwest environment to help her remain in touch with the landscape there and provide a continuity of feeling. Like the leaves at Lake George, the bones would soon become fundamental to her sense of place. Later routinely sourced and painted, they also added a rhythm to her work in the studio after she made New Mexico her permanent home. And while an essential subject in the history of the *nature morte* as a metaphor for mortality and the inevitability of time passing, the bones and skulls would amount to much more than a revival of the *vanitas* for O'Keeffe. Epitomised by her famous *Cow's Skull: Red, White and Blue* 1931, an image of a ragged cranium set against the colours of the national flag, her new subject joined soil and spirit in what would become a most powerful and original contribution to American modernism.

Her paintings of bones also helped O'Keeffe orchestrate a shift from her typecast persona and into new territory – from 'woman artist of Manhattan' to 'Saint Georgia of New Mexico'.[15] As if to confound her critics or provide a reminder and link to her broader oeuvre, the early skull paintings feature flowers: an artificial, funereal calico rose crowns the head in *Horse's Skull with White Rose* 1931, for example, while in *Ram's Head, Blue Morning Glory* 1938 (p. 9) a single bloom floats under the graceful twist of one horn, enhancing the ornamental qualities of the image and creating a modern *memento mori*.[16] O'Keeffe eventually abandoned such pairings as she recast the Southwest trophy-aesthetic of skulls on domestic display, sifting it through her modernist filter and presenting it anew.[17] 'The bones seem to cut sharply to the center of something that is keenly alive on the desert', she wrote in 1939,[18] a statement writ large in her *Pelvis IV* 1944 (p. 119), in which the vastness of the eternal blue sky and the solidity of the earthly relic are held in exquisite counterpoise.

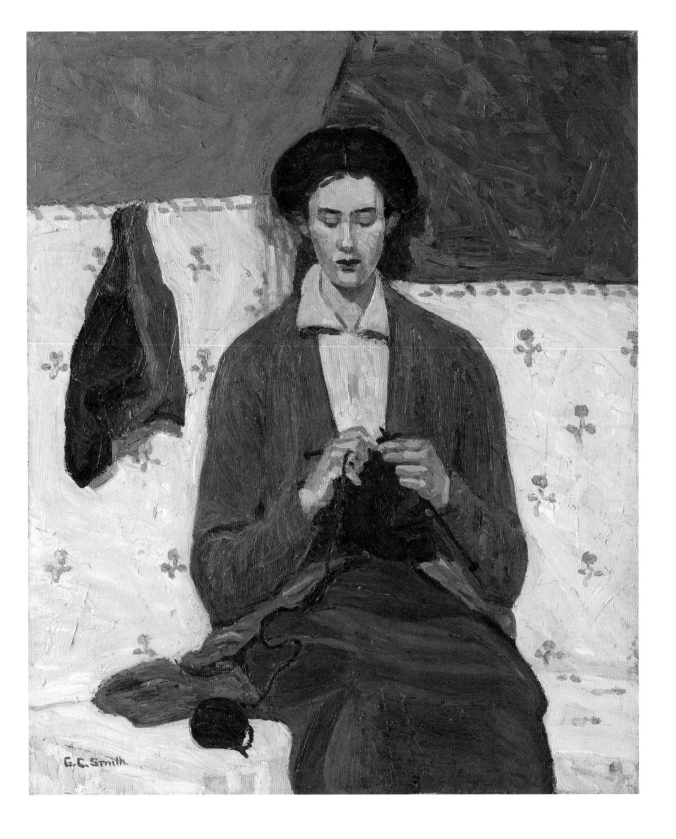

Grace Cossington Smith
The Sock Knitter 1915

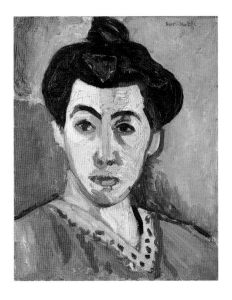

Henri Matisse
Portrait of Madame Matisse:
The Green Line 1905
oil on canvas, 40.5 x 32.5 cm
National Gallery of Denmark,
Copenhagen
Gift of Ingeniør J. Rump
Foundation 1936

Margaret Preston
Sketchbook on colour
theory c.1917
pencil and oil paint with notes
in pencil and black ink, 20 x 16.2 cm
National Gallery of Australia,
Canberra
Gift of Mrs L. Hawkins 1987

Like O'Keeffe, Grace Cossington Smith also found a world of wonder and enlightenment underpinned by fundamental truths in familiar subjects, with the idiomatic qualities of local conditions forming the basis for much of her shimmering, vibrant art. While O'Keeffe was honing her microscopic view of nature in America, Cossington Smith was turning her eye to the beauty of simple forms from her own backyard.

Cossington Smith had long looked to her immediate environment for subject matter: flowers, fruit and vegetables, and the things of everyday life that reveal in their forms functionality and signs of use formed the basis of even her earliest drawings. Her first exhibited painting, *The Sock Knitter* 1915, emerged from the same domestic impulse. An image drawn from the quotidian particularities of her life and a modern, suburban theme – a portrait of her sister Madge knitting socks for the war effort – it is pointedly at odds with the heroic masculine trope that dominated national painting until that time. It is also notable for stylistic reasons, with its compressed picture space and flatly painted, decorative background divided into four distinct planes suggesting the study of Matisse's portrait of his wife, *The Green Line* 1905, in which the background blocks of colour meet disjunctively behind the head of the sitter. 'In those days I felt everything was a pattern', Cossington Smith remarked. 'It wasn't a forced thing at all'.[19]

While *The Sock Knitter* has come to hold a significant place in Australian art as a herald for the advance of modernism, it was also a student work, dating to Cossington Smith's time at Antonio Dattilo-Rubbo's atelier in Rowe Street, Sydney. An Italian émigré, Dattilo-Rubbo's classical training supported his own fairly conservative painting, though his outlook was more liberal than that of avid anti-modernist Julian Ashton at the rival Sydney Art School. Dattilo-Rubbo had a practice of reading to his students at lunchtime, and it was in this way that Cossington Smith heard about, perhaps even before she saw to any large extent, the revolution in art made by the likes of Matisse,

Cézanne and Van Gogh. By the 1910s their inventions were not the newest to emerge from the European avant-garde, but their efforts had been sustained and held sufficient clarity for influences to persist and circulate.

It was during one of these lunchtimes at the school that Margaret Preston came to talk to Cossington Smith and her peers about the methodology of her art, and demonstrated the chart she used to determine the colour schemes for her paintings. It was the first of only two encounters between the women – curiously, as they exhibited in Contemporary Group shows together – and long forgotten by Preston when she awarded the younger artist the Mosman Art Prize in 1952 for *Gum Blossom and Drapery* (p. 155). But it is tempting to consider that the ideas presented that day might have precipitated Cossington Smith's own colour tests of around 1926, which included an annotated series of chromatic opposites in a wheel rotation. By now her investment in Beatrice Irwin's book *The New Science of Colour* had been thoroughly secured, and she was well aware of colleagues Roland Wakelin and Roy de Maistre's colour-music paintings of 1919. Though idiosyncratic, Preston's theory was based in part on the solar spectrum of Newton's 'Optiks', for which he analysed refraction. His summation that colour is a property of the light that reflects from objects, rather than inherent to the objects themselves, might well have struck a chord with Cossington Smith given her growing interest in precisely that relationship.

It may not be coincidental, then, that around this time, having quietly determined her own path in art, Cossington Smith ceased taking Dattilo-Rubbo's classes and began painting with new vigour and strength in her little studio at the bottom of the garden at Cossington, the family home in semi-rural Turramurra. The transformation was immediate: gone was the dark tonality of her populated central Sydney scenes, and in their place a singing, harmonious palette inspired by the colours of nature. Where her last work made under Dattilo-Rubbo, *Still Life with Vegetables* 1926 (private collection), bears the weight of an overwrought, Cézannesque contortion of form and manipulated, tilted planes, *Pumpkin Leaves Drooping* of the same year sees Cossington Smith dismiss perspectival concerns and evoke the living, if listless, energy of her subject with short, staccato brushstrokes. She aimed for 'firm, separate notes of clear, unworried paint', according to her first curatorial champion, Daniel Thomas, as a way of modulating forms individually as well as in relation to each other.[20] The space and parameters of her picture-making had changed, too. Where before she conceived a finite image, with all visual information contained within the frame, now she cropped her compositions so that nature's 'crowding fecundity', as Mary Eagle has described it, is unresolved.[21] This is true of *Arums Growing* c.1927 (p. 140), in which a tangle of plants presses against the front of the picture plane, though more sparsely realised in *Lily Growing in a Field by the Sea* c.1927 (p. 141) and *Foxgloves Growing* 1929 (p. 144), where the consciously active titles and clipped slices of imagery work together to conjure a wider, expanded scene in the mind's eye.

Cossington Smith received much support at the outset of her independent journey from the Turramurra resident and modern art advocate

Grace Cossington Smith
Pumpkin Leaves Drooping 1926

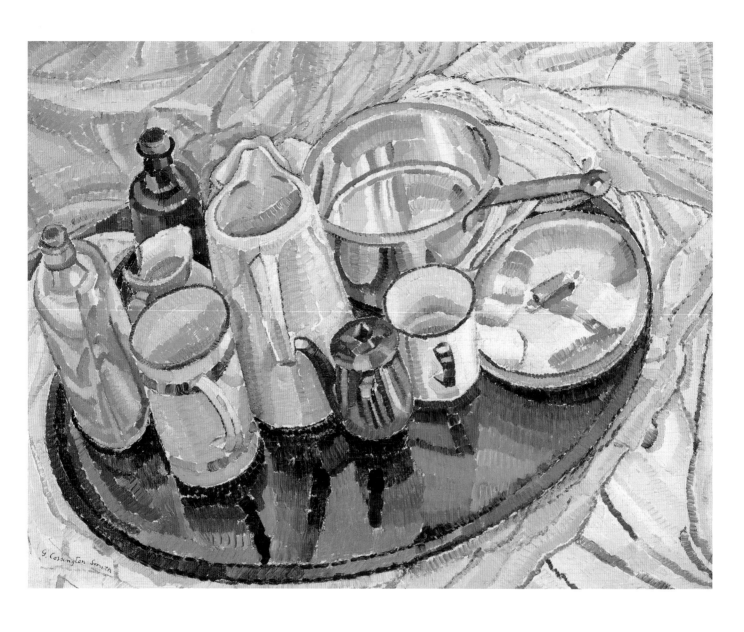

Grace Cossington Smith

Things on an Iron Tray on the Floor c.1928

Grace Cossington Smith
Daffodils Growing 1930
oil on card, 35.5 x 54.5 cm
Art Gallery of Western
Australia, Perth
Acquired with funds from the
Sir Claude Hotchin Art
Foundation and the Nanny
Barker Bequest Fund 1996

Grace Cossington Smith
Hippeastrums Growing 1931
oil on pulpboard, 37 x 32.2 cm
Private collection

Ethel Anderson, both personally and publicly. Reviewing the artist's debut solo exhibition at Grosvenor Galleries, Sydney, in 1928, Anderson acknowledged that her paintings were full of the beauty of everyday, human experience, and praised their illuminating qualities. 'Miss Grace Cossington Smith's pictures … have the cool elegance of hail, or cherry blossom in a spring shower. They are high pitched and clear, like sheep-bells heard on windy heights. And they are all happy pictures', she wrote.[22] The exhibits comprised some of her most courageous paintings, yet all the imagery was drawn from a limited environment. Along with her flower pictures, some of which, like O'Keeffe's, render irrelevant the formal still life table and focus squarely on form and colour, Cossington Smith exhibited the now much-lauded *Trees* c.1927 (p. 52), and the sparkling *Things on an Iron Tray on the Floor* c.1928. This last is an improbably unstill still life that bears the imprint of human activity – which is felt as much as it is observed. All the lines are broken into little dots and dashes and the objects are weighted towards the back of the tray, as if someone has just set it down and it is vibrating with the tinkle of landing. The surrounding background is not floor-like at all, but instead radiates around the objects in a lively manner. It was unlike Cossington Smith to fashion an arrangement for painting – on the whole she preferred to paint things simply as she saw them. Thus the emphasis of this picture is not on the odd assortment of bottles, jugs, mugs and saucepan, but rather on its concentric rhythms and radiant hues.

The paintings that followed similarly attend to the small, quiet narratives of daily rituals and to the cyclical nature of things, closely observed and often gently poignant. Small flower studies like *Daffodils Growing* 1930 acknowledge the haphazard, simple beauty of unpicked blooms, while *Waratah* c.1928 (private collection) and *Hippeastrums Growing* 1931 zoom in to reveal the patterns and rotations of the forms, so close to the picture surface that they seem ready to burst from its confines. As the writer Drusilla Modjeska describes:

'These flowers haven't been arranged for us to enjoy; [Cossington Smith] has taken us to them as they grow and has filled the frame with them so that we look into petal and stamen as if we could reach inside and touch the essence of flower-ness'.[23] Those painted after the passing of the artist's mother in April 1931 register another key, exerting their life-force in an 'incendiary rejection of the death principle', as Bruce James has observed.[24] Painted in May 1931, *Poinsettias* (p. 154), for example, pictures a branch plucked from the garden at Cossington, the artist's small, striated brush marks corresponding with the feathery but bright red bracts and emitting something of the energy of the outside atmosphere. James calls it 'an extravagant parabola charged with preternatural vitalism'.[25] When she turned her eye to wildflowers from the bush in the 1940s and 50s, Cossington Smith re-toned her palette in appreciation of their soft, modest looseness and loveliness.

This was a different mode of image-making to the one employed by her compatriot, Margaret Preston, though Preston too was captivated by Australia's native flora later in her career, and set herself the task of its assiduous analysis. Like O'Keeffe and Cossington Smith, Preston's aesthetic had been honed during the 1910s. Unlike the other two she had felt the call of Europe keenly, first visiting in 1904–05 and again leaving her hometown of Adelaide for France in 1912, where she brightened her palette and the sense of light in her pictures. She arrived in London in 1913 to witness the pervasive influence of Post-impressionism. Roger Fry's two landmark exhibitions on the subject held at the Grafton Galleries in 1910 and 1912 had announced the arrival of modern art in England, disrupting prevailing taste and showcasing the revelatory work of Cézanne, Matisse, the Fauves, Van Gogh, Gauguin, the cubists and the 'outsider' artist Henri Rousseau. Fry's colleague Clive Bell's influential book *Art* appeared two years later, offering a theoretical basis for the developments – the principle of 'significant form'. Advocating the primacy of values such as line, colour and shape over content and ideas as the universal quality of all successful art, Bell maintained his theory provided the key to achieving unilaterally felt aesthetic emotion. By the time she painted *Still Life* 1915 (p. 77), Preston had turned her back on the tonal imitation of her early work in favour of the 'decorative' possibilities in art. This was not, as the word implies, a reference to surface ornament or prettiness, but rather an emphasis on rhythm and design. She never looked back.

After returning to Australia in 1919, Preston ushered in the new decade with a renewed sense of purpose and productivity. She had by now gathered a number of precepts to guide her individual development. From Japanese art, studied at the Musée Guimet in Paris, she grasped the importance of composition: 'the putting together of the artistic elements in such a way that each shall glorify the other', as Dow described.[26] From Cézanne and Gauguin she learned to weave colour and form into an integrated whole and the enlivening effect of a so-called 'primitivist' aesthetic. And from Cubism she understood the importance of creating a geometric structural axis for her pictures, using perspective 'as a servant, not as a master', and eliminating all photographic likeness.[27] The domestic, floral still life remained

Margaret Preston
Decoration, Still Life 1926
oil on canvas, 50.8 x 46.7 cm
Art Gallery of South
Australia, Adelaide
Elder Bequest Fund 1940

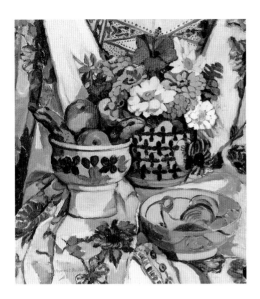

her preferred subject, on which she additionally conferred a thoughtful and even poetic arrangement of flowers, again taking her cue from Eastern practices: 'The Japanese flower book says: "A slender spray of scarlet cherries, in combination with a budding camellia, gives an echo of departing winter, coupled with a prophecy of spring"'.[28]

The paintings that ensued mark the mature phase of Preston's work. In *White and Red Hibiscus* 1925 (p. 123) she attended to decoration and an all-over pattern, the flowers filling the picture space and their shapes repeated in the darker cloth that anchors the composition in its light-dark harmony. In a reprise of the patterned effect painted the following year, *Decoration, Still Life* 1926 sees the entire canvas – bowls and vase, the draped cloth, and even the wall behind – embellished with a range of floral and abstract motifs. Rather than competing with the 'real' flowers and fruit, they take the eye on a circular journey, dispersing focus and instead drawing attention to the efficacy and intricacy of her well-planned design. The tightly composed *Still Life* 1925 (p. 32) balances the organic forms of the anemones and fruit with the flat black-and-white stripes of the surrounding room. It is an unlikely but entirely successful image, though her contemporaries may not have caught on to its coy derivativeness and debt to Léger's purist painting, *Nature Morte* of 1923 (now known as *Bowl of Pears* p. 33). A reproduction of this painting appeared in the French magazine *L'espirit nouveau*, to which Preston subscribed, in May 1924. A comparison between the two works shows Preston's careful adaptation of Léger's flat line-work, compressed picture space and overarching compositional structure. It was a short leap – a rehearsal even – towards her coolly elegant and dispassionate but wholly original *Implement Blue* 1927 (p. 11).

That year Preston was honoured with a special edition of the nation's foremost art journal, *Art in Australia*, devoted entirely to her work. Along with commissioned essays by her friend, the artist Thea Proctor, and the professor

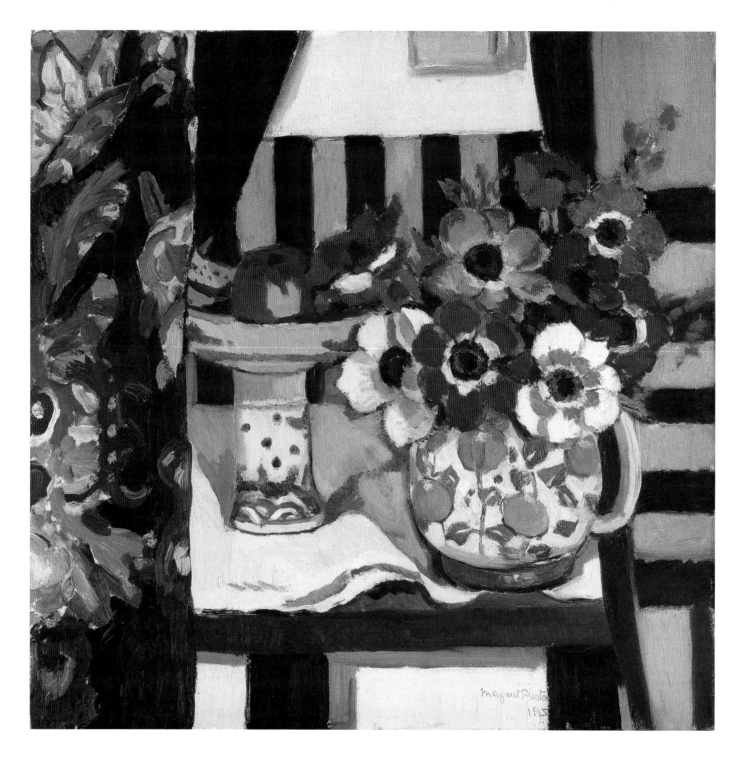

Margaret Preston
Still Life 1925

Margaret Preston
Still Life 1927 (untraced)
oil on canvas
reproduced in *Art in Australia*
December 1927

Fernand Léger
Bowl of Pears 1923
oil on canvas, 79 x 98 cm
Museu de Arte de São Paulo
Assis Chateaubriand
Gift of Carolina Penteado
da Silva Telles

of anthropology at the University of Sydney, Alfred Radcliffe-Brown
(who, incidentally, opened Cossington Smith's first solo exhibition in 1928),
Preston wrote an autobiographical epistle which she titled 'From eggs to
Electrolux', that offered a tidy if somewhat selective summary of her career
to date. Though the 'Electrolux' paintings *Implement Blue* and *Still Life* 1927
(now lost) represented only a fleeting diversion from her flowers, it was
precisely this machine-age connotation that the critics admonished when
contemplating her new, spare forms and bravely reductive aesthetic.
Yet these works laid the ground for a most fruitful development that resulted
in three of Preston's most celebrated paintings: the triumphant monochrome,
Banksia of 1927 (p. 39), and the declaratively emblematic and related pair,
Western Australian Gum Blossom (p. 35) and *Gum Blossom (or Eucalyptus)*
(p. 34) of 1928. In the first of the two she assimilated the primordial appearance
of the eucalypt with her taut modernist aesthetic by way of a strikingly simple
vertical axis; it is contrived and exacting, yet still reverential. In the other she
emphasised the natural rhythm of the leaves and the bursting fecundity of
the blossoms, the composition balanced by several gumnuts arranged on the
table below and demonstrating the artist's close, almost botanical accuracy
in depicting the plant. The flat and blocky, indeterminate backdrops in
all three paintings emphasise the exoticism of the native plants but also
foreground Preston's skill in finding geometric order in organic forms, and her
driving individualism – a difficult task in light of modernism's air of influence
and its generative terms.

Such images represented a peak in Preston's modernist vision, but soon
gave way to another pressing agenda: her pursuit of a new national art.
Her vibrantly coloured *Coral Flowers* (p. 131) and *Australian Gum Blossom*
(p. 128) of 1928 notwithstanding, she next turned to a more representational
mode where naturalism was prioritised. This was consolidated when she
moved to Berowra in 1932, where the virgin bush of her 14-acre property

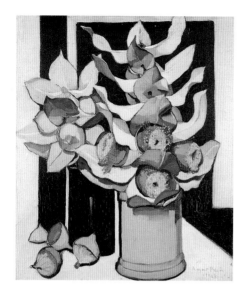

Margaret Preston
*Gum blossom
(or Eucalyptus)* 1928
oil on canvas, 53.4 x 46 cm
Art Gallery of
Western Australia, Perth
Purchased 1956

offered contact with the seasonal flowering of native plants. While she still cut specimens to paint inside, she also began to depict them in their natural setting; *Australian Rock Lily* 1933 (p. 134) is but one of numerous examples. 'Australian landscape and flora are still in the Stone Age', Preston said in 1937, 'and their real quality can be truly expressed only by artists who are content to tread the primitive paths of their ancestors, see with their eyes and express what they see with patient sincerity'.[29] Her constructed 'Aboriginal' still lifes that followed were her attempt to marry her contemporary cultural aspirations with the integrity and genuineness of human expression she recognised in the art of Australia's first peoples.

It was a goal not dissimilar to that of O'Keeffe and Cossington Smith: to develop an authentic art composed of essential elements that would tilt towards the universality of experience. 'The word truth in art opens out a vast and limitless argument',[30] Cossington Smith wrote, pointing at once to the potential of the project yet also the difficulty of the task. As her oeuvre, and that of O'Keeffe and of Preston also make clear, obstacles, objections and stereotypes did not diminish the experience, but instead steeled a resolve to continue with investigations. Far from being 'useless', the painting of flowers could give life to abstract ideas and represent real world knowledge. In persisting with the genre of the still life – and in the process rearranging its procedures and features – they expressed all they knew about art, and at the same time the 'doubleness of mind' needed to turn towards the future.[31]

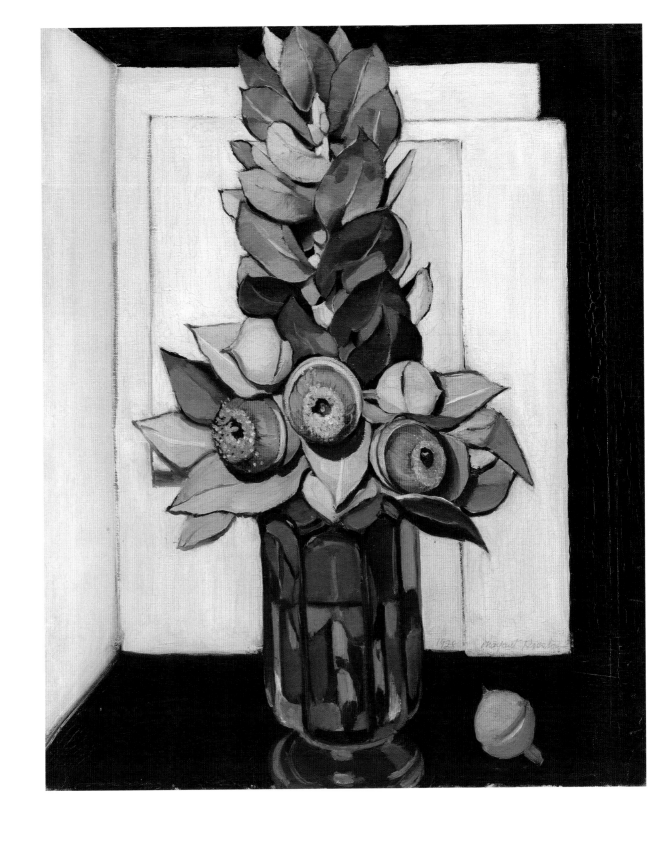

Margaret Preston
Western Australian Gum Blossom 1928

Georgia O'Keeffe
The Black Iris
1926

KATHLEEN PYNE

Among the works of the male modernists Alfred Stieglitz exhibited at his New York galleries, Georgia O'Keeffe's floral images performed the critical role of representing the feminine.[1] Sensationalising both her personal image and her aesthetic, he characterised her work as embodying a feminine, receptive principle, which he contrasted with a reciprocal masculine virility exemplified in the paintings of Arthur Dove. At first angry at this eroticised interpretation, O'Keeffe eventually came to terms with it. By the end of the decade she consciously played upon her public image in wittily constructing the fluttering gestures of her roses and the priapic verticality of her jack-in-the-pulpits.[2]

The five *Black Iris* canvases from 1926-27 exude a quiet and complexity, interrupting the flow of exuberant colours and open shapes that mark her cannas, callas, petunias and tulips throughout the 1920s.[3] Originally called a 'Dark Iris' when exhibited at Stieglitz's Intimate Gallery, *The Black Iris* of 1926 invites the viewer into its shallow space to puzzle through the multiplicity of forms veiling and circling its centre. Waiting there, its dark eye looks back at us, protected by a multitude of lids. On close inspection the petals disclose their faint opalescent shimmer of fuchsia and lavender. These delicate veils either move aside, as in the grey petals at the lower right, to reveal the dark red iris of an oculus ringed in black, or the veils remain upright, as in the blushing pink petals at the left, to keep the centre concealed. As it works both to open and to close our view of the iris's hidden space, O'Keeffe's flirtatious arrangement of the flower responds to her desire to shape our experience of it as intimate, yet strange.

In fact, O'Keeffe designed the image so as to intensify the iris's dark mystery. In a statement about her floral paintings for her 1926 exhibition at the Intimate Gallery, she stressed her practice of enlarging the form in order to engage the viewer in a deeper exploration of its essence: 'One rarely takes the time to really see a flower. I have painted what each flower is to me and I have painted it big enough so that the others would see what I see'.[4] This canvas, at nine by seven inches, is tiny, relative to other O'Keeffe formats. But O'Keeffe magnifies the small but complex flower at the centre, which in turn forces the viewer to move up against the iris pressing against the picture plane and produces a framing that cuts off the iris at its edges, blocking out all else.[5] As we peer down into the flower's normally unseen space, we enter into its world, discovering a drama of perpetually shifting colour and gestures. With all else banished from our view, its microcosm becomes our macrocosm; the soft petaled body enfolds our vision.

The iris's mystery is effected in our discovery of its secret miniature world, which is here visualised as a dark, living presence surrounded by an almost imperceptible wafting of iridescent light. All at once, it is reticent to show itself and chaste, yet seductive. Beyond these expressive devices, O'Keeffe amplified the flower's sensuousness through a repetition of linear movements, of forms within the form, a continual undulation of rhythmic lines which define its edges. And, in this dark iris, she went still further to make these internal rhythms emphatic, painting in each petal's edge with a sutbtly raised line of impasto.

In the 1920s, O'Keeffe staked her compositions on arresting colour effects and a velocity of movement, even in images such as this dark iris whose diminutive size would not readily foster the dynamic or the dramatic.[6] The 1926 and 1927 exhibitions of her work at Stieglitz's Intimate Gallery were crucial in establishing the connection between her self-identity and her floral imagery, even as they complicated that gendered identity by including her paintings of skyscrapers. While she brought her Lake George compositions of landscapes and natural objects to life through imbuing them with rippling, dynamic lines, she shifted to geometric streamlining when she turned to motifs from the urban environment. In this way, O'Keeffe acknowledged the cultural coding of the world as gendered, and she consciously exploited that duality of masculine/feminine in her own formal vocabulary and mystifying self-representation.

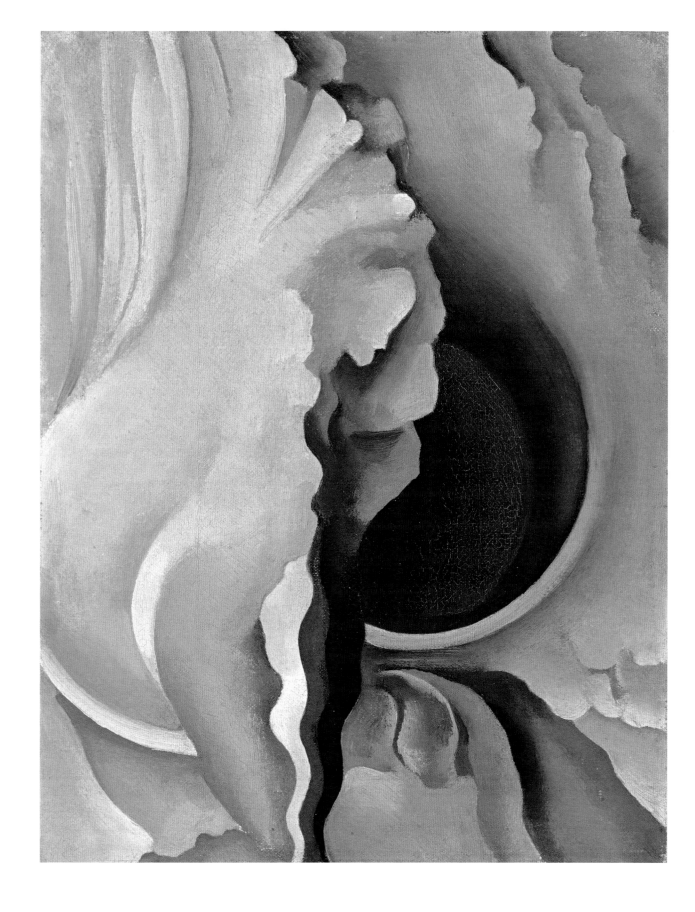

Margaret Preston
Banksia
1927

ROBYN MARTIN-WEBER

Without its cluster of flower-heads, this painting is simply an arrangement of rectangles, cubes and cylinders. It offers an almost textbook example of the laboratory table of modernism. Preston places her objects of study on a slab, all blacks and greys, making a site for the painting's and the painter's eureka moment. The triangular shards to the right, the cramped frames to the left and the refracted surface to the rear answer an explosive event at the heart of the image. If we didn't know that the central vases were created by the gifted potter, Gladys Reynell, it would be easy to read them as spent shell-casings, often recycled as home décor during this postwar period.

So pronounced is the dynamism of *Banksia*, so shattering its pictorial effects, that a first-time viewer might flinch. It is a matter of record that some Sydney viewers found aspects of Preston's project of the late 1920s a cause for dismay, even distrust. The sumptuous colours of canvases such as *Thea Proctor's Tea Party* 1924 (p. 125) and *Strelitzia* 1925 (National Gallery of Victoria, Melbourne) could be appreciated and, at a push, embraced. But the monochromes that followed, especially those depicting the prickly shrub which gives *Banksia* its title, were regarded as provocations. So they were. Preston was a natural stirrer. Her instincts were political and often propagandist. As far as the Australian cultural milieu allowed for it, she was an influential educator, writer, adjudicator, taste-maker, and exhibitor: a force to be reckoned with, and a feminist too, though not one to readily accommodate rivals, male or female. *Banksia* is the work of a woman who saw no need to pander to conservative expectation or play to the crowd, despite her evangelism when it came to art and art-making.

There is something unpleasant about *Banksia*, the unpleasantness of modernism at full tilt.

We see it first in the colour scheme, little more than a scale of flat-brushed creams, whites, and greys, alleviated by flecks of olive, ochre, and red. These tints would not look amiss in certain of the more sober conceptions of Picasso or Juan Gris. Preston was very well-travelled, a true 'moderne', having the means to drive, sail and, most importantly, fly the globe. Few Australian artists could match her exposure to the many compelling currents, old and new, that

characterised world art in her day. Partly as a result of this geographical mobility, and partly through her own curiosity, Preston was a traveller in mental realms as well. While working in a country physically distant from the powerhouses of international modernism, she could delve at will into a memory-bank of experience that included encounters with original examples of works from a wide suite of artistic 'isms', not excluding the relatively esoteric outreaches of Italian Futurism and English Vorticism.

Banksia is evidence of this. It enlists Preston's responses to post-impressionist flattening, cubist dislocation, and jazz-age animation, all finessed by her secret weapon: a printmaker's knack for the disposition of black against white. Equally Preston has not forgotten her training under the academic master Bernard Hall at the National Gallery School in Melbourne, as she tackled the demanding problem of pure tone.

The graphic imperative exploited by Preston in *Banksia* also activates the masterpiece *Implement Blue* 1927 (p. 11) and the much-eulogised *Western Australian Gum Blossom* 1928 (p. 35), pictures that were deliberate attempts to forge an authentic form of Australian modernism. They were domestic in scale and intended placement but public in meaning and ambition. *Banksia serrata*, the saw banksia depicted here, is the floral emblem of Botany Bay. The plant was first collected there by Joseph Banks and Daniel Solander in 1770, though the genus wasn't named until the 1780s. In the immemorial centuries before that, it had served as a medicinal, ceremonial and practical resource for the Aboriginal possessors of the continent. It was typical of Preston to be without fear in conscripting so richly loaded a cultural item. Her campaign earlier in the 1920s to co-opt Aboriginal art as the basis of a new, wholly Australian school of design flowed logically and occasionally controversially from the appropriationist urge.

The hardiness of the plant, its ability to thrive in extremes, and its resistance to environmental and creaturely attack, hence make *Banksia* something of a coat-of-arms for the artist.

Margaret Preston
The Monstera Deliciosa
1934

CAROLYN KASTNER

The Monstera Deliciosa 1934 was painted during the years Margaret Preston lived in Berowra, in bushland north of Sydney on a tributary of the Hawkesbury River between 1932 and 1939. During those years she painted still life arrangements of flowers from the surrounding countryside in a variety of compositional styles. While she faithfully paints the details of the strange plant called *Monstera deliciosa*, she constructs improbable surroundings that disregard all laws of nature. The geometry of the space and cropped framing of the artwork recall her compositional studies of Fernand Léger and the formal and geometric organisation of her own paintings, such as *Implement Blue* 1927 (p. 11) and *Western Australian Gum Blossom 1928* (p. 35) from the mid 1920s. In a career defined by continual experimentation and change, her earlier mastery of those techniques has a new purpose here as she works to create a national art defined by the subject matter.

Fully mature, the blossom unfolds to expose the fruit prominently at the centre of the composition, yet the abstraction of the adjacent space quickly defines the pictorial field as an unnatural space. Following the strategy of a botanical illustration, the artist depicts the plant in its multiple stages of development and domesticates the arrangement as a still life on a table that utterly defies gravity as it tips toward the viewer. The dark vessel that holds the flower, fruit and leaves finds stability as it squarely meets and delimits the bottom edge of the canvas. The painting even seems to bend light and space on the left margin where the hue of the horizontal leaves shifts unnaturally as it crosses a vertical band of white pigment. Stranger still is the optical play of light and shadow across the centre of the visual field. Two parallel diagonal grey lines highlight a sweep of shifting hues that traverse the base of the yellow fruit, the interior of the blossom, and cross an undefined white ground and a green leaf. The alternating shades of dark and light further confound the pictorial space as it joins an oblique field of white pigment that meets the upper edge of the canvas on a diagonal. These formal tactics call attention to the flat surface of the canvas and the artifice of the painting itself. And while they might be named after European strategies and styles (British Vorticism, or Purism as advanced by Le Corbusier and practiced by Léger) they also demonstrate Preston's

strong pull toward modernity even as she pictures national identity, ideas she resolves in the painting to express the specific art and environment of Australia.

A direct comparison between *The Monstera Deliciosa* and a relatively unknown work by Georgia O'Keeffe – *Pink Ornamental Banana* painted in Hawaii in 1939 – demonstrates the success shared by these artists as they brought their perpetual curiosity and a specific set of skills together to transform an original idea into a uniquely engaging work of art. Like Preston, O'Keeffe had painted flowers throughout the 1920s and returned to the familiar subject when she experienced a new environment in the Territory of Hawaii, as Preston did in Berowra. *Pink Ornamental Banana* is an asymmetrical composition that has such a strong central focus that it takes time to see how skillfully balance is achieved. The advancing colour of the central banana bud dominates the painting in the same manner as the white blossom and yellow fruit of Preston's painting. The subtle harmony between the green banana leaf and the opposing small green flower balances the composition that is cropped at the bottom edge of the canvas. In a similarly refined arrangement, Preston uses the green of the vertical bud and the surrounding leaves to stabilise her painting. Most enjoyable for me is to observe how each artist deployed her knowledge of abstraction to complete the compositions. Though O'Keeffe expressively fills the space with clouds of complementary colours and Preston's choice is a puzzle of hard-edge geometric forms, they both imbue the margins with pure painting.

Georgia O'Keeffe
Pink Ornamental Banana 1939
oil on canvas, 48.3 x 40.6 cm
Georgia O'Keeffe Museum, Santa Fe
On loan from James M. Rosenfield
in memory of Lois F. Rosenfield

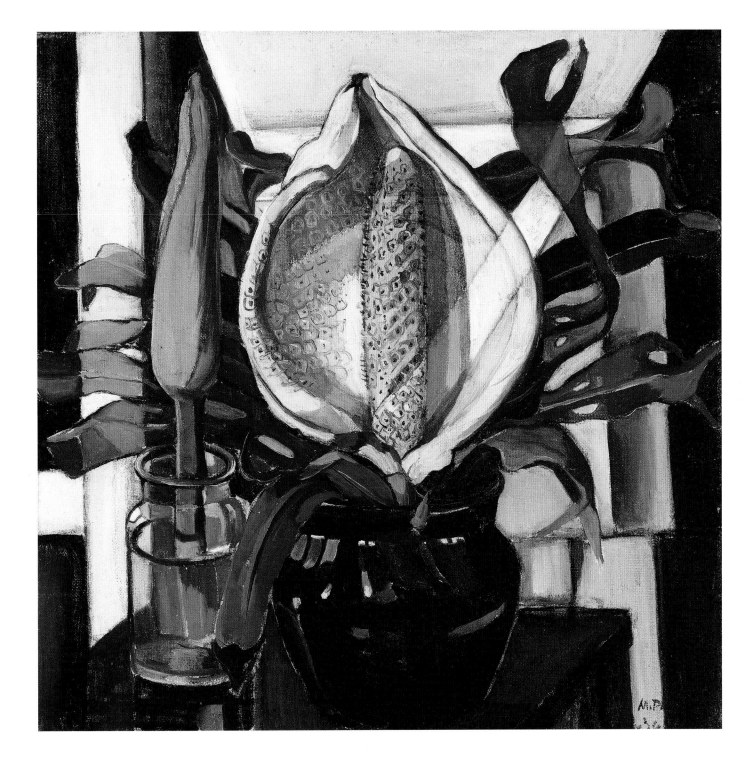

Unveiling nature: landscape in the 'epoch of the Spiritual'

DENISE MIMMOCCHI

In 1931, Grace Cossington Smith gazed at the landscape of Black Mountain in Canberra and considered in its place a radiating vision of nature's metaphysical energies. The artist's *Black Mountain* c.1931 (p. 67) depicts a landscape that appears ignited by an electrical charge into vitalist motion, an impression visually footnoted by the telegraph poles whose forms synthesise into the greater rotations of the composition. Cossington Smith gave little away concerning influences on her art, but *Black Mountain* appeals to Kandinsky's idea of abstraction as 'unveiling' the true laws of nature and giving shape to a greater reality, the meanings of which elude direct representation.[1]

Portraying the landscape with an aura-like manifestation, Cossington Smith came closest in *Black Mountain* to realising the mystical terms of modern colour that she had gleaned from the American writer Beatrice Irwin in *The New Science of Colour* (first published in 1915). It is one of the sources of modern creativity known to have had an impact on Cossington Smith as in 1924 she transcribed its text and colour diagrams.[2] But the book's broader message of colour as a regenerative force with the potential to visually translate spiritual consciousness would have confirmed her already established awareness of colour as an artistic key to a deeper expression of the modern world. Her knowledge of international modernist colour theories ultimately served to augment her faith in her own creative creed of painting the world through 'colour vibrant with light'.[3]

As Cossington Smith increasingly claimed light-enriched, golden hues as the central feature of her palette (seen in, for example, *Yarralumla* 1932 p. 149) she contemplated the idea of a 'black mountain' as the inverse of her luminal colour world.[4] She used the darkened mass as a central and grounding force in *Black Mountain*; a shape that is void of light but from which coloured light radiates. With much left unformed in this sparsely painted work (the colour of the paper provided the yellow tones of her preferred palette), the artist creates through the mountain image a mighty compositional thrust that tilts the world, and around which all movements of colour gravitate.

Finding release from the strict order of appearances, *Black Mountain* suggests how the artist revelled in the sensation of colour to describe the animated undercurrents and spiritual dimensions of the landscape.

At the time that Cossington Smith created her remarkable landscape, the American Georgia O'Keeffe had returned to the New Mexico desert. After an initial stopover in 1917, O'Keeffe finally fulfilled her desire to revisit in 1929, when she stayed in Taos for four months. Returning in 1931 and regularly thereafter, she finally relocated to the region in 1949.

As O'Keeffe confronted the exhilarating expanse of New Mexico and its diverse landscapes of mountains, river systems and mesas, she initiated a series of panoramas that translated the region's spectacular land-forms into statements of her connections with place. Indicative of these works is *Back of Marie's No. 4* 1931 which was based on the view from Marie Tudor Garland's ranch where O'Keeffe was staying.

While the work is a close representation of the landscape, the composition also follows the reality of the artist's eye as she lingers between the contours, crooks and crevices of mountain formations. O'Keeffe's work in New Mexico refreshed her understanding of the centrality of colour to her practice, and what she described as her 'effort to create an equivalent with paint colour for the world – life as I see it'.[5] In *Back of Marie's No. 4*, the world is compressed into zones of colour: infusions of rich purple hues describing darkened mountains, ochres that suggest desert sand, a forthright sky blue and a summer eruption of cottonwood tree green. We see again an artist who contemplated her surrounds, and created a richer evocation of place through her colour translations of the landscape.

O'Keeffe also adopted a compositional rhythmic drive whose movements distil the landscape's forms. A decade earlier, she had painted closely cropped views of contours of fabric. In these works she transmuted the miniature rhythms of the everyday into something mysterious and epic that suggests something beneath (including *Series 1, No. 12* 1920 and *Abstraction White* 1927, pp. 102, 103). Her evocation of the New Mexico mountains is not dissimilar, with the rhythmic folding of colour creating the impression of the landscape's malleable skin, or once again the landscape's veil that suggests forces beneath.

O'Keeffe was aware of D.H. Lawrence's sense (as he wrote in reference to America) that 'all creative art must rise out of a specific soil and flicker with a spirit of place'.[6] From the time she began to stay in New Mexico, she repeatedly emphasised her deep links to the landscapes of the Southwest. It was a connection that evolved over time but solidified when she permanently moved there. She would often refer to having had a great feeling of fulfilment when alone in the landscape. As Wanda Corn has recognised, the sense of painting from a position of a spiritual connection to place, of returning to landscapes that were deeply familiar and which they considered sacred, was shared by various of O'Keeffe's American artist colleagues in the Stieglitz circle. 'Spirit was the mystery of a physical place ... its psychological hold on the artist'.[7] The notion of the spirit was deeply entrenched in O'Keeffe's idea

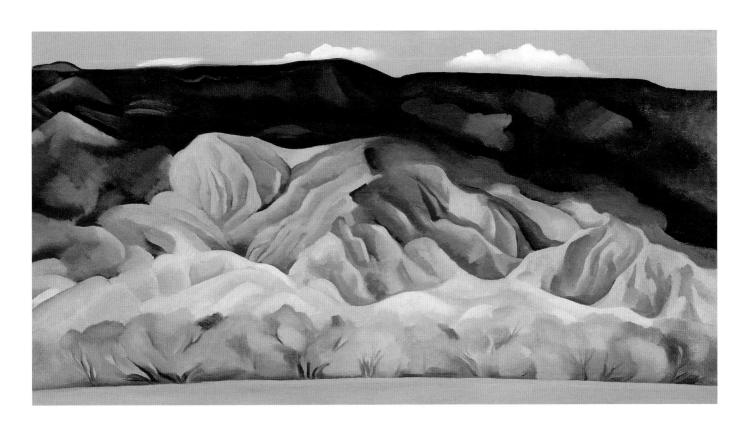

Georgia O'Keeffe
Back of Marie's No. 4 1931

of painting the landscape, guiding her redefinitions of place through colour in the works she produced which revolutionised landscape painting in America.

It was a decade after O'Keeffe's initial summers in New Mexico that the Australian artist Margaret Preston turned her attention from still life to landscape painting. Through this shift in her practice she authored her own revolution in her nation's landscape art.

Preston's artistic metamorphosis has been examined with reference to her experience of living in a bush landscape.[8] During the 1930s she lived at Berowra, a bushland suburb north of Sydney that fringes the vast Ku-ring-gai Chase National Park. Preston had moved to a region that was marked by the long-standing occupation of Aboriginal Australians. She had become an avid student of Aboriginal art in museum collections, whose sophisticated abstract designs she promoted as the basis of a modern and distinct national art form.[9] Living in a landscape rich in ancient Aboriginal rock carvings and paintings further fuelled her growing realisation of the inextricable links between culture and country for Indigenous Australians.[10]

In 1940 Preston travelled to areas in northern and western Australia to view Aboriginal rock art sites and took in a spectacular array of forms including the Wandjina figures of the Kimberley, the ancient rock galleries at Gunbalanya (Oenpelli), the 'x-ray' art of Kakadu, and the distinct Tiwi designs of Melville and Bathurst Islands. In all, she encountered an artistic heritage whose magnificence she realised rivalled the greatest achievements of Western art. But from her experiences in Berowra, Preston was aware that Aboriginal cultural markers of place were not confined to Australia's remote regions – they also surrounded the modern, domesticated spaces of white Australia. Perhaps this catalysed an approach to landscape within her own practice, for the notion of the domestic as the terrain from which viewers could best experience the values of abstract art was fundamental to Preston's modernist thinking.

It was after Preston returned to live in Sydney in 1939, and had absorbed the lessons of her trips to northern Australia, that she painted one of the first in a series of innovative landscapes: *I Lived at Berowra* 1941. This painting suggests how the experience of her bushland home remained pivotal in

Photograph from Margaret Preston's photograph album, 1940s, of a rock carving at Ku-ring-gai
Courtesy of the Australian Institute of Aboriginal and Torres Straight Islander Studies, Canberra

Distant view of Margaret Preston's house at Berowra 1936
Photograph: Harold Cazneaux
Preston archive
Art Gallery of New South Wales Library and Archive, Sydney

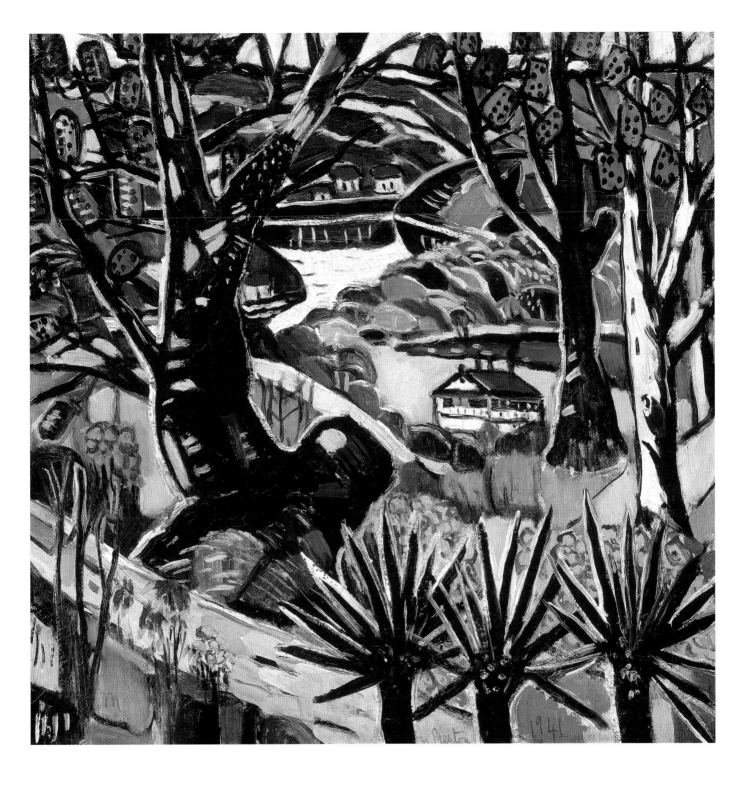

Margaret Preston
I Lived at Berowra 1941

shaping her vision as a landscape painter. It was unlike Preston to suggest a sense of the personal in her work; indeed, she claimed the importance of formalist objectivity over emotional values in art.[11] However, in *I Lived at Berowra* memory intercepts her formalist vision for an imaging of the essence of place.

The work is a landscape in the vein of a still-life painter, with disparate elements signifying various features of her bushland home brought into a tight, unifying compositional structure. Imagery of the region's distinct flora, of Berowra's red-roofed houses, glimpses of nearby Berowra Creek, and the gnarled banksia tree of her garden all appear in this composite envisioning of an experience of place. As in her later landscape, *Blue Mountains Theme* c.1941 (p. 73), Preston here proposes a landscape composed and amplified by the relationship of its parts. She also refers to the traditions of Taoist–Buddhist Chinese landscape painting that she had observed from her student days. 'They paint the spirit. We paint the object', she later concluded.[12]

But the overriding framework through which Preston projects the essence of place is that of Aboriginal art. Her memory of Berowra is coloured by a palette derived from Aboriginal art: the black and white contoured rhythms of the landscape forms recall the Queensland forest shield designs she had studied during her northern travels. Preston amalgamates dots and schema drawn from a diverse range of Aboriginal cultural traditions, using a generalised and appropriated sense of Aboriginality to invoke a visual language of place. Her aim was to reference Indigenous Australian art, as understood through the precepts of Western modernism, as a basis for a distinct national art form, and one that extracted 'the essentials of nature and the spirit of country'.[13] As such, in *I Lived at Berowra,* Preston recontextualised the landscape into one in which the 'emotionless' art of a formalist still-life painter sought to extract a spirit of place to redefine the aesthetics of modern Australian cultural nationalism.

The great epoch of the Spiritual which is already beginning ... will provide the soil in which a monumental work of art must come into fruition.

— Wassily Kandinsky 1910–11[14]

It has been long understood that landscape painting is a *construction* of place; that '"landscape" is made in the mind'.[15] Traditions of landscape painting are formulated by the desires of the age and shaped by cultural attitudes and codes and communal ideals of an attachment to nature. By the early twentieth century, when notions of the spiritual were shaping the forms of developing abstraction, the image of landscape was redefined by a desire to express its unseen forces.

The examples of works discussed by Cossington Smith, O'Keeffe and Preston, while stylistically diverse, are bound by this modernist drive to probe

Georgia O'Keeffe
Evening 1916
watercolour, 22.5 x 30.5 cm
Georgia O'Keeffe Museum, Santa Fe
Gift of the Burnett Foundation
and the Georgia O'Keeffe
Foundation 1997

Georgia O'Keeffe
Evening Star No. VI 1917
watercolour, 22.5 x 30.5 cm
Georgia O'Keeffe Museum, Santa Fe
Gift of the Burnett Foundation 1997

beyond the landscape's known forms and represent a deeper, spiritual conception of place. While landscape subjects were central to the artists' repertoires (though at a later stage for Preston), it was through their individual interrogation of the systems by which to visualise nature – in its miniscule and monumental formations, its physical manifestations and metaphysical energies – that they revolutionised the traditions of landscape painting in their respective countries. As landscape served as a potent symbol of nationhood in both America and Australia, their modernist redefinitions of place also challenged assumptions underpinning cultural identity.

The 1910s, the dawn of Kandinsky's spiritual epoch, was a formative decade for O'Keeffe, Preston and Cossington Smith as they sought to reorient their academic student practices toward principles of abstraction. In an era of modern art when colour carried sensuous, psychological and spiritual meanings, the use of subjectively-formed palettes became the keynote of the artists' modernist transformations. The pervasive idea that abstract art shared the qualities of music, that it visualised abstract sensations, and was shaped synaesthetically by colour harmonies and rhythmically induced forms, also guided O'Keeffe, Preston and Cossington Smith's burgeoning modernism. They all understood, as O'Keeffe stated, that 'the idea of music could be transcribed into something for the eye'.[16] The artists pursued these ideas to shape non-visible realities as they developed abstracted languages to reinvent the landscape.

A sense of connection

In her earliest series of abstracted landscapes, O'Keeffe drew on her modernist training to paint a sense of connection to her environment, a theme that would become an enduring subtext in her work. Her close reading of Kandinsky's *Concerning the Spiritual in Art* (1911) in 1916 reinforced her determination to 'say things with colour and shape that I couldn't say in any other way – things I had no words for'.[17] Experimental watercolours produced shortly after (including *Evening* 1916 and *Evening Star No. VI* 1917) convey her feelings of

immersion in the wide Texan landscape, in minimal compositions of simplified form, intensified colour, and unfolding rhythms.

O'Keeffe's abstracted expression of the landscape had also been informed by the compositional principles of Arthur Wesley Dow, her teacher in 1914, and his mentor, the influential Orientalist scholar Ernest Fenollosa.[18] Dow claimed it was 'not the province of the landscape painter merely to represent trees, hills and houses – so much topography – but to express emotion ... by [their] art'.[19] Believing the ultimate purpose of art was to 'fill a space in a beautiful way',[20] and that elements of design could embody emotional sensations, he promoted the use of the stylised tenets of composition and colour harmonies sourced from Japanese and Chinese art as a basis for artistic expression. Dow's influence became so entrenched in O'Keeffe's aesthetic thinking that she would see the colour-enriched sunsets of the Texan landscape as a 'Dow canyon'.[21]

Preston was similarly inspired to view the landscape through the prism of Dow and Japanese-inspired art forms, though with different outcomes. Like O'Keeffe, Preston cited Dow's dictum about art 'filling a space in a beautiful way' as informing her transition to modernism.[22] She studied Dow's influential *Composition* (1913), a practice guide to applying his methods of abstraction, and also kept Fenollosa's *Epochs of Chinese and Japanese Art* (1912) in her library. These texts, along with her own study of Japanese *ukiyo-e* prints in the Musée Guimet in Paris in 1912, encouraged her understanding 'that a picture could have more than eye realism'.[23]

In Sydney during the 1920s, Preston produced her first body of landscapes in the form of a series of woodblock prints based on scenes from the city's water-bound environs. The debt to Japanese stylisation and Dow's elements of pictorial creation are clear in these boldly coloured compositions of simplified form and strong linear rhythms. Despite their Japanese guise, Preston's prints are instantly recognisable as Sydney scenes. With images of rolling waves, rich blue harbour waters, sinewy silhouettes of gum trees, and the cubic patterns and bustling movements of the cityscape, her prints exude the dynamic energies and pulsating undercurrents of the modern metropolis. Preston saw Japanese prints as 'statement[s] of Vital fact', and this series of woodblocks popularly envisaged the spirit of Sydney's modernity (pp. 126–27).[24]

While Preston remained focused on the lessons of Japanese-inspired design, O'Keeffe channelled such influences toward visualising 'a spiritual reality'.[25] From 1918, O'Keeffe initiated a decade-long routine of painting at Lake George in upstate New York during the summer and autumn months. She used subjects from the region's fecund terrains to produce works that delved into organic realities, creating strange new formations as statements of an 'equivalent for what I felt'.[26]

In an early group of Lake George paintings, O'Keeffe translated her experiences of rowing across the lake at night into enigmatic abstracted compositions, including *Series 1, No. 10* 1919. The rising shapes in the foreground, suggesting the bent legs of a figure in the boat, appear as glowing

Georgia O'Keeffe at Lake
George c.1908
Photographer unknown
Georgia O'Keefe Museum, Santa Fe
Gift of the Georgia O'Keeffe
Foundation 2006

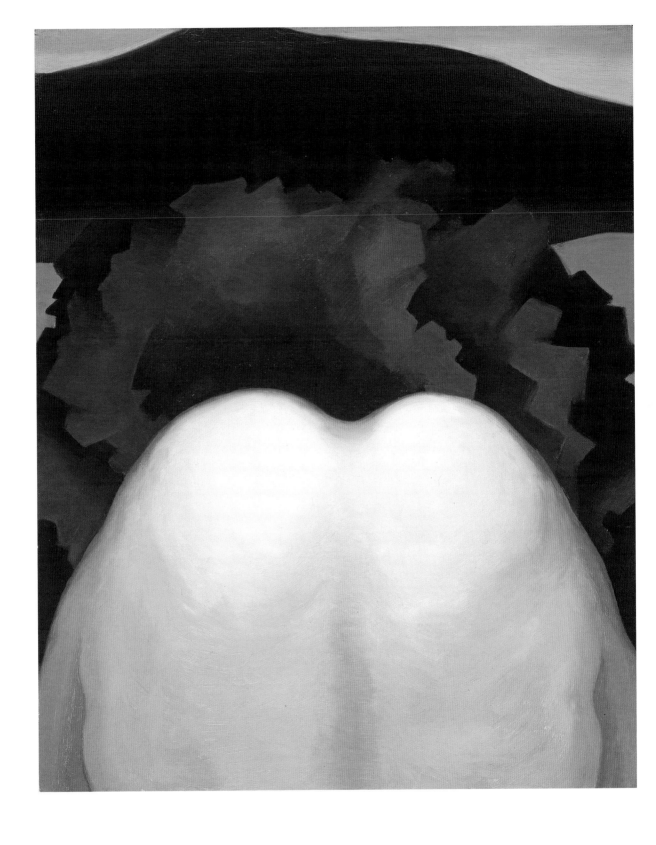

Georgia O'Keeffe
Series 1, No. 10 1919

Grace Cossington Smith
Trees c.1927

bulbous beacons that guide through the darkened waters. This beautifully ambiguous painting with its deeply evocative colour suggests an immersion in place, and of being cradled in the landscape's forms. But there also lurks an unsettling feeling as the unknown of night closes in and around this solitary, luminous presence. Translating the landscape into a personalised symbolic language and drawing on the veiling shades of darkness, O'Keeffe implies larger natural mysteries.

Cossington Smith also painted landscapes that inferred a spiritual attachment. Her exaltation in nature motivated the brilliant colour expression that shaped her distinct portrayal of place. Cossington Smith was taught in Sydney by Antonio Dattilo-Rubbo, an artist more traditional than modernist in his methods, but who nonetheless encouraged his students to explore post-impressionist colour. Posters of modernist paintings by Cézanne, Gauguin, Van Gogh, Pissarro, Seurat and Vuillard lined his studio walls and served as guiding examples of expression beyond the quotidian. Cossington Smith was particularly taken with the work of Van Gogh and in an early oil sketch painted her own bedroom as *Van Gogh's Room* c.1916. This small work represents a great creative epiphany, where the artist registered the potential to transform her ordinary surroundings into colour statements of luminal magnificence, by investing things 'with the power of spiritual life'.[27]

When Cossington Smith left Dattilo-Rubbo's classes in the mid 1920s, the leafy seclusion of her family home and studio in the upper northern Sydney suburb of Turramurra became the centre of her artistic production. Observing her natural surrounds, she visualised the vital movements of growth that underscore the natural world. As in *Black Mountain*, her inclusion of telegraph poles in the landscape can be read as signalling the virtual energies underlying places. In *The Beach at Wamberal Lake* 1928-29 (p. 145) for example, the spindly, leaning form of the telegraph pole echoes the tree's organic movement; the telegraph pole's kinks mirroring the broader motion of the lake, providing

an impression of the landscape's charged undercurrent. But it was Cossington Smith's pulsating, colour-saturated brushwork across tilting, often concentrically formed compositions that became the primary metaphor for describing the ordinary world in perpetual metaphysical motion.

While Cossington Smith commonly painted domestic and local suburban landscapes, she saw in them a nature wild and energised. From the corners of her garden she observed the criss-crossing rise of leaves and plants and portrayed them as an impenetrable organic force in works including *Pumpkin Leaves Drooping* 1926 (p. 27) or *Arums Growing* c.1927 (p. 140). She extended these closely cropped views into a broader vision in works including *Trees* c.1927 (p. 52). Here, her tightly structured brushwork, reminiscent of the tapestry-like surfaces of Gauguin, animates the landscape through a charge of colour, the domestic detailing of a garden hose almost lost within the rhythmic abstraction of organic forms.[28]

Cossington Smith conceptualised the landscape through allusions to its energies in compositions developed from her intimate observations of nature. In her paintings she often represented the landscape through small features that grasped her attention. She foregrounded, for instance, a lone lily, a flowering peach tree or the brilliant colour of a jacaranda in blossom as natural entities that appear to embody her spiritual kinship with place and propel their surrounds into a vibrant chorus of colour (pp. 141, 143, 151).

Cossington Smith was equally versed in composing the landscape in monumental rhythmic formations. While earlier works engage the eye in surface rhythms of colour, in *Landscape at Pentecost* 1929 (p. 71), vision recedes into deep, seemingly infinite space. She applied the rhythms used to describe such sweeping, expansive views to her portrayals of the Sydney Harbour Bridge, where an immense, surging vitalism transcends the mechanics of the bridge's construction, and transposes its forms to greater, spiritual heights (pp. 13–15). In both urban and natural landscapes, Cossington Smith invoked a soaring energy to describe the modern world that encompasses the movements of human endeavour.

In her depictions of modern nature, O'Keeffe enlarged organic detail into grand proportions, akin to those of her New York skyscrapers. Informed by the philosophies of Henri Bergson and D.H. Lawrence, she aimed to visualise the dynamics of organic growth that were understood to parallel human creative energies.[29] O'Keeffe closely observed systems of growth in the world around her, using abstraction as a tool to magnify these vitalist feats, and project them onto the wider landscape. In her close views of the unfurling motions of Lake George plants, for example *Canna Leaves* 1925 (p. 104), O'Keeffe anticipated the monumental rhythms that created the seemingly malleable surface skin of her mountains of New Mexico such as those in *Untitled (Red and Yellow Cliffs)* 1940 (p. 86). She would also hone in on panoramic views, reducing expanse to essence. In her 'black place' series, for example, O'Keeffe returned to paint the dramatic dark hills northwest of her home at Ghost Ranch, increasingly shedding topography for paintings that distilled the landscape into contoured rhythms of sensuous colour, as seen in *Black Place, Grey and Pink* 1949.[30]

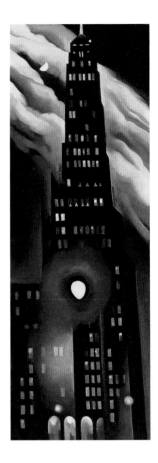

Georgia O'Keeffe
Ritz Tower 1928
oil on canvas, 102.2 x 35.6 cm
Private collection, Houston

Georgia O'Keeffe
Black Place, Grey and Pink 1949

For the art historian Henri Zerner, it was the charged subject of landscape, rather than the more commonly cited still-life genre, which was modernism's laboratory table.[31] In O'Keeffe's spiritual unveiling of nature, landscape served alongside still life as her laboratory for the abstract. Like Mondrian (who also understood that 'natural appearance *veils* the plastic expression of rapports')[32] O'Keeffe used compositions of trees to elaborate representational dissolution. She painted the cottonwood trees that surrounded her Abiquiú home, their features evaporating with the movements of the seasons to become part of a greater rhythmic choreography of dissolving form (pp. 110-12). Paintings such as these reveal O'Keeffe's abstracting impulse to be attuned to her experiences of local landscapes and linked to the cycles of nature.

Cossington Smith also tested the limits of representation in her art by dissolving the forms of landscape. Later in life, she claimed that Australians were 'still waiting for somebody to paint the Australian bush as it is'.[33] She searched for this essence in her last landscape series, which included *Bush at Evening* 1947 (p. 61). Here, she has exchanged her saturated colour for a subdued 'bush' palette and abandoned her tightly structured brushwork for loosely applied strokes. Her colours float, seemingly within spaces of light, leaving a fugitive impression, a scrubby 'unruliness' that expresses the primordial energy of the bushland. In her earlier *Bonfire in the Bush* c.1937 (p. 156), Cossington Smith conveyed the feeling of being enveloped into nature through patterned brushwork that fuses the shapes of the figures with formations of the landscape. A decade later she painted the landscape's features dissolving to energy. Space became unstructured, and 'colour is at last released from form, released into light'.[34]

Painting nation

While modernism mapped new spiritual frontiers through a universal language of dissipating forms, metaphysical energies, and vitalist growth, its artists also applied their cultural vernacular to invoke the distinctiveness of local soil and engage with ideas about 'nation' through landscapes.

Preston's landscape painting production was small; around 25 works which were largely produced between 1940 and 1946. By shifting her attention to this genre, Preston seized upon a motif central to the Australian concept of nationhood to advance her campaign for a modern, national art: to create 'an art by Australians for Australians' that conveyed an essence of the country.[35] In *Rifle Birds*, a painting reproduced on the cover of the lifestyle magazine *The Home* in 1928, Preston first applied her cultural nationalism to the modernist landscape. She painted stylised mountain ranges signifying the Australian interior, which echo the stark geometry of the Aboriginal taphoglyphs (carved trees) in the foreground, a visual link that implies the connection between Indigenous culture and the land. By the 1940s, when she was concentrating on landscape painting, Preston extended her simulation of the Aboriginal embodiment of the land so as to portray 'the national, spiritual

VOL. 9. NO. 7. JULY 2nd, 1928 *The*

HOME
THE AUSTRALIAN JOURNAL OF QUALITY

Rifle Birds—painting by Margaret Preston.

UNKNOWN AUSTRALIA
PICTURES OF NORTHERN AND CENTRAL AUSTRALIA AND S. W. TASMANIA
Price
Per Copy **2/-** PUBLISHED BY ART IN AUSTRALIA LTD. Annual
Subscription **24/-**

and characteristic features of this country'.[36] In *Grey Day in the Ranges* 1942 (p. 89), Preston cloaks the landscape in blackened rhythmic contours and an ochre palette, using these visual triggers of Aboriginal art to emphasise the 'spiritual side of this great land'.[37]

Grey Day in the Ranges is panoramic in outlook, yet intimate in feel. Even with her large ambitions concerning cultural nationalism, and in works that radically revised the traditions of Australian landscape painting, Preston held to her belief in creating an accessible modern art that could be easily lived with. Her compact, 'domestic' paintings challenged the tradition of the popular Australian pastoral landscape of expansive views of the country's agricultural wealth (and its implied ownership by a white male population). By contrast, Preston's 'spiritual' remapping of the landscape was coded by its Aboriginal guise and the modernity of its abstract design. Notwithstanding the complexities of cultural appropriation that operate in her work, with her modernist primitivist quest for authenticity ultimately erasing the meanings and agency of Indigenous culture, Preston's proposal to integrate black and white cultural sources as the basis of her national painting (within a format aligned to the 'feminine' spaces of the home) is one of the revolutionary visions of Australian twentieth-century art.

O'Keeffe introduced the idea of art as an emblem of nation after she began to immerse her practice in the landscapes of the Southwest from the 1930s. Through her earliest associations with Stieglitz and his stable of artists, she connected to the New York avant-garde's ideas concerning the development of a distinctly national modernist culture. O'Keeffe often repeated the fact of her American artistic roots, that she had by-passed the ubiquitous pilgrimage to Europe and created a modern art on her own national terms, based on her experiences of American landscapes. As a girl,

Georgia O'Keeffe
*Black Cross with Stars
And Blue* 1929
oil on canvas, 101.6 x 76.2 cm
Private collection, Santa Fe

she had been captivated by the mythologies of the American West, and imagined the idea of America through notions of the country's enthralling expanse.[38] O'Keeffe's dreams of vastness continued to shape her art, and when she confronted the 'wonderful emptiness' of the Southwest, she established her desire to paint 'the Great American Thing'.[39]

Artists had gravitated to Taos and Santa Fe in New Mexico from the mid 1800s, and in the early twentieth century the region attracted a generation of modernist painters and writers. In the spectacular distinctions of the landscape, its great, simplified colour-form masses and presence of Indigenous cultures, they saw the site of 'genuine America', seemingly impervious to the material culture of the metropolis.[40] From her earliest pilgrimages to the Southwest O'Keeffe registered, as artists had before her, landscapes encoded by the cultures of its Hispanic and Native American populations, and she inscribed their ubiquitous presence in the landscape through symbolic form. She painted scenes marked by the crosses of Hispanic churches and the dark foreboding forms of the Penitent crucifix. Understanding the profound connection between Pueblo people and their country, her early paintings from the region included a tree at the hallowed grounds of Bear Lake as a towering offshoot of sacred Pueblo land, extending infinitely upward to reference an enduring ancient spirituality (p. 106).

O'Keeffe's images of the Southwest were forged through intimate connection and yet are resolutely epic in feel. In describing a spiritual closeness to the land, she contributed modern landscapes of national distinction. But O'Keeffe ultimately realised her 'Great American Thing' in her skull paintings. Sourced from the landscape, O'Keeffe's skulls were painted as symbolic markers of place, but they also appeal to a broader vision of nationhood. Her bone subjects are associated with the earlier presence of skulls in American nineteenth-century painting, where they featured as the trophies of conquest, as romantic symbols of the passing of the Old West,

Georgia O'Keeffe
Church Steeple 1930

and as mementos of the vanishing buffalo. They also came to symbolise the concept of American Indians as a 'doomed' race.[41] But O'Keeffe was explicit in distinguishing her bone subjects from these traditions. In her compositions, bathed in the desert's clarified light, they carried new meanings of the strange mysteries of an eternal nature.[42] Imaged floating with blossoming flowers, her bones were not the traditional reminders of death, but vital and enigmatic exemplars of O'Keeffe's encounters with nature.

'It is breathtaking', wrote O'Keeffe as she flew over New Mexico, 'as one rises up over the world one has been living in'.[43] Her experience of flying had confirmed for her the essential vitalist patterns by which she comprehended the environment, and she made tangible 'the world all simplified and beautiful' in paintings of abstract motifs that followed the movements of river systems (pp. 63, 116–17). Painted from drawings she made from the air, they could equally have been her grounded statements of the infinite rhythms of the landscape.

Preston similarly painted the landscape as mediated by plane travel in *Flying Over the Shoalhaven* 1942 (p. 62). It was her climactic landscape painting, and merged her cultural construction of the 'Aboriginal' landscape with a statement of the earth's enduring forms. Of all her works, it implies a sense of the infinite.

Cossington Smith's late references to landscape remained intimately earthbound (pp. 95, 97). In her final series of golden interiors, the garden features as a constant presence, glimpsed at through windows or mirrors. Despite the domesticity of these subjects, these works embody a feeling of vastness in their luminal grandeur and in their exploration of the unbounded terrain of the individual psyche. Using tilted compositions and disorienting reflections, Cossington Smith dissolves any sense of borders between internal and external spaces. The light of the interior of her home becomes fully immersed in the glow of the outside natural world.

Cossington Smith did not see her art in terms of national sentiment, but nonetheless throughout her career she produced works that reinvented the Australian landscape. While Preston and O'Keeffe rounded off their visions of the landscape with outward, expansive views, and in large national statements, it is fitting that Cossington Smith found her own radical artistic resolution in glowing statements of nature envisaged as she peered outward to the garden from a corner of her home.

Grace Cossington Smith
Bush at Evening 1947

Margaret Preston

Flying Over the Shoalhaven River 1942

Georgia O'Keeffe
Pink and Green 1960

Margaret Preston
Aboriginal Landscape
1941

CARA PINCHBECK

Aboriginal Landscape 1941 by Margaret Preston is a dynamic, provocative painting. Such is the optical interplay between opposing elements – light and shadow, form and colour, representation and abstraction – that the eye dances across the canvas with multiple elements jostling for attention. This is no tranquil scene, but a charged depiction of landscape in which Preston seeks to embed her idealised notions for a distinct national art informed by Aboriginal styles, imagery and techniques.

Preston promoted the need for such an art from the mid 1920s, initially outlining her staunch beliefs in the article 'Aboriginal art artfully applied' in 1924.[1] In this text Preston acknowledged the influence of Japanese art on French artists and the widespread adoption of Japanese techniques and styles. Given the acceptance of this model of cultural appropriation, she advocated Aboriginal art as an appropriate influence for Australian work, which she hoped would 'kill the South Kensington dullness which has pervaded and perverted the decorative impulse of this country'.[2] Preston felt an urgency to realise an 'Australian spirit before other nations step in and we are left without even having tried'.[3]

For Preston key elements that could be derived from the work of Aboriginal artists were the elimination of distracting details through the simplification of forms and limited mark-making to represent physical features. An avoidance of symmetry in favour of irregularity was also vital, connected with a necessary awareness of rhythm, and spontaneity would achieve an immediacy of expression. Preston suggested the use of earth tones to present form as 'simple flat colour laid in fine juxtaposition'.[4]

These influences are clearly visualised in *Aboriginal Landscape*, in which certain elements point to particular aspects of Aboriginal art. Rendered in dusty creams through to burnt oranges and shades of brown, delineated with black, the work evokes the ochre palette of bark paintings from the coastal reaches of the Northern Territory. The bold, flattened patchwork of colour is suggestive of the geometric patterning on shields from northern Queensland, while the brilliant cream line-work segmenting the composition is reminiscent of the dominant white outlines of western

Arnhem Land painting. Each of these Indigenous styles is highly codified and regionally specific. Yet, while Preston had travelled widely and was aware of such differences across Australia, here she merges these divergent visual languages, discarding any sense of meaning and specificity.

This tendency towards generalisation is echoed in the very title of the work. In an Aboriginal context 'landscape' implies a superficial reading of a scene, a presentation of surface imagery opposed to the Aboriginal notion of 'country' as an all-encompassing reading of the land that establishes connection to place and informs one's sense of identity. For Preston, avoiding this complexity of country was a deliberate method as she sought to paint with what she believed was 'stark truth, copying [Aboriginal artists] in eliminating the western idea of time and place'.[5] In the process, however, she eliminated the particular references to place and time inherent in the art she drew from, misunderstanding and erasing the very foundation from which Aboriginal artists draw inspiration.

This disconnection to the country depicted is clearly evident in the way *Aboriginal Landscape* is structured. Viewers can survey the scene only from an elevated vantage point, with a view of the distant mountains interrupted by a palisade of trees and obscure geometric forms transecting the prospective track at the left. These barriers seem telling given the contentious relations to land in Australia between Aboriginal and non-Aboriginal people.

The multiple opposing forces at play in *Aboriginal Landscape* create a tension that is both intriguing and confusing. It is a conflicted image, informed by but devoid of Aboriginal sensibilities and cultural authenticity, which seeks to envisage a truly representative spirit of Australia. It is, as the Aboriginal curator Djon Mundine has noted, 'a veneer by someone who is still like a tourist in their own country'.[6]

Grace Cossington Smith
Black Mountain
c.1931

ANN STEPHEN

Modernist landscape is at the core of Grace Cossington Smith's oeuvre, with subjects ranging from intimate garden views to pastoral landscapes, bush scenes, and seascapes. All are painted with her characteristic brushstroke combining intense colour and powerful rhythms. Among her most daring early landscapes is *Black Mountain* c.1931 which features Canberra's dominating natural backdrop, then bare and treeless. The artist had visited the national capital when it was still no larger than a small country town, to give art lessons to the Governor-General's wife, Lady Isaacs, at the invitation of a mutual friend.[1]

Across the centre of the exposed cardboard, sketchy red tracks fan out to form an array of lines. A thick red band skirts the foreground, bordered by concentric broken semicircles of olive and lime green. These dense ribbons of colour contrast with the broody black presence of the mountain along the high horizon. Blue brushstrokes radiate like an aura above. The medium of watercolour and gouache allowed her to work fast and boldly, marking the successive planes with expansive gestures and feathery washes.

Cossington Smith's pastoral landscape has a disorienting movement that sweeps out to engulf the viewer in a wave of energy. Its instability is profoundly different to the rock-solid symmetry of Arthur Streeton's *Land of the Golden Fleece* 1926 (National Gallery of Australia, Canberra), one of the most popular and reproduced images of the period. While both artists represent an iconic rural landscape, the sense of a secure national symbol is undone by Cossington Smith's composition. It is not just that telegraph poles tilt into the land but that the entire composition seems electrified by a new vision. How did she arrive at such a radical treatment in a genre dominated by the conservative blue-and-gold tradition of Streeton?

Cossington Smith, like many of her female contemporaries, spent the best part of two decades studying, in her case with the Sydney teacher Antonio Dattilo-Rubbo, beginning in 1910. This long apprenticeship was interrupted by an extended tour to Europe between 1912 and 1914 in the company of her father and sister, including three months spent in Germany, where she attended art classes in Stettin, then an emerging modern city connected by rail to Berlin. Nothing is known of who taught her or what exhibitions she saw there, though she confessed to being underwhelmed by the Impressionists, as she recalled: 'I can remember being slightly disappointed when I saw the Impressionists because I found their colour a bit thin and anaemic. None of them seemed to paint with that enjoyment of the full brush'.[2]

A desire for colour combined with her own brand of spiritual intensity suggests she would have been attracted to the artists of Der Blaue Reiter group who in 1912 had published their *Almanach* in Germany. Later Cossington Smith's interest in colour and mysticism was captured by the writings of the theosophist Beatrice Irwin. She would transcribe Irwin's entire book *The New Science of Colour*, and many of its exercises echo through her subsequent paintings. For instance Irwin advocated specific colours that 'constitute a safe middle path, between the mysteries of the senses and of the soul'.[3] As curator Deborah Hart has noted, Irwin singled out particular 'mental colours in her chart [which] included olive green (sedative) rose madder, fawn, royal blue and emerald green (recuperative) and violet and chrome (stimulative)'.[4] Four of these colours are used in *Black Mountain*.

Black Mountain is one of a remarkable group of works that the artist made following her mother's death. Like *Sea Wave* 1931 (p. 91) it has radiating waves of colour that push out beyond the edge of the frame. The art writer Bruce James has described these paintings as works of mourning. Cossington Smith had sought consolation for her grief in communion with the landscape, entering a trance-like state, as Irwin advised:

> In any land, sky or sea-scape, you can find large pools of colour, in which you must immerse your consciousness. During this process of concentration remain quiescent, let thought and deduction come after, but for the moment just focus your attention on the colour whose vibrations you desire.[5]

Georgia O'Keeffe
Storm Cloud, Lake George
1923

DENISE MIMMOCCHI

When Georgia O'Keeffe first visited Lake George in upstate New York as an art student in 1908, she painted, by her own reckoning, one of the foundational landscapes of her career. The painting, now lost, was based on her experience of being in the darkened lakeside landscape; of rowing across the lake at night, and walking along its shores. 'In the darkness it all looked just like I felt', O'Keeffe later recalled.[1] This work was one of two nocturnes that she remembered in detail over 60 years later as formative achievements of her landscape painting career. Through them it seems she registered darkness as a powerful aesthetic mode to infer natural mystery and express the sublime experience of being immersed in nature.

While O'Keeffe's artistic identity would later become bound to the landscapes of New Mexico, it was from the verdant terrains of Lake George that she had earlier drawn inspiration and finessed a modern approach to painting the natural world. Between 1918 and 1934 O'Keeffe made annual trips to the popular tourist haven, where she lived for the summer and autumn months at Alfred Stieglitz's family property.

Over this period O'Keeffe drew on subjects sourced from the lake's landscape: its plant life, trees, farm produce and views. As she extrapolated a sense of both the minutiae and cosmic expanse of the landscape, she refined an artistic vision that transitioned between elements of abstraction and representation. Her nocturnal epiphany also remained an important reference point, and impressions of a dusky world pervade O'Keeffe's Lake George paintings as she sought to visualise the unseen forces of nature.

O'Keeffe produced a number of paintings based on the streamlined forms of the lakeside panorama, where she envisaged the landscape as a silent, enigmatic place. *Storm Cloud, Lake George* 1923, a silhouetted, powerful vision of the area's dramatic summer storms, is a climactic painting in this series. Here, the artist features the mountainous lake environs of the landscape, but it is the parallel unfurling energies of sky and water that are the work's true subject. The densely shaped atmosphere is composed as an overarching foreboding vitalist force, while the lake's waters crescendo below.

Storm Cloud, Lake George is remarkable for O'Keeffe's commanding use of a near monochromatic palette. Modulating between deepest blues, greys and blacks, she invokes the subtle hues of night to drive the emotional intensity of the work. Using blackened forms set against a russet sky, a colouring that O'Keeffe derived from the rich pigments of the Lake George autumn, she handles seamless brushwork to image stylised movements of water and air as mighty elemental forces.

O'Keeffe's stormy nocturne, featuring a dramatic lunar illumination through parting clouds, alludes to the Romantic's feeling for the sublime as well as the Symbolist's sense of mystery. The nineteenth-century traditions of moody landscape painting may have informed O'Keeffe's work, but are here translated into an indelibly modernist vision of nature. Distilling elements of 'form and force' into a rhythmically formed composition, her abstracted arrangement is an image of the powerful essence of the natural world, implying the metaphysical energies that underlie specificities of place.[2]

Lake George was renowned for its spectacular storms. Stieglitz once wrote of his fascination with their dramatic display, while noting O'Keeffe's ambivalence.[3] Their spectacle may have served as a reminder of the drowning she witnessed during an unexpected storm while she was out boating one evening.[4] Perhaps it was with this lingering memory of nature's fateful capacity that she depicted the storm as an awesome but darkly ominous power in *Storm Cloud, Lake George*.

While the painting could serve to illustrate this narrative, it transcends the need for anecdote. *Storm Cloud, Lake George* is a broader portrait of natural potency as described through the movements of form and colour alone. It is an image of the generation of natural energies akin to O'Keeffe's magnified portrayals of minuscule movements of plant growth. Inscribing darkness to accentuate life's vitalist mysteries, O'Keeffe would depict a storm-ridden landscape, or the unfurling of a black iris, as equally momentous motions of natural creation.

Grace Cossington Smith
Landscape at Pentecost
1929

TRACEY LOCK

Seen from an elevated viewpoint upon a crest, Grace Cossington Smith's *Landscape at Pentecost* 1929 depicts a cultivated landscape. Across the foreground a heavily furrowed road surges up like a solid wave, before taking a dramatic plunge; its ribbon-like ruts slowly ebb into the quiet distance of the mauve and green hills. A favoured motif among early twentieth-century artists, the open road symbolised the progress of the modern age or a personal voyage of transition. But in Cossington Smith's vitalist vision her road connotes something far more deeply felt; in it the line of energy reaches forward, summoning the viewer.

Perhaps as a gentle guide Cossington Smith has positioned near the physical centre of the scene a small white marker, an unpainted thin unit of ground that reveals the preliminary pencil lines for the composition. Much reduced in scale compared to the advancing road, this incongruous, nameless signpost points sideways towards no place. The elsewhere it indicates seems inconsequential compared to the solid reality of the immediate location.

Much changed in later years into a lush garden suburb in Sydney's north, the semi-rural locality pictured here was a familiar one for Cossington Smith. Only a few minutes by foot from her house and garden studio in Turramurra, the view is generally regarded as looking north along Bannockburn Road, near the corner of Pentecost Avenue. Her generalisation of the local road name 'Pentecost' into the painting's evocative title is itself indicative of Cossington Smith's embrace of her place as both *heimlich* and holy. Consistent with its Biblical allusions, *Landscape at Pentecost* appears to lift from its own pictorial anchor points, dynamically thrusting outward and forward, emulating a moment of exaltation. Channelling a sense of the divine into her own humble sensibility, Cossington Smith joins earth and space – chaos and void – into a unified symphony of form and colour.

The work is one of a handful of significant paintings, all confidently large in scale, that the artist produced around the time of her first solo exhibition at the Grosvenor Galleries in Sydney in July 1928.[1] The strength of this key period in her oeuvre resides in her exploration of the pictorial tensions that can be achieved through twisting or rotating form off the vertical axis to create what the artist's friend Roland Wakelin described as 'a rhythmic flow of line'.[2] This can be seen in the composition's dynamic inward pull towards a hidden vortex below the left verge. The surrounding trees, orchards, paddocks and clouds strain towards the lunging, lopsided curve of the foreground road, while emanating directional impasto brushwork activates the whole pictorial surface. Everything reinforces the '*concentric* feeling in the design, the feeling of "radiation from centres" which is the basic truth of life itself'.[3]

Cossington Smith's absorption of her artistic influences served a personal goal, the visual endorsement of her faith.[4] She was the granddaughter of an Anglican clergyman and her own parents were equally devout. The distinctly English character of her familial Christian values can be detected in her pantheistic understanding of a transcendental, benign spirit in nature, and aligned with a secular sense of spirituality underpinning modern art. A pervasive sense of the religious was latent in her home environment. The artist even noted that her family bungalow had been designed in 1899 for 'Mr Baker the Quaker' and its timber-panelled meeting room used as a Quaker house of worship, a space for unmediated communion with the divine. Just as her celestial late interiors have been lauded for capturing the spirituality embedded in familiar things, her pivotal compositions like *Landscape at Pentecost* demonstrate an intimacy with the open spaces and structures of her surrounding physical world, one absorbed into a consciousness that affirms a godly benevolence in nature.

In this way, *Landscape at Pentecost* is deeply experienced rather than analytically observed.[5] Its maker is like a visionary who reveals to us the glory we might otherwise not see. As Cossington Smith herself described, 'art is the expression of things unseen – the golden thread running through time'.[6]

Margaret Preston
Blue Mountains Theme
c.1941

REBECCA COATES

Exemplifying Margaret Preston's aim to forge a specifically Australian modernist aesthetic and language, *Blue Mountains Theme* c.1941 combines her knowledge of Aboriginal art and the Australian bush with Asian and Western painting traditions.

Preston wrote extensively about her expansive travels, and what she saw directly informed her paintings and woodblock prints. By the early 1940s, when *Blue Mountains Theme* was made, she had spent extended periods travelling in Europe and North America, as well as throughout Central and South America, Australia, and China, which she first visited in 1926. On a subsequent visit with her husband in 1934, she toured Yunnan province in the southwest, known for its landscapes of snow-capped mountains, lakes and deep gorges, and delivered a lecture on the area and its art at the Art Gallery of New South Wales in 1938. Preston was drawn to a depiction of space in Chinese art that appeared timeless, a quality she also saw in Australian Aboriginal art.

Preston's interest in Aboriginal art had been developed through her study of Indigenous painting and objects in Australian collections, including the Australian Museum in Sydney, and excursions she undertook with the Anthropological Society of New South Wales to Aboriginal sites around Sydney. Preston had experienced the bush first-hand, living at Berowra, approximately 40 kilometres north of Sydney, between 1932 and 1939, where there were traces of Indigenous habitation. She had also visited sites in Queensland, Arnhem Land, and Western Australia, which informed her understanding of the landscape. Though Preston has subsequently been criticised for using and appropriating Aboriginal symbols and imagery, her reference to Aboriginal forms was not unique at the time. Ure Smith, publisher of a number of notable journals, had commissioned Aboriginal-inspired covers from other artists, and featured articles on the subject as well.[1] Preston claimed her interest in Aboriginal art stemmed as much from a desire to create a specifically Australian art, as from the art itself.

Preston's landscape paintings of the early 1940s sought to capture the 'spiritual essence' she found in Aboriginal art. These works reveal the fundamental structure and colour of the landscape: its harsh beauty, rough textures, and vast volumes and masses. *Blue Mountains Theme* is also formally framed by two strong verticals, with a tall eucalyptus sapling on the left of the painting, and the long slash of a waterfall on the right. Human habitation has no place in this depiction, which instead shows Preston's drive to identify the essential features of this unique landscape within a composite view of place. Motionless clouds hang over an arrangement of boulders and ridges with black outlines that create an abstracted, patterned effect. Preston's debt to Aboriginal painting is reflected in her flattening of perspective, and recourse to an elevated, or bird's-eye, view. As with many of her paintings of the early 1940s, Preston reduces her palette to a range of greys, earthy browns, ochres, and creamy whites. This muted palette of colours is applied here, as in other works, in what was perceived as an 'Aboriginal manner', using a system of short strokes and dots. Of the subject, Preston wrote: 'Knowing the New South Wales ranges well, I have tried to paint them with stark truth, copying the natives in eliminating the western idea of "time and place" … I know that art is of the mind and a picture a replica of the mind's vision'.[2]

Blue Mountains Theme was one of seven oil paintings that Preston made in a brief three-year period, which were included in an international exhibition that toured the United States and Canada in 1941 and 1942: Art of Australia 1788–1941. Sponsored by the Carnegie Corporation, the exhibition was organised by the Fine Art Gallery of Yale University. It was seen as an exercise in Australian–American relations as new economic, political, and social allegiances were being forged during wartime. Preston's 'Aboriginal' landscapes presented a new artistic language to reflect a modernist nation. Interestingly, eleven bark paintings and two drawings by Aboriginal artists were shown in the exhibition as part of a broader 'official' Australian art history.

Abstraction and the creation of national identity

CAROLYN KASTNER

Born in the nineteenth century, Margaret Preston (1875), Georgia O'Keeffe (1887), and Grace Cossington Smith (1892) each pursued a distinctive style of modern art expressive of their individual creativity and the particularities of living in Australia or the United States during the first half of the twentieth century. Inspired by the natural world, they transformed their observations into imaginative, abstracted compositions looking to European practices of art while nurturing a distinctive identity for modernism at home. These shared aspirations are a central theme of this exhibition.

O'Keeffe, Preston and Cossington Smith came of age in a period when an international and transnational exchange of ideas transformed the goal of painting from its traditional narrative purpose to an expressive act of an individual artist's creative freedom. The vocabulary of abstraction is common to their artistic development and professional success. Significant to each artist was the will to express a specific sense of place, especially the quality of light and colour they observed at sites that have become synonymous with their work: New York, Sydney, and the natural environments of the American Southwest and east-coast Australia. As perceptive observers, they refined and distilled their observations, using the techniques of abstraction to transform their personal experiences into paintings that evoke rather than depict the places that inspired their work. The record of how and where artists beyond the urban centres of Europe entered into the discourse of modernism and especially abstraction is still developing. This exhibition and catalogue investigate how three artists individually contributed to the transnational conversation of abstraction while creating art identified by unique geographies, specific national identities, and similar colonial histories.

Between 1911 and 1919, as all three artists pursued their own art, the idea of abstraction advanced in a transnational exchange of exhibitions, publications and manifestos in Europe.[1] With other artists in the United States and Australia they became eager students of modern art, as the discourse of abstraction developed to challenge representational traditions, though they

also felt compelled to establish a distinctly local modernism in response. Having developed skills through education and curiosity the three young artists gained confidence in their own creative practices.

While travelling in Europe, Preston carefully studied the art of late nineteenth-century painters, such as Paul Cézanne and Paul Gauguin, who had established the conditions for abstraction by rejecting academic training and embracing personal experience outside of the studio. Cossington Smith's study of post-impressionist art came via reproductions at home in Australia. Both artists were attracted to painters who had abandoned the refined brushwork of representation for a dense and personalised application of pigment that allowed colour and painting technique to express visual perception and emotion.

While O'Keeffe never left the United States to study art, Preston and Cossington Smith both studied European art and independently sought teachers and exhibitions in Great Britain, France and Germany. Between 1904 and 1906, Preston began an eclectic study of modern art in Europe and experienced the new work of modernists such as Gustav Klimt, exhibited at the tenth Munich secessionist exhibition in 1904. Influenced by this experience, on her return to Adelaide Preston began to reduce illusionism in her work as she pursued aestheticism and experimented more with light and colour. Her work evolved further through an intellectual engagement with colour and form as she studied the art of Cézanne and Pablo Picasso on a second European sojourn that began in Paris in 1912. During this period she also took notice of Japanese woodblock prints, the source of a dramatic change in how European artists perceived and constructed pictorial space, unregulated by Western notions of perspective. She began to compress the space of her paintings, which have an increased emphasis on asymmetrical patterns and compositions. She moved to London in 1913 where she was introduced to the designs of Roger Fry and the Bloomsbury group and later studied at the Camberwell School of Arts and Crafts. These activities opened Preston to new ideas that were consolidated in works such as *Still Life* 1915, as she adapted what she had learned to the goals of her own creativity. In 1919 she returned to Australia and married William Preston, who supported her personally and financially; during the following year they settled in Sydney.

Cossington Smith began her art studies in Sydney with drawing classes under the tutelage of painter Antonio Dattilo-Rubbo in 1910. As early as 1911 her drawings showed an affinity with abstraction, as she expressed the density of light and shadow as patterns on the surface of the paper. Between 1912 and 1914 she attended classes in England and Germany, but she did not study modern art until her return to Sydney and Dattilo-Rubbo's classes, where she first began to paint in 1914. She learned to appreciate the work of post-impressionists Cézanne, Van Gogh, and Gauguin from colour reproductions brought back from Europe by Dattilo-Rubbo and fellow student Norah Simpson. Their influence is visible in the dense colours and divided canvas of *The Sock Knitter* 1915 (p. 24), which demonstrates her special interest

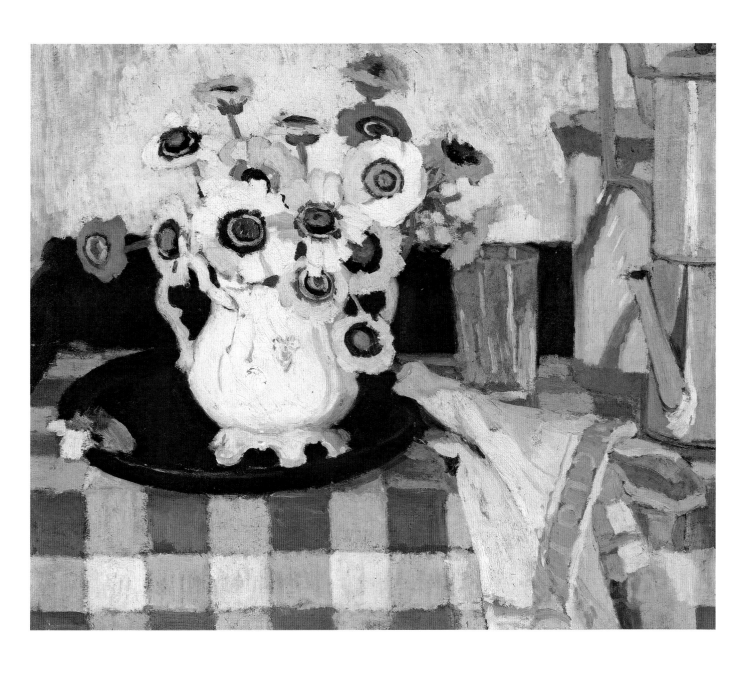

Margaret Preston
Still Life 1915

Grace Cossington Smith
Study of a Head: Self-Portrait 1916

Georgia O'Keeffe
No. 17 Special 1919
charcoal on paper, 50.2 x 32.3 cm
Georgia O'Keeffe Museum, Santa Fe
Gift of the Burnett Foundation
and the Georgia O'Keeffe
Foundation 2006

Alfred Stieglitz
Georgia O'Keeffe – Hands c.1919
gelatin silver photograph
23.9 x 19 cm
Georgia O'Keeffe Museum, Santa Fe
Gift of the Georgia O'Keeffe
Foundation 2006

in separating colour and subject. Her study of Van Gogh's painting of his bedroom is revealed in drawings, notes and a finished painting of her own bedroom (p. 53), with its asymmetrical composition and expressive use of colour to create mood.

O'Keeffe's concept of modern art was shaped by the work of avant-garde artists from the cosmopolitan capitals of Europe that she saw in New York during her studies at Columbia University Teachers College between 1914 and 1915. She experienced the drawings of Auguste Rodin, Cézanne, Henri Matisse, Picasso and Georges Braque at Alfred Stieglitz's gallery 291, located at 291 Fifth Avenue. She was also introduced to the ideas of pure painting and abstraction published in a 1912 volume of Stieglitz's journal that summarised Wassily Kandinsky's *Concerning the Spiritual in Art*, first published in Munich in 1911.[2] Kandinsky's theory of harmonic colour and form and the individual practice of visually expressing a psychological or spiritual creativity reached an eager audience across Europe and in the United States.[3] Stieglitz also exhibited the art of Americans Arthur Dove, Marsden Hartley, and John Marin, who worked with the encouragement of Stieglitz to respond to European modernism and the unique urban and industrialised characteristics of the United States.

O'Keeffe, Preston and Cossington Smith were first trained in European academic traditions of representation but individually discovered and pursued the emerging practices of abstraction. Early in their careers, O'Keeffe and Cossington Smith developed specific drawing practices that became important as they worked out the method and structure of their compositions. O'Keeffe began creating organic abstract drawings in charcoal in 1915, a dramatic shift from her earlier representational work that marks the beginning of her personal vocabulary of abstract forms, based on techniques taught by Arthur Wesley Dow.[4] During the autumn of 1915 her correspondence with fellow student Anita Pollitzer is filled with the excitement about the books they were

reading on abstraction, including Kandinsky's.[5] Looking back on those years O'Keeffe described it as a very exciting period in the development of her art:

> I had been taught to work like others and after careful thinking I decided that I wasn't going to spend my life doing what had already been done. I realized that I had things in my head not like what I had been taught – not like what I had seen – shapes and ideas so familiar to me that it hadn't occurred to me to put them down. I decided to stop painting, to put away everything I had done, and to start to say the things that were my own.[6]

Cossington Smith's drawing shifted from a practice focused on the process of drawing itself to one that prepared the ground for her paintings. By the mid 1920s her drawings became more schematic as the compositions of her paintings grew more complex in pattern and rhythm. Measured and ruled in grids of squares, her drawings have notations specifically directed to the surface of the canvas. The most elaborate of these is her study for *The Bridge in-Curve* 1930 (National Gallery of Australia, Canberra), which appears at first glance as a plan for building the bridge, not for painting it.

By the turn of the twentieth century, American and Australian painters had their own goals for art as a practice distinct from European modernism. Their common goal was to establish a modernism tied to its place of origin. Drawing from the cultures, images, and colours of a particular place was important to them, and influenced their approach to abstraction. A pure non-objective painting could not carry the desirable identifiers to articulate divergent cultures and places. The question of how to preserve the specificity of place and contribute to the discourse of modernism became an individual quest for O'Keeffe, Preston, and Cossington Smith. In each case they brought their grounding in European traditions and attunement to developments in modern art to the question of how to express local cultures, traditions, and environments. They resolved this in hybrid works of art that shared a commitment to what they had learned from both European abstraction and a close observation of their surroundings. They learned to achieve compositional techniques of distilling and simplifying forms from the natural world and deployed them across the surface of the canvas in a shallow and flattened pictorial space that denied narrative, while evoking locally identifiable motifs, colours, and subjects. Each painting is expressive of their experience, not a representation of what they saw.

Painting a specific sense of place

During the 1920s all three artists asserted their individual voices as they lived and worked in their respective suburban or cosmopolitan environments while at the same time exploring nearby natural locations. The artists brought their training, curiosity, and creativity to the exploration of colour and abstraction.

Drawing upon her experience in Europe and her interest in Roger Fry's Omega Workshop and the woodblock prints of Japan, Preston made a shift in

her medium as well as her style when she began to create a suite of hand-coloured woodblock prints in the 1920s. She exhibited 65 prints in 1925 in joint exhibitions with her friend Thea Proctor in Sydney and Melbourne. The nature of the medium encouraged the simplified compositions of the modernists she had admired in Europe, and her focus on local subjects intensified. *Circular Quay* 1925 (p. 126) depicts a busy transport hub on Sydney Harbour, a distinctly modern scene with its multiple storied buildings rising above the water, while *Sydney Heads (2)* 1925 (p. 127) evokes a more peaceful water view through a tracery of Australian gum trees. The series also included depictions of flowers native to Australia, demonstrating her increasingly strong interest in creating a nationally identifiable art. Preston continued to explore these ideas at the end of the decade, using a colour palette drawn from the natural environment. Also during the 1920s she began to publicly share her views about a specifically Australian art as a frequent contributor to Sydney Ure Smith's journals, *Art in Australia* and *The Home*.

Cossington Smith's work also changed dramatically in the 1920s as she filled her increasingly abstract canvases with saturated oil pigments in a decidedly specific application of paint across the picture plane that ignores the rules of perspective. She no longer followed form with naturalist strokes of colour, instead increasing her use of dense and choppy brushstrokes. As she had learned from her studies of post-impressionist paintings, this action had two immediate effects. First it brought the entire picture field to the surface of the canvas, and secondly it revolutionised the viewer's experience, from one of passive reception to an active interpretation of forms that emerged from the paint. Though *Trees* c.1927 (p. 52) did not receive positive reviews in Sydney, Cossington Smith's painting technique brought her into the discourse of twentieth-century abstraction.[7] *The Bridge in-Curve* 1930 (p. 15) is another painting which announces the place and moment of its making with a highly conceptual and dynamic composition that matches the modernity of the bridge itself. The structure of the bridge and its surroundings emerge from paint laid down in radically expressive angles that evoke the scene before her, but do not represent what the artist saw. Cossington Smith's painting *Sea Wave* 1931 (p. 91) demonstrates her ability to hone this abstract painting technique even further. Its horizontal bands of subtle colour that insistently map the surface of the canvas defy a fixed reading or specific sense of place; only the title locates it with certainty as a particular natural form.

O'Keeffe moved to New York during the summer of 1918 and joined the efforts of the Stieglitz circle, a passionate group of modernists determined to create an identifiable 'American modern art', distinct from European traditions, a search O'Keeffe called 'the Great American Thing'.[8] In 1924 O'Keeffe married Alfred Stieglitz, who played a significant role in promoting her art by organising annual exhibitions of her work. The younger artist adapted her life and art in New York to her husband's established habit of spending winter and spring in the city and retreating to his family compound at Lake George in upstate New York during the summer and autumn. By 1924 O'Keeffe was recognised as one of America's most important and successful

Georgia O'Keeffe
A Street 1926
oil on canvas, 122.2 x 75.9 cm
Georgia O'Keeffe Museum, Santa Fe
Gift of the Burnett Foundation 1997

Chrysler Building, New York n.d.
Photograph: Georgia O'Keeffe
Georgia O'Keeffe Museum, Santa Fe
Gift of the Georgia O'Keeffe
Foundation 2006

artists, famous for her paintings of Lake George flowers, but known also
for her paintings of New York City skyscrapers – an essentially American
image of modernity. O'Keeffe's *A Street* 1926 is located in the heart of New
York City. The restricted palette and the simplified geometric forms of the
buildings rising from the street indicate O'Keeffe's growing awareness of
modern photography as well as abstract composition. A life-long gardener,
she also painted the trees and garden at Lake George in works such as *Corn,
No. 2* 1924, which names the subject of a composition of organic shapes and
colours. Yet O'Keeffe's unfamiliar angle and the narrow, cropped composition
disorients and heightens the viewer's experience, much as her cityscapes do.

Contributing to a transnational discourse from a specific place

Abstraction and colour remained a strong interest for all three artists as
they matured, though they used very different techniques. Cossington Smith
painted the interiors of her beloved home Cossington during the 1940s and
50s. Though she built her composition with the same expressive brushwork of
her earlier paintings, she dramatically heightened the luminosity of the colour:
'I use squares in the way I paint ... because I feel in that way ... light can be
put into the colour, whereas just to put colour onto the surface in a flat way,
I feel that gives a dead look'.[9] The complex compositions are a disorienting
arrangement of views across and through interior space that extend through
windows and doors to include glimpses of the surrounding landscape. The
reference to the mirror in the title of *Interior with Wardrobe Mirror* 1955 (p. 97)
hardly helps a viewer to understand how its pictorial space is arranged, yet
when standing before the work of art the sense of light is immediately and
gloriously clear. This is also true of *The Window* 1956 (p. 95), with its spectrum
of yellows illuminating the canvas. Her technique of laying down squares

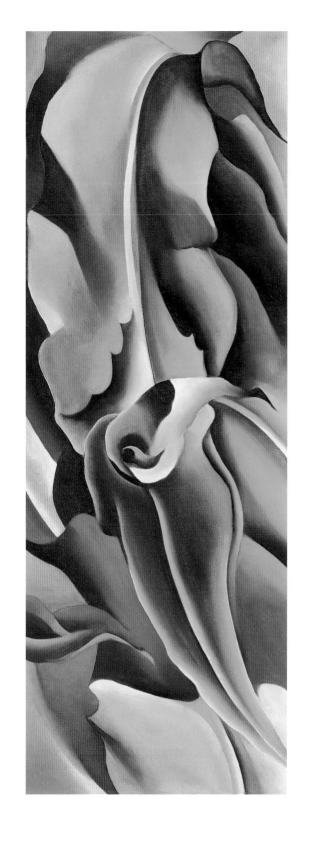

Georgia O'Keeffe
Corn, No. 2 1924

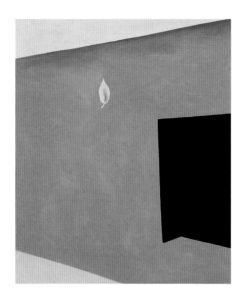

Georgia O'Keeffe
Patio Door with Green Leaf 1956
oil on canvas, 91.4 x 76.2 cm
Georgia O'Keeffe Museum, Santa Fe
Gift of the Burnett Foundation and the
Georgia O'Keeffe Foundation 1997

Georgia O'Keeffe's
Abiquiú House n.d.
Photographer unknown
Georgia O'Keeffe Museum, Santa Fe
Gift of the Georgia O'Keeffe
Foundation 2006

from a brush loaded with colour, refined by years of observation and practice, transforms the familiar rooms of her home into the shimmering surface of a painting that optically engages the viewer.

Similarly, O'Keeffe's home was an inspiration for her art during the 1950s. While her hard-edge abstractions of the patio door located at her Abiquiú house may seem at odds with Cossington Smith's painterly interiors, they are joined by the close looking and deep familiarity that brought innovation to both artists. O'Keeffe always recited the story of how the wooden door within the patio inspired her to buy the house: 'It was a good sized patio with a long wall with a door on one side. That wall with a door in it was something I had to have. It took me ten years to get it – three more years to fix the house so I could live in it – and after that the wall with a door was painted many times'.[10] In 1949, the year O'Keeffe made New Mexico her permanent home, that wall with a door in it was the subject of four paintings. The door was always in O'Keeffe's sightline and on her mind, as she moved between the rooms that opened onto the patio. During her first decade in the house, the patio door was the subject of more than 20 paintings. As she explained: 'I am always trying to paint that door – I never quite get it'.[11] Like Cossington Smith, she was fascinated by the effects of the ever-changing light in her home. Her spare compositions render the courtyard as an abstract puzzle of geometric shapes. In *Patio Door with Green Leaf* 1956 O'Keeffe framed an oblique view of the patio and visualised the door as a levitating irregular rectangle against the adobe wall. The single green leaf identified in the title floats on the surface of the painting resisting both perspective and narrative.

From 1932 to 1939 Preston lived in Berowra, 40 kilometres north of central Sydney on a tributary of the Hawkesbury River, where she painted the natural bush of Australia from her own backyard. In the 1940s she joined the Anthropological Society of New South Wales and began to study the art of Aboriginal Australians. She also advocated for an original Australian

Georgia O'Keeffe
In the Patio VIII 1950

Georgia O'Keeffe
Untitled (Red and Yellow Cliffs) 1940

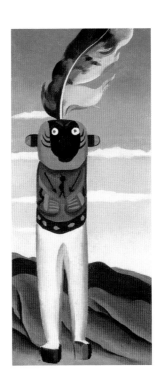

Georgia O'Keeffe
A Man from the Desert 1941
oil on canvas, 40.6 x 17.8 cm
Georgia O'Keeffe Museum, Santa Fe
Gift of the Georgia O'Keeffe
Foundation 2006

art. Her goal was nothing less than to revitalise national landscape painting by introducing characteristics indigenous to the land and the people who inhabited it before colonial contact. She looked to Aboriginal art, which she admired for its colour and form, and made several artefacts the subject of her painting *Aboriginal Still Life* 1940 (p. 88).

In a similar way, O'Keeffe explored traditional art forms of the Southwest while seeking a new perspective on American modernism. Though she did not share Preston's aim of creating a hybrid art, from 1931 she did study Hopi kachina (or katsina) dolls as still-life objects. She represents the bright primary colours and abstract shapes of their costumes in more than a dozen small drawings and paintings, most of which remained in her possession. Hopi artist Ramona Sakiestewa observes them as studies by O'Keeffe learning from another artist: 'O'Keeffe titles her work with her own associations, which takes them out of the realm of collecting or ethnography. She studies them in no other way than for her own art making'.[12]

The katsina paintings were part of a radical new direction in O'Keeffe's artwork that had begun in the summer of 1929, when she made the first of many trips to the American Southwest. During the next two decades she lived and worked in northern New Mexico for part of each year, a pattern she rarely altered until she made it her permanent home, three years after Stieglitz's death. Landscapes are the enduring images from the years that followed her first visit, but she also painted the vernacular architecture of the region, as well as the religious arts of the Hispanic and Indigenous cultures. Her new work coincided with a growing interest in regional scenes by American modernists who were seeking a distinctive view of America, beyond the urban centre of New York City. O'Keeffe's greatest success came with the recognition of her simplified and refined paintings of mountains and cliffs near her home, such as *Untitled (Red and Yellow Cliffs)* 1940, which express her deeply personal response to the colours of the high-desert terrain. She was not alone in finding inspiration in New Mexico. Other artists supported by Stieglitz, including John Marin, Marsden Hartley, and Ansel Adams, spent time in New Mexico and shared her fascination with its qualities of light and colour.

While O'Keeffe's paintings are largely devoid of cultural references, Preston pursued her goal for a distinctive Australian art by adopting Aboriginal design motifs and natural pigments in paintings such as *Aboriginal Landscape* 1941 (p. 65). As the art historian Ruth Phillips reminds us, modernists in Australia and the United States shared an interest in the Indigenous art specific to the land and the colonised people who inhabited the continents at contact. They admired the unique set of ideas and influences that grew from these distinctive places.[13] Though their interest in Indigenous art entered the twentieth-century discourse of 'primitivism', Phillips separates it from the racialised concept by identifying it as 'aesthetic primitivism' and considers it 'as the primary engine of modernism's global dissemination ... in its essence, a movement dedicated to the appropriation of new ancestors'.[14] She reminds us that artists trained in the practices and aesthetics of European modernism also welcomed contact with the Indigenous cultures and their art. Preston and

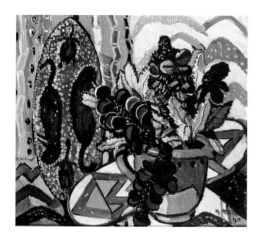

Margaret Preston
Aboriginal Still Life 1940
oil on canvas, 43.6 x 48 cm
Queensland Art Gallery, Brisbane
Gift of the Godfrey Rivers Trust
through Miss Daphne Mayo 1940

ethnographer Leonhard Adam championed Aboriginal arts during the 1940s, as art came to be regarded as 'the medium through which Indigenous and non-Indigenous cultures could move closer together'.[15]

Preston was a prominent speaker and published her appreciation for Aboriginal art as she sought a national art identified with modern painting techniques, Indigenous cultural motifs, and the grandeur of the Australian landscape. The local context of culture, geography, colour and light became a distinguishing feature of the work of non-Indigenous artists like Preston, who absorbed the specific colours of the land and the Aboriginal art of Australia in her own work. She argued that these activities gave structure to a national art: 'It has been said that modern art is international. But as long as human nature remains human every country has its national traits ... It is important for a great nation to make a cultural stand ... My wish is to see a combined attempt by our artists to give us an art that no other country in the world can produce'.[16]

Phillips argues that it is time to trace the networks of contact and exchange between Indigenous artists and modernists, such as those in Australia and the United States, in order to develop a global understanding of 'modernist primitivism' as an exchange of ideas rather than as one-way transmission. She seeks to reposition art such as Preston's within a transcultural and transcontinental flow of ideas on the topics of abstraction and modernism, in the context of its production among Indigenous and non-Indigenous artists during the early twentieth century.[17] In that context, Preston's ideas and the network of her inspirations and contacts with Aboriginal art are as important to art history as the record of the European art that informed her work as she pursued an original Australian art.

Influenced by modern theories of art and fired by their individual imaginations, Preston, O'Keeffe and Cossington Smith found their own style of abstraction in hybrid practices that were based in the close observation of the natural world. Freed from narrative and mimetic representation, their art is marked by their personal ideas and specific approaches to abstraction in response to the particular environment, geography, and cultures of Australia and the United States.

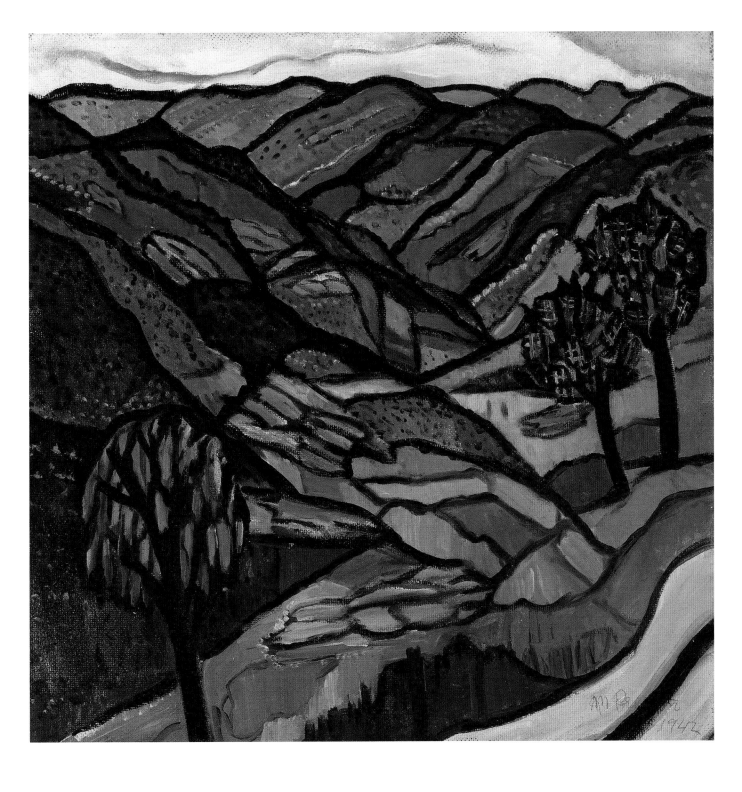

Margaret Preston

Grey Day in the Ranges 1942

Grace Cossington Smith
Sea Wave
1931

DEBORAH EDWARDS

For Baudelaire the sea was landscape in perpetual movement. For Grace Cossington Smith in her small landscape-in-motion *Sea Wave* 1931, where all pulses under a clay sky, light is no longer the artist's primary metaphor for meaning; instead rhythm and energy itself, perpetual motion, has become its central vehicle. Cossington Smith inscribes her name along the energised curve of a wave in a painting in which she makes tangible, in arguably her most majestic form, her essential apprehension of the world.

A painting of the New South Wales coastline, in 'bruise-palette' hues, seen as if through the curved closed bubble of the fish-eye lens, *Sea Wave* is composed in two rough halves, in which sky and sea have become mirrors – although not quite. In one, the energy of clouds and sky is seemingly random, non-rational, elaborated in scudding, multi-directional veils of colour; in the other, there is the systematic, rhythmically patterned energy of waves breaking upon the shore: pure energy mirrors energy forged into form. Such meanings are conveyed through Cossington Smith's brushwork, where flicked and feathery strokes of pigment in the sky face the squarer, banded patternings of the sea. The shifting exchange between the space of naturalism and its disruption by the modernist surface, between intellectual objectivity and the subjective encounter, shape this painting's forms.

Sea Wave is emphatically colourist and indelibly solid, while spatially also very much of the surface, and in this respect it acutely foregrounds those apprehensions which underlie the commitment to dynamism and rhythmic construction in the art of significant Sydney modern artists of the era. Certainly with this work and other landscapes, Cossington Smith joined many progressive peers in declaring her immunity from interwar nationalistic impulses in Australian art which were centred largely on landscape painting.

Sea Wave, with its pared-back vista of air and water, has traditionally been discussed in the context of the artist's profound grief at her mother's death: Cossington Smith and her stricken family had left Sydney in May 1931, a month after the funeral, to spend time at the coastal towns of Thirroul and Bulli, south of Sydney. *Bulli Pier* 1931 (p. 147), a painting of the same coastline with an engagingly local palette and the humanising projection of a curved pier, was also a product of this trip.

It has been widely held that Australian modern painters of the 1920s and 30s tended to avoid the landscape genre, that their painting-ground was the cityscape. Certainly moderns such as Cossington Smith made the metropolis central to their art. They joined American painters Georgia O'Keeffe and Peter Blume, for example, in frequently rendering the teeming modern city empty and silent. Alternatively, in elevated views, they imaged the density and deep spatiality of the urban environment, and the masses of people within it. Cossington Smith, a painter of Sydney city life since the years of World War I, wrought some of her greatest works from the personal melding of anxiety and celebration which accompanied her encounters with the city in the 1920s.

Yet in *Sea Wave* the artist trades her previous commentaries on modern life for something profoundly else. Here, one of the most inventive landscapists of all Australian moderns radicalises the local tradition. Cossington Smith's creation of a modestly-sized painting describing immense space, her shift away from local colour to a non-mimetic palette, and her focus on the monumental, 'universal' forms of sky and sea alone, invite a metaphysical reading. Such an apprehension of the landscape, while intrinsic to the remarkable efflorescence of Aboriginal painting in Australia from the early 1970s, is nonetheless a noticeably uncommon one in the history of white-Australian landscape painting.

Cossington Smith paints the littoral zone of land and sea, sea and sky without specificity regarding time of day, weather, or the details of this Thirroul coastline, and thus renders time and place void. *Sea Wave* signals the artist's theosophically oriented interest in colour as aura, halo, or vibration, a vehicle to image a world, a universe, as *charged*, beyond the quotidian real. In the vibrating ambience of this world Cossington Smith composes upon the metaphor of the wave to claim meaning as the larger, eternal movement and interrelationship of all matter and energy. In doing so she creates an exceptional talisman of vitalist and transcendental intent.[1]

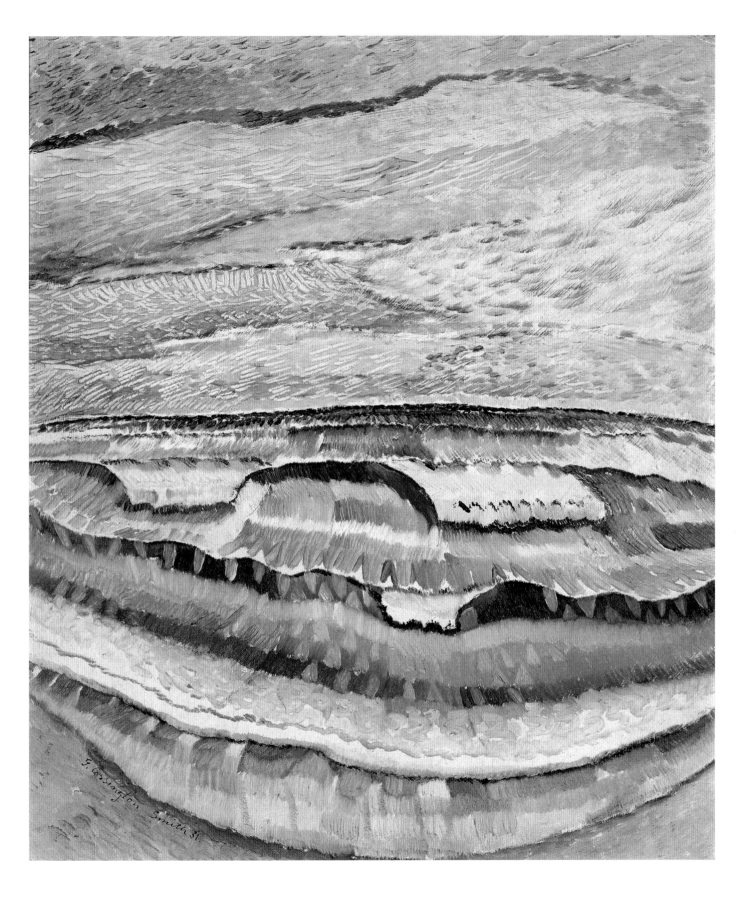

Georgia O'Keeffe
Blue Line
1919

KYLA MCFARLANE

Georgia O'Keeffe's *Blue Line* 1919 is an abstract painting from early in her career, produced in close proximity to pivotal moments and movements in her life. In April 1917 O'Keeffe held her first solo exhibition at Alfred Stieglitz's gallery 291 in New York. A year later, in June 1918, she moved from Texas to live with Stieglitz and paint. That was also the year she moved from watercolours to oil as her primary medium.

These are observations external to the work itself, a painting that rewards close looking. O'Keeffe's title leads us to two abstract notions: a colour, a form. It draws us to the blue line as the painting's central subject, a narrow, slightly wavering cleave around which the painting's divided composition turns.

Blue Line has a sculptural quality that also hinges upon the central split opened up by the blue line of its title. In the lower half of the painting we see curvilinear passages of colour – pink, blue, black, green and white – being pulled into the central blue sentinel, their edge becoming the line. Above, and to the outer edges of the frame, these colours bleed into a diffuse mist. This accords with Barbara Haskell's observation that O'Keeffe 'reengaged with oil by emulating the rippling quality of her charcoals and watercolours, gently feathering her rainbow palette of hues into one another in order to create animate, breathing forms'.[1] The composition is both intimate and expansive, suggesting a close observation of natural forms or an imagined space that is limitless and elusive.

Blue Line triggers a series of associations across O'Keeffe's oeuvre. These are associations made through the recurrence of the line, and the assertion of the colour blue. We might look back to *Blue Lines* 1916 (Metropolitan Museum of Art, New York), the artist's austere, delicate watercolour and graphite abstraction. Here, two lines rise from a deep blue watercolour ground, gradually expanding into two slightly open seams. The line on the left takes a small detour, zigzagging away from its pair on the right. The work is a simple, yet careful depiction of linear forms brought into a close compositional relationship, its boldness a precursor to the central cleave of *Blue Line* that echoes the rising, wavering form O'Keeffe had developed three years prior.

This bold clarity of line can be witnessed in later works where the central line seems to rend the canvas open, such as *Line and Curve* 1927 (National Gallery of Art, Washington), or in the diaphanous, billowing colours split in two by the white arrow-line in *Abstraction Blue* 1927 (Museum of Modern Art, New York).

Blue Line can be considered in relation to the photographs of Paul Strand, whom O'Keeffe had met in 1917, and whose photographs were reproduced in Stieglitz's final issue of *Camera Work* in June 1917 along with reviews of O'Keeffe's 291 exhibition.[2] Here, Strand's photographs of shadows on a porch and bowls in sunlight have a particular affinity with O'Keeffe's abstraction. While Strand explicitly examines objects and the play of light in the observable world, he draws his photographer's eye close to his curvilinear subjects, allowing them to also become a series of abstract relationships between light and dark, form and shadow. In *Blue Line*, O'Keeffe's elusive abstraction enacts a similar tension between the organic and geometric and between the constraints of the composition and the expansiveness of the form. We can imagine a continuity beyond the edge of O'Keeffe's picture plane and Strand's photographic frame. The subject exceeds these boundaries whether it is imagined or observed.

While O'Keeffe was to vacillate between figurative and abstract painting across her career, we can view her early forays into abstraction as formative and enduring. Decades after she painted *Blue Line*, O'Keeffe observed:

> It is surprising to me to see how many people separate the objective from the abstract. Objective painting is not good painting unless it is good in the abstract sense. A hill or a tree cannot make a good painting just because it is a hill or a tree. It is lines and colors put together so that they say something. For me that is the very basis of painting. The abstraction is often the most definite form for the intangible thing in myself that I can only clarify in paint.[3]

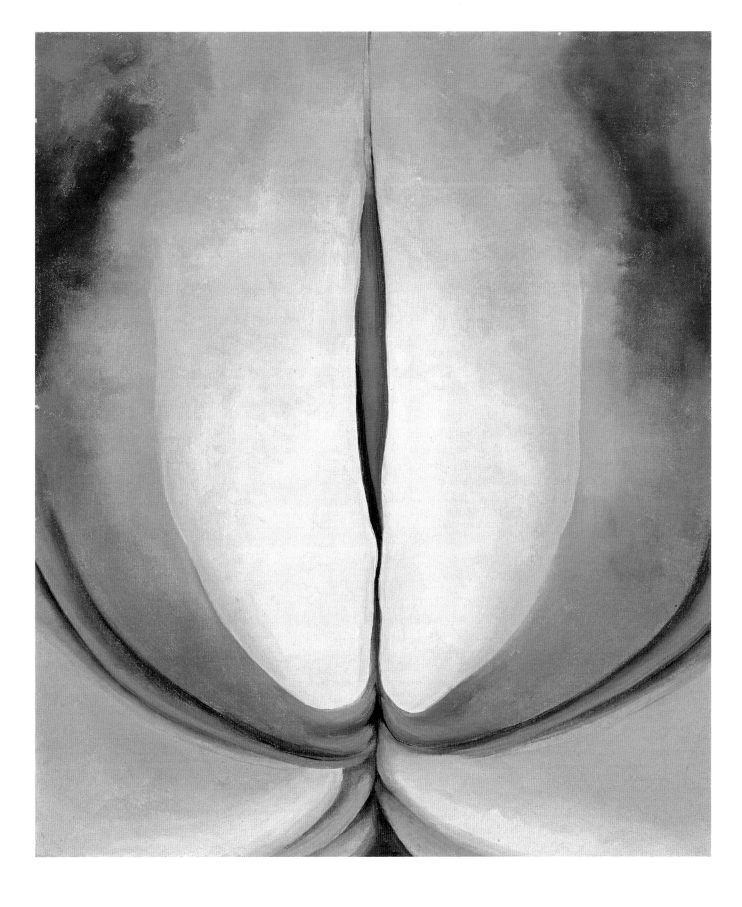

Grace Cossington Smith
The Window
1956

BRUCE JAMES

The first thing we notice about *The Window* 1956 is its facture: the way the paint actually sits on the surface. It's exuberant, thick, fragmented, parti-coloured. The way it glints is noticeable too.

This isn't just painterly razzle-dazzle, though there is that. Rather, a maenad energy can be recognised in the high-pitched palette, the vitalist splurges of pigment, the sense of an edgy choreography across the whole composition and the feeling that the painter has pulled out all the stops in an effort – without *showing* effort – to wrest a powerful and talismanic image into being.

The Window is the proof of an artist's devotion to the *action* of picture-making. That this particular artist was, at the time, a frizzled suburb-dweller in her none-too-athletic mid 60s, with a character more formed by High Anglican attitude than anatomical abandon, does not diminish the degree of her bodily investment in the work. Admittedly, Cossington Smith's version of bodily investment can't compete with the gutsy enterprise of a Margaret Preston, still less with the full-frontal praxis of a Georgia O'Keeffe. But there's nothing pallid or inhibited about *The Window*.

The very size of the painting support, the largest Cossington Smith had used in almost 30 years, and one of only a handful of similarly sized panels from the decade, is the real-world vouchsafe of her inner-world desire to make a grand artistic statement by means of this declarative painting.

Why? And why in 1956?

Even an artist as fashion-averse as Cossington Smith felt the tug of contemporaneity. And she was, after all, a Modern. Australian postwar painters, especially in Sydney, had begun to adopt some of the milder tenets of Abstract Expressionism, including John Olsen, William Rose and Eric Smith. These young lions participated in a landmark exhibition, Direction 1, at Macquarie Galleries in December 1956. A significant number of their works were painted on the same commercially available masonite panels chosen by Cossington Smith for *The Window* – and subsequently for *Interior with Blue Painting* 1956 (p. 96) and *Enid on the Sofa* 1957 (private collection). These builder's standbys were known as *four-by-threes*, being four feet by three feet in Australia's pre-metric measurement.

By the 1950s, they were plentiful, popular and cheap. Their smooth finish invited gestural flourishes and an expressive attack, as suitable for Cossington Smith's ramped-up intimism as for the Ab Ex showiness she doubtless sized up at this moment. If we put aside *The Window*'s specifics as a studio interior, it parses as an essay in pure paint, approaching non-objectivity. It's an artefact that argues, and intends to argue, for the painter's claim to relevance amid challenge and change.

Not incidental to this, Macquarie Galleries was the artist's long-term dealer. *The Window* would thus be understood in the context of the abstractionist gambit its author was determined to contest. The smaller yet still dazzling *Interior with Wardrobe Mirror* 1955 (p. 97) unfolds as a practice run. Cossington Smith limbered up in the indoor arena of its happy-go-lucky hues and helter-skelter perspectives. Then, in a torsion that instigated the solar brilliance of *The Window*, she turned outward to the sun! Her loveliest interiors, right through to the late 1960s, would strive to look out, not in, lighted by a sunflower sunniness it is impolite not to associate with her earliest art-historical hero, Van Gogh.

The blast effects of a mid-life infatuation with Pierre Bonnard might also fan the painting's heat.

Cossington Smith primed her panel with a matte white ground, possibly an early PVA house paint. Here and there it shows through. She applied her high-quality oil pigments with brush and palette knife. They constitute a harlequinade of lemon, chrome yellow, cadmium orange, iron red, viridian, alizarin crimson, Prussian blue, cobalt blue, and both zinc and lead white. The only blacks are the traces of lead pencil marking out the rudiments of her composition. Cossington Smith may have leant the panel against the wall as she worked, accounting somewhat for its tilted line of sight. The thrice-windowed space is one of several she adapted for studio practice and for storage. Small pictures jostle in stacks to the right, larger ones loom dust-draped to the left. These, and the racy jug and sewing basket (?) nearby, are the occupants of the room. Not human at all, yet pulsing. We are, and why not, inside an artist's mind, peering out through the nose-and eye-slits

Grace Cossington Smith
Interior with Blue Painting 1956
oil on composition board, 90.7 x 122.2 cm
National Gallery of Victoria, Melbourne
Purchased 1956

of a skull. What we see is a landscape, now tamed bush but once part of the region's native forestation. This eucalyptus vista would be lazily patriotic were it not an outlook Cossington Smith had been busily painting since 1914, when the Smiths acquired their Turramurra home and called it Cossington.

The Window suggests many genres. It is an interior, a still life, a landscape and an experiment in visual perception. It's a manifesto as well, written entirely in the clarion colours and radiant strokes which are the hallmark of the painter's mature style. And it is, moreover, an act of faith: 'There is a feeling of an abyss, a void between oneself and everything outside, and one has the impulse to bridge it. The thing which I always

endeavour to express is an animistic quality – a certain mystical throbbing throughout nature.' The words are John Olsen's, published at the time of Direction 1.[1]

The sentiment is Cossington Smith's, trumping the store-bought mundanity of her masonite and issuing a representationalist countermand to the abstractionist forces arrayed before her.

Grace Cossington Smith
Interior with Wardrobe Mirror 1955

Georgia O'Keeffe

see also

Blue Line 1919 (p. 93)

Series 1, No. 10 1919 (p. 51)

Storm Cloud, Lake George 1923 (p. 69)

Petunia No. 2 1924 (p. 19)

Corn, No. 2 1924 (p. 83)

The Black Iris 1926 (p. 37)

Church Steeple 1930 (p. 59)

Back of Marie's No. 4 1931 (p. 45)

Ram's Head, Blue Morning Glory 1938 (p. 9)

Untitled (Red and Yellow Cliffs) 1940 (p. 86)

Black Place, Grey and Pink 1949 (p. 55)

In the Patio VIII 1950 (p. 85)

Pink and Green 1960 (p. 63)

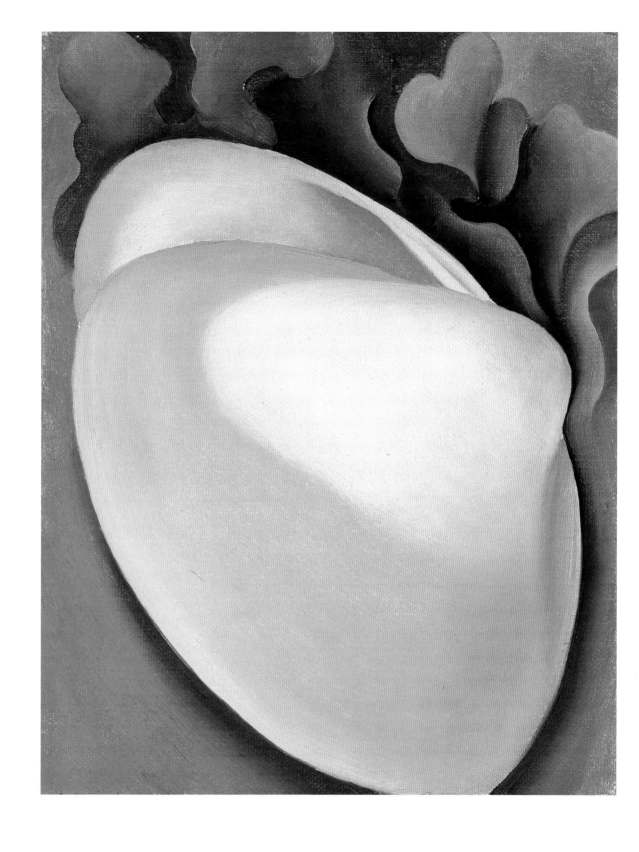

Georgia O'Keeffe
Tan Clam Shell with Seaweed 1926

Georgia O'Keeffe
Series 1, No. 12 1920

Georgia O'Keeffe
Abstraction White 1927

Georgia O'Keeffe
Canna Leaves 1925

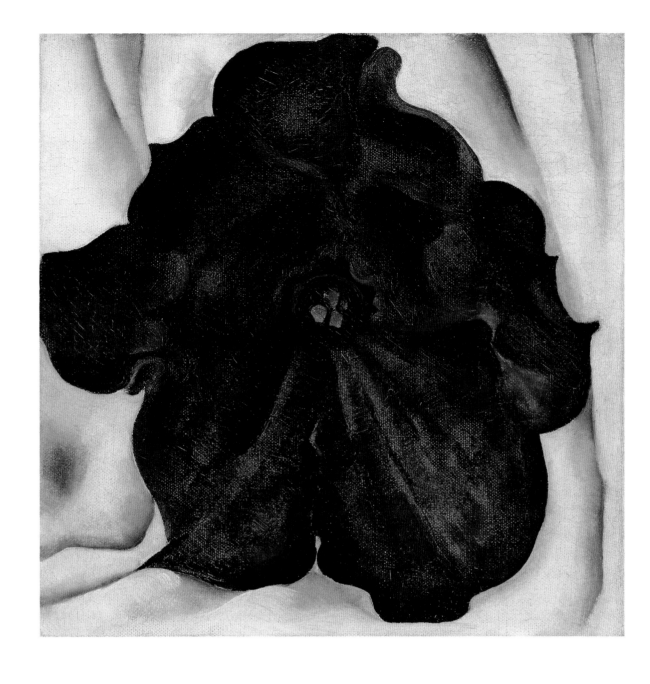

Georgia O'Keeffe
Untitled (Purple Petunia) 1925

Georgia O'Keeffe
Bear Lake, New Mexico 1930

Georgia O'Keeffe
Gerald's Tree I 1937

Georgia O'Keeffe
Purple Hills Ghost Ranch – 2/Purple Hills No. II 1934

Georgia O'Keeffe
Pedernal 1941

Georgia O'Keeffe
Cottonwoods Near Abiquiú 1950

Georgia O'Keeffe
Cottonwood Tree in Spring 1943

Georgia O'Keeffe
Winter Cottonwoods East IV 1954

Georgia O'Keeffe
Mesa and Road East 1952

Georgia O'Keeffe
In the Patio III 1948

Georgia O'Keeffe
Blue Black and Grey 1960

Georgia O'Keeffe
Blue - A 1959

Georgia O'Keeffe
Pelvis IV 1944

Margaret Preston

see also

Still Life 1915 (p. 77)

Still Life 1925 (p. 32)

Implement Blue 1927 (p. 11)

Banksia 1927 (p. 39)

Western Australian Gum Blossom 1928 (p. 35)

The Monstera Deliciosa 1934 (p. 41)

I Lived at Berowra 1941 (p. 47)

Aboriginal Landscape 1941 (p. 65)

Blue Mountains Theme c.1941 (p. 73)

Flying Over the Shoalhaven River 1942 (p. 62)

Grey Day in the Ranges 1942 (p. 89)

Margaret Preston
Still Life c.1915–16

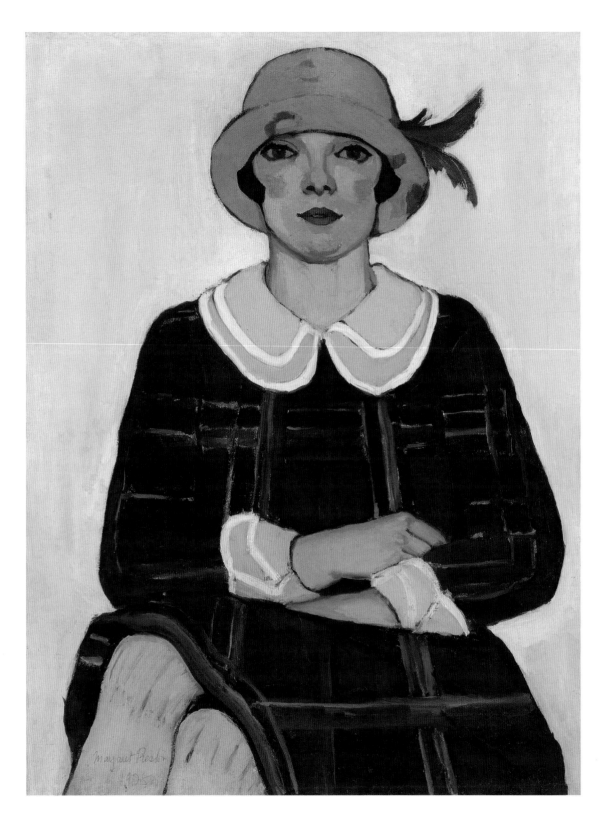

Margaret Preston

Flapper 1925

Margaret Preston

White and Red Hibiscus 1925

Margaret Preston
Thea Proctor's Tea Party 1924

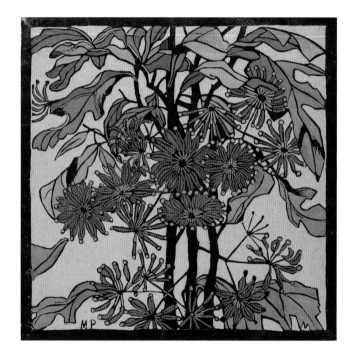

Margaret Preston
Wheelflower c.1929
Anemones 1925
Circular Quay 1925

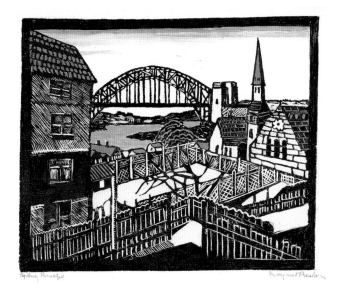

Margaret Preston
Sydney Heads (2) 1925
Rocks and Waves c.1929
Sydney Bridge c.1932

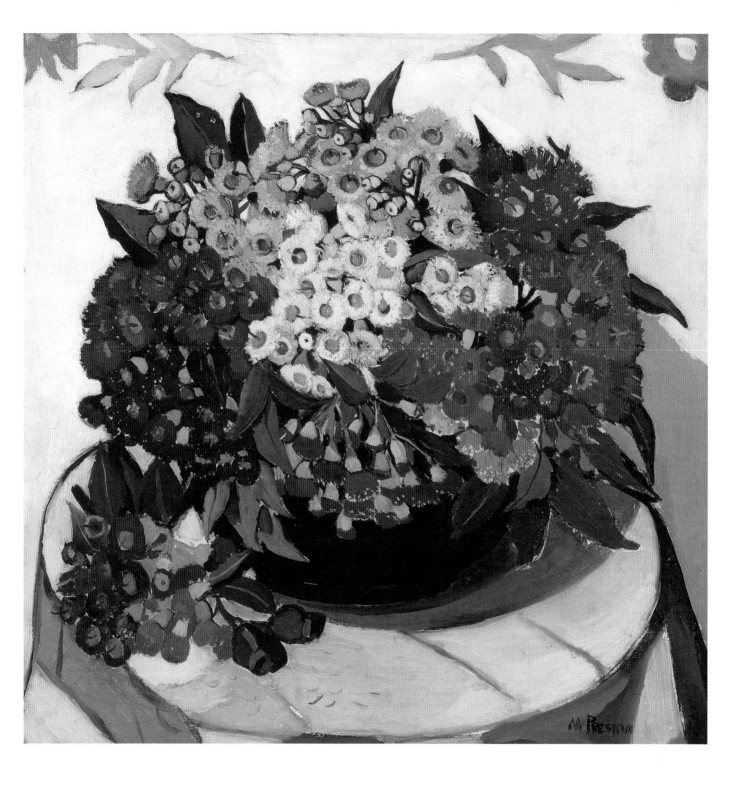

Margaret Preston

Australian Gum Blossom 1928

Margaret Preston
Self Portrait 1930

Margaret Preston

Double Hibiscus 1929

Margaret Preston
Australian Coral Flowers 1928

Margaret Preston
Aboriginal Flowers 1928

Margaret Preston
NSW and West Australian Banksia 1929

Margaret Preston
Australian Rock Lily 1933

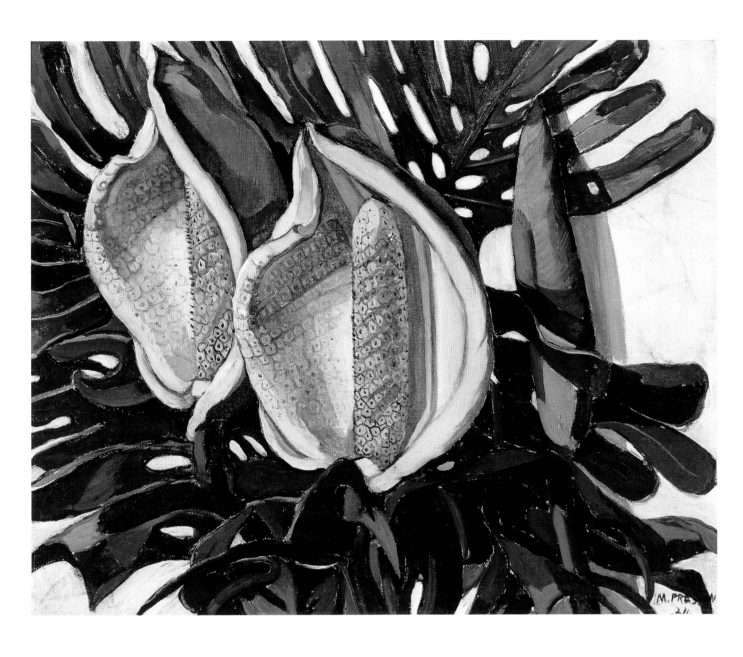

Margaret Preston
Monstera Deliciosa 1934

Margaret Preston
The Brown Pot 1940

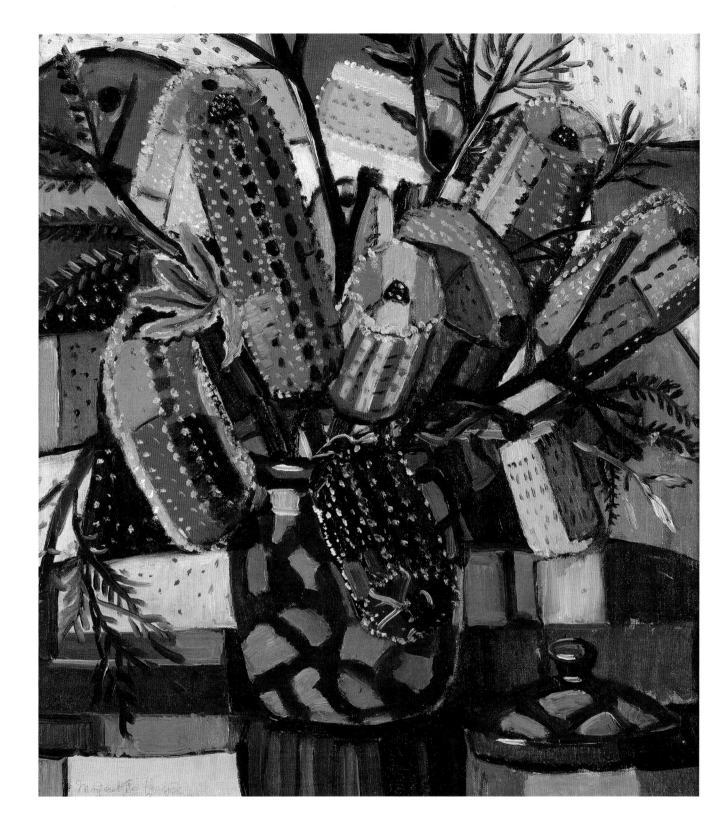

Grace Cossington Smith

see also

The Sock Knitter 1915 (p. 24)

Study of a Head: Self-Portrait 1916 (p. 78)

Pumpkin Leaves Drooping 1926 (p. 27)

Trees c.1927 (p. 52)

Things on an Iron Tray on the Floor c.1928 (p. 28)

The Curve of the Bridge 1928–29 (p. 14)

Landscape at Pentecost 1929 (p. 71)

The Bridge in Building 1929–30 (p. 13)

Black Mountain c.1931 (p. 67)

Sea Wave 1931 (p. 91)

Bush at Evening 1947 (p. 61)

Interior with Wardrobe Mirror 1955 (p. 97)

The Window 1956 (p. 95)

Grace Cossington Smith
Centre of a City c.1925

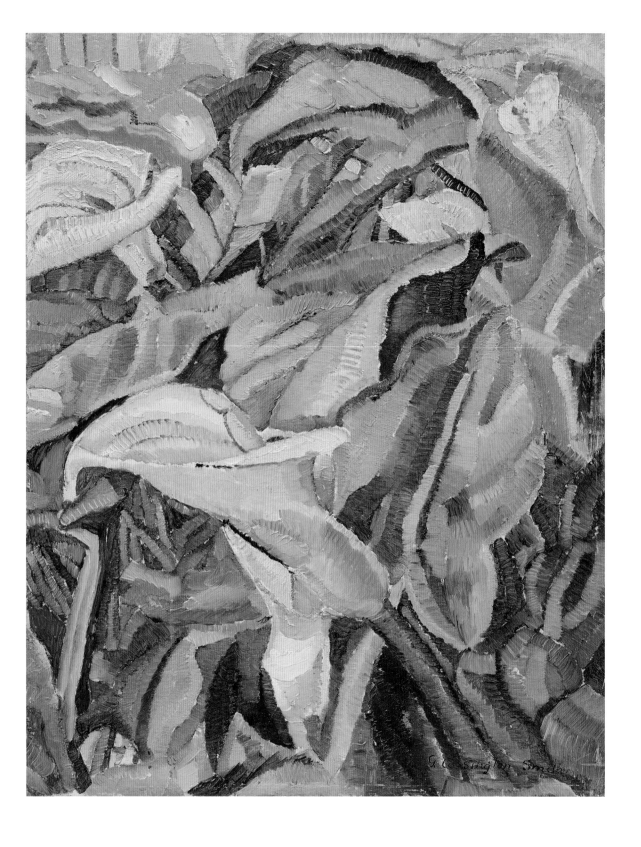

Grace Cossington Smith

Arums Growing c.1927

Grace Cossington Smith
Lily Growing in a Field by the Sea c.1927

Grace Cossington Smith
Landscape with Jacaranda c.1933

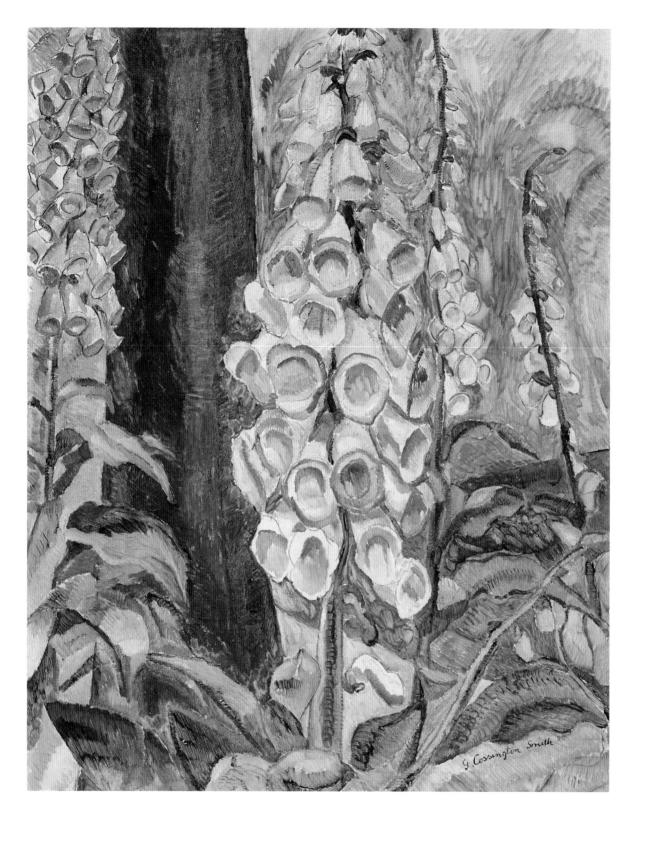

Grace Cossington Smith
Foxgloves Growing 1929

Grace Cossington Smith
The Beach at Wamberal Lake 1928–29

Grace Cossington Smith
Bulli Pier, South Coast 1931

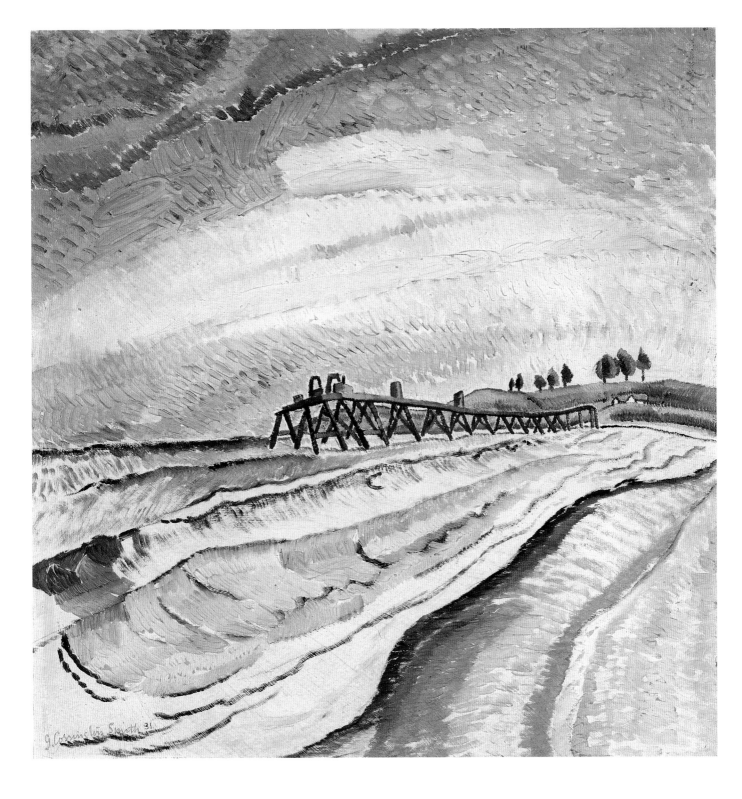

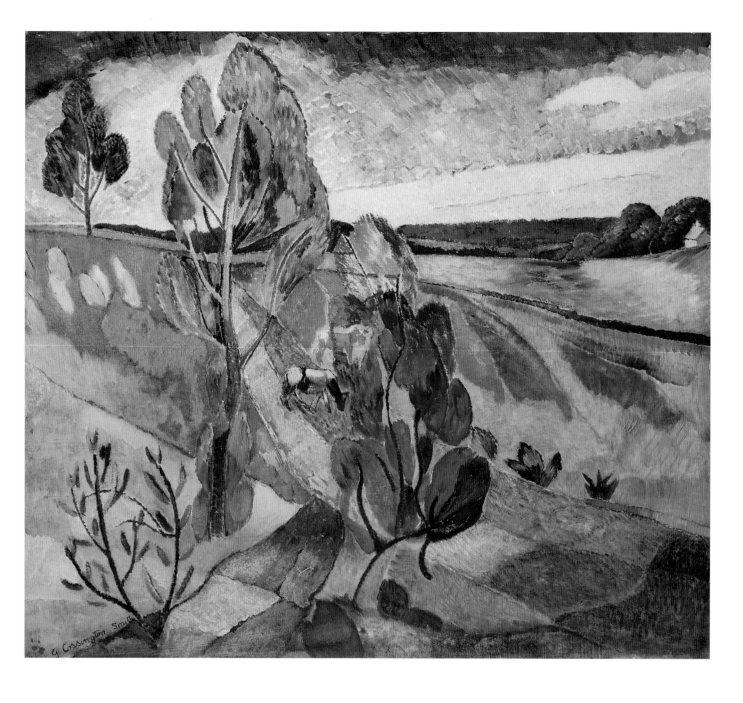

Grace Cossington Smith
Landscape at Pentecost c.1932

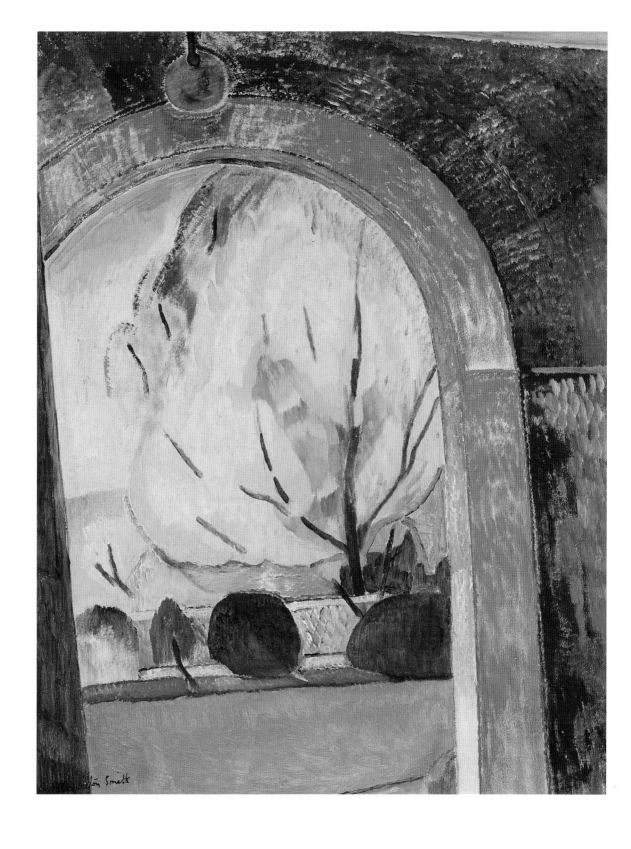

Grace Cossington Smith
Yarralumla 1932

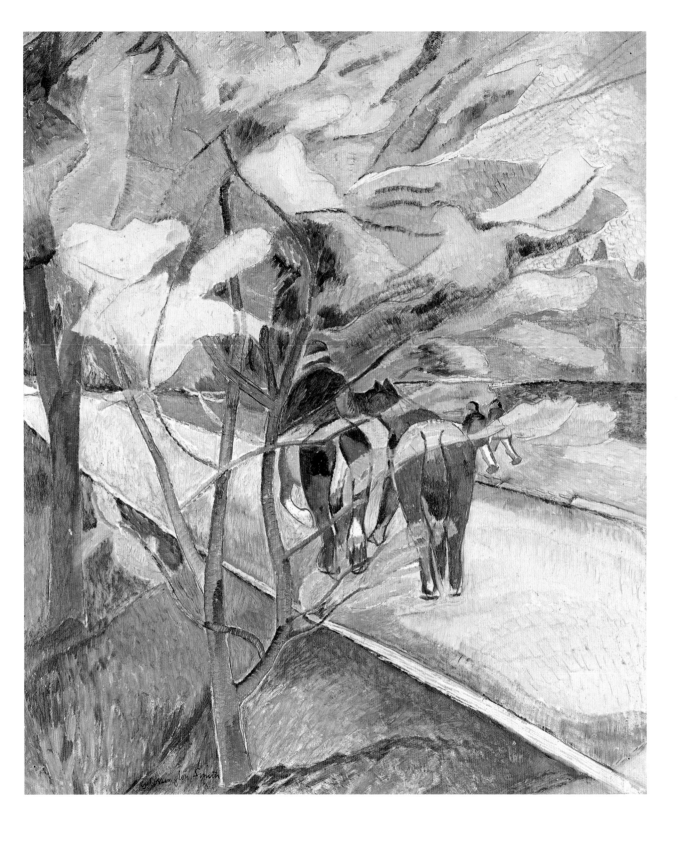

Grace Cossington Smith

Road with Two Horses c.1933

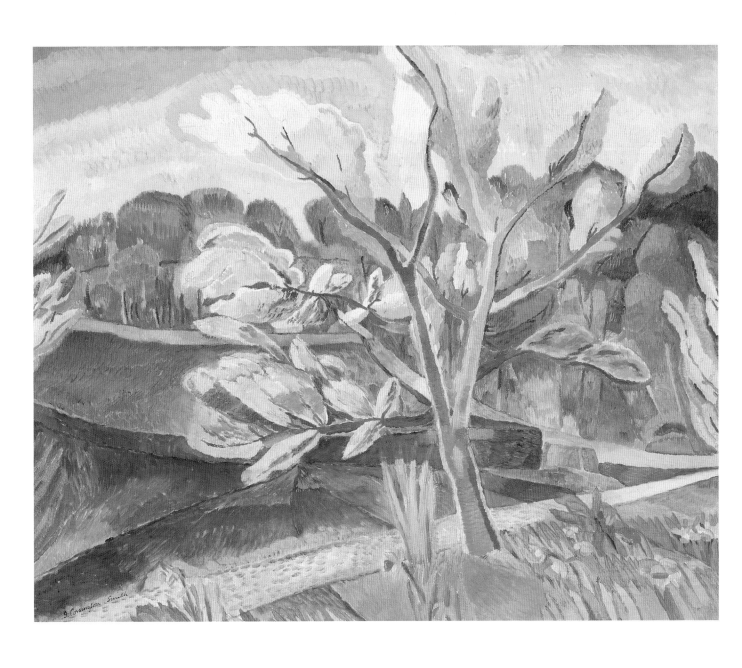

Grace Cossington Smith

Landscape with Flowering Peach 1932

Grace Cossington Smith
The Lacquer Room 1936

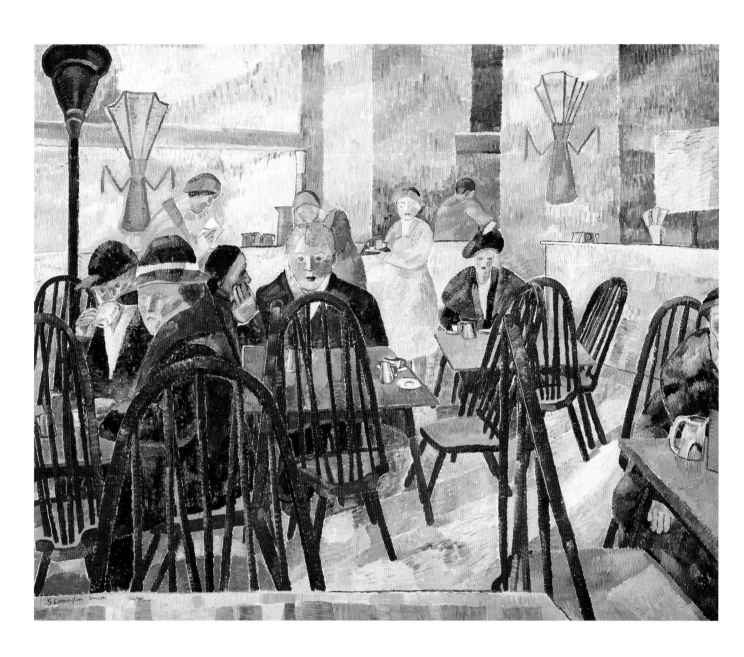

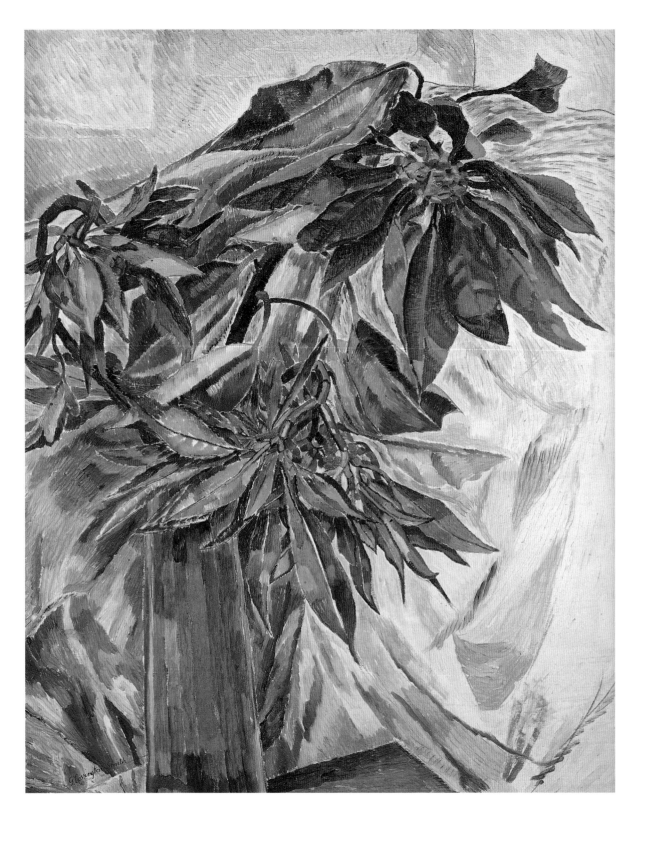

Grace Cossington Smith
Poinsettias 1931

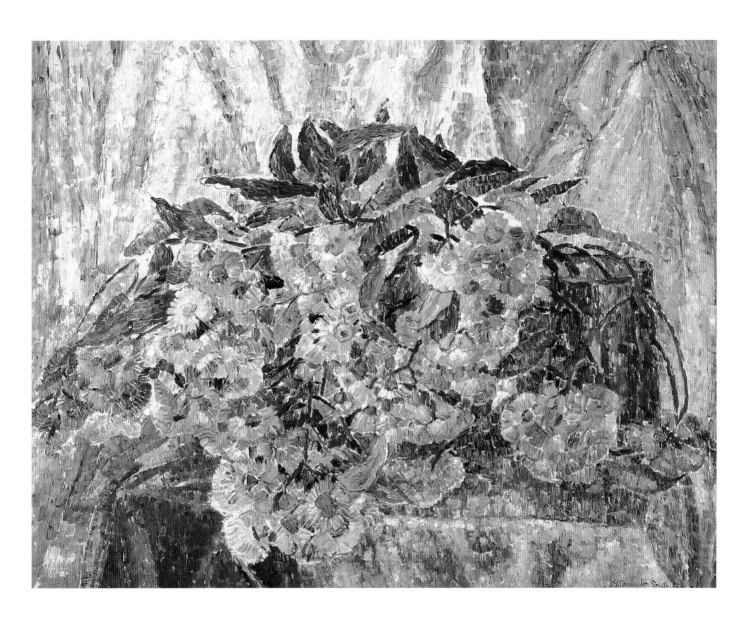

Grace Cossington Smith
Gum Blossom and Drapery 1952

Grace Cossington Smith
Bonfire in the Bush c.1937

Artists' biographies

Georgia O'Keeffe (1887–1986)

Georgia Totto O'Keeffe was born on 15 November 1887, and grew up on a farm near Sun Prairie, Wisconsin, in the United States. As a child she and her two sisters received art lessons at home. By the time she graduated from high school in 1905, O'Keeffe had determined to make her way as an artist.

She studied at the Art Institute of Chicago (1905–06) and the Art Students League in New York (1907–08), where she learned the techniques of traditional realist painting. In 1908, she won the League's William Merritt Chase still-life prize for her oil painting *Untitled (Dead Rabbit with Copper Pot)*. The direction of her artistic practice shifted dramatically four years later when she was introduced to the ideas of Arthur Wesley Dow at the University of Virginia. Later O'Keeffe studied with Dow in New York from 1914 to 1915, at Columbia University Teachers College. In the autumn of 1915 she accepted a position teaching art at Columbia College, in South Carolina. During that period, she began a series of abstract charcoal drawings as she developed a personal vocabulary of forms and shapes to express her feelings and ideas. She mailed some of these highly abstract drawings to a friend in New York City, who showed them to Alfred Stieglitz, who exhibited ten of them in 1916 at his avant-garde gallery 291. A year later, he presented O'Keeffe's artwork in a solo exhibition. In the spring of 1918 he offered O'Keeffe financial support to paint for a year in New York. She accepted his invitation and moved from Texas, where she had been teaching at the West Texas State Normal College since the autumn of 1916.

Stieglitz and O'Keeffe were married in 1924 and she adapted her life in New York to Stieglitz's habits and his pattern of spending winter and spring in the city and retreating to his family compound at Lake George in the summer and autumn. By the mid 1920s, O'Keeffe was recognised as one of America's most important and successful artists, known for her paintings of New York skyscrapers – an essentially American image of modernity – as well as the flowers that grew at Lake George. Stieglitz played a significant role in promoting O'Keeffe and her artwork, organising annual exhibitions from 1923 until his death in 1946.

In the summer of 1929, O'Keeffe made the first of many trips to northern New Mexico. For the next two decades she spent part of most years living and working in New Mexico, a pattern she rarely altered until she made it her permanent home in 1949, three years after Stieglitz's death. The stark landscape, distinct Indigenous art, and unique regional style of adobe architecture inspired a new direction in O'Keeffe's artwork. Her New Mexico paintings coincided with a growing interest in regional scenes by modernists, who were seeking a distinctive view of America beyond the urban centre of New York City.

Suffering from macular degeneration and discouraged by her failing eye sight, O'Keeffe painted her last unassisted oil painting, *The Beyond*, in 1972. But O'Keeffe's will to create did not diminish with her eyesight. In 1977, at age 90, she observed, 'I can see what I want to paint. The thing that makes you want to create is still there'. Late in life, and almost blind, she enlisted the help of several assistants and continued to work in watercolour and pencil until 1982. She also produced objects in clay from the mid 1970s until two years before her death, in Santa Fe, on 6 March 1986, at the age of 98.

Alfred Stieglitz
Georgia O'Keeffe – After Return from New Mexico 1929
gelatin silver photograph, 7.8 x 11.7 cm
Georgia O'Keeffe Museum, Santa Fe
Gift of the Georgia O'Keeffe Foundation

Todd Webb
Georgia O'Keeffe Photographing the Chama Valley, New Mexico 1961
gelatin silver photograph, 20 x 20.5 cm
Georgia O'Keeffe Museum, Santa Fe
Gift of the Georgia O'Keeffe Foundation

Opposite
Alfred Stieglitz
Georgia O'Keeffe at '291' in Front of Her Charcoal 'No. 15 Special' 1917
platinum print, 24.3 x 19.4 cm
Georgia O'Keeffe Museum, Santa Fe
Gift of the Georgia O'Keeffe Foundation

Margaret Preston (1875–1963)

One of Australia's best-loved and most recognisable twentieth-century artists, Margaret Preston was born Margaret Rose McPherson in Port Adelaide, South Australia, on 29 April 1875, the first of two daughters to marine engineer David McPherson and his wife Prudence. The family moved to Sydney a decade later where Margaret attended the Fort Street School atop Observatory Hill and overlooking Sydney Harbour, which would become the subject of a number of her later works.

She determined as a twelve-year-old that she wanted to be an artist, whereafter her parents arranged tuition with the landscape painter William Lister Lister. When the McPhersons moved to Melbourne in the early 1890s, Margaret attended Oberwyl Ladies College where she learnt china, fan and silkscreen painting under Madame Bertha Mouchette. She enrolled at the Art School of the National Gallery of Victoria in 1893, Australia's most prestigious art college at the time, training under impressionist painter Frederick McCubbin. A brief stint at the School of Design, Painting and Technical Arts in Adelaide followed her return to her home town for family reasons, before she resumed studies in Melbourne in 1896, this time under the instruction of the National Gallery School's director, Bernard Hall.

Upon graduation Preston returned to Adelaide, joining the South Australian Society of Artists and establishing a studio in the city in 1899, where she conducted art classes. Her early paintings remained true to the tonal realism she learnt at the Gallery School until her exposure to the work of Van Gogh, the Fauves and Puvis de Chavannes during her first European trip in 1904–06. A second, longer period overseas from 1912–19 heralded her conversion to a modern style influenced by Post-impressionism and Japanese prints.

She married William Preston in Adelaide on 31 December 1919 before the couple moved to Sydney and settled in the harbourside suburb of Mosman, which would be her base for most of the rest of her life. The ensuing decade saw Preston establish her reputation as a painter of highly individual modernist still lifes and an outspoken cultural commentator. She began to write regularly on the arts for both specialist and popular magazines, and commenced a regular program of travel through western, central and northern Australia, Asia, the Pacific region, Europe and North and South America. Her advocacy for a new, vernacular national art gathered momentum during this time, a result of her exposure to other cultures including Indigenous art in Australia and New Guinea.

This was consolidated when the Prestons moved to Berowra, north of Sydney on the picturesque southern reaches of the Hawkesbury River in 1932. The virgin bush of their acreage allowed Preston to witness the seasonal display of native plants and she began painting flowers in their natural settings, turning to a more representational style and a muted, earthy palette. Returning to Mosman in 1939, Preston commenced a series of remembered and composite landscape paintings influenced by the colours and motifs of Aboriginal art, expressing her newfound respect for the ancient and timeless country of Australia.

Through the 1940s Preston lectured widely on art, including a popular series sponsored by the Carnegie Corporation at the Art Gallery of New South Wales, wrote articles and designed covers for the *Jindyworobak Review* – a nationalist platform – and joined the Society of Realist Artists, while her association with the New South Wales Anthropological Society saw her visit a range of remote Aboriginal rock art sites. She continued to exhibit until the late 1950s though held her last solo show of colour stencils at the Macquarie Galleries in 1953, after which her production diminished. She was hospitalised in October 1962 and died the following May, aged 88.

Margaret Preston in her Adelaide studio c.1909
Photographer unknown
State Library of South Australia, Adelaide
PRG 280/1/6/327

Margaret Preston c.1925
Photograph: Dorothy Warner
Art Gallery of New South Wales Library and Archive, Sydney

Opposite

Margaret Preston with gum blossoms, Gunbalanya (Oenpelli), Northern Territory 1947
Photographer unknown
Art Gallery of New South Wales Library and Archive, Sydney

Grace Cossington Smith (1892–1984)

Grace Cossington Smith is one of the most inventive and exceptional of the colour painters to emerge from Australia's first wave of modernism that developed in the early decades of the twentieth century.

Born on 20 April 1892 as one of five children to English migrant parents, Cossington Smith grew up in Sydney's northern suburbs. In 1914 the family moved to the Turramurra residence that remained Cossington Smith's lifelong home and centre of her artistic production.

In 1910 Cossington Smith began her studentship with the painter Antonio Dattilo-Rubbo whose central Sydney studio became the site of much artistic experimentation with post-impressionist colour, light and form during the interwar period. After travelling to England (and briefly Germany) from 1912, where she enrolled at the Winchester School of Art, Cossington Smith returned to Dattilo-Rubbo's classes in 1914. She claimed not to have studied modern art while overseas, but under Dattilo-Rubbo's tutelage between 1914 and 1920 Cossington Smith learnt the methods of Van Gogh, Cézanne, Gauguin and Seurat. She began to create compositions that, while anchored in realism, simplified form, flattened space and intensified colour.

In 1915 Cossington Smith made her exhibiting debut with *The Sock Knitter* (p. 24) at the Royal Art Society in Sydney, a painting that speaks of her knowledge of Matisse and Cézanne. Depicting Madge, the artist's sister, knitting socks for soldiers serving on the frontline in World War I, the painting is not only distinctly modern in appearance, but also counterpoints the common narratives of masculine heroism in wartime by focusing instead on the efforts of women on the home front.

By 1926, when Cossington Smith left Dattilo-Rubbo's studio, her visits to Sydney's urban centre became less frequent. The leafy terrains around Turramurra and the landscapes surrounding Sydney's light-filled harbour formed the subjects of her art. In 1924 she read and transcribed the American Beatrice Irwin's *The New Science of Colour* (1915). The book's message of deciphering spirit through colour fuelled Cossington Smith's established interest in colour as a luminal and constructive force capable of invoking the energetic undercurrents of her subjects.

From around 1927 Cossington Smith began sketching the progress of the Sydney Harbour Bridge's construction. She developed from these a series of works that represented the bridge as a monumental, organic-like force. Capturing the pulsating dynamics of the bourgeoning metropolis, Cossington Smith's bridge paintings are amongst the greatest examples of early Australian modernism.

While Cossington Smith worked in relative seclusion from her upper-north shore home, she was consistently present in Sydney's art world as a regular exhibitor in group and solo exhibitions from the 1920s onwards. While she downplayed the impact of European modernist art forms on her work, she claimed the lasting influence of Cézanne. This is most evident in a late series of bush scenes in 1947–48 where the landscape is painted as a dissolving force, her loose, pigmented brushwork conveying the impression of colour floating in light.

From the late 1950s, when Cossington Smith was a carer for her invalid sister Madge, she embarked on her last series of paintings based on the rooms and spaces around her home. Cossington Smith transformed her unassuming subject matter into sites of dazzling, radiating energy. The paintings serve as the climactic fulfilment of her enduring desire to express 'colour vibrant with light'.

Cossington Smith moved to a nursing home in northern Sydney in 1979. By this stage she had given up painting, but her recognition as one of Australia's foremost modernist painters was cemented after a major retrospective exhibition at the Art Gallery of New South Wales in 1973, the same year she was awarded an Order of the British Empire. She died at age 92 in December 1984.

Grace Cossington Smith c.1924 (detail)
Photographer unknown
Private collection

Grace Cossington Smith c.1930–40
Photographer unknown
Australian War Memorial, Canberra 8522207

Opposite
Grace Cossington Smith knitting socks, Turramurra c.1915
Photographer unknown
ACT Historic Places, Lanyon Collection

Timeline

	SELECTED WORLD AND ART EVENTS	GEORGIA O'KEEFFE	MARGARET PRESTON	GRACE COSSINGTON SMITH

1875			born in Port Adelaide on 29 April, the first of two daughters to David and Prudence McPherson	
1885			moves to Sydney with her family	
1887		born near Sun Prairie, Wisconsin, on 15 November, second of seven children to Francis and Ida O'Keeffe	singles out a visit to the Art Gallery of New South Wales with her mother as one of the reasons she becomes an artist	
1888			undertakes first her artistic instruction from seascape artist William Lister Lister	
1890	American-born art critic and Australian correspondent Sidney Dickinson publishes essay, 'What should Australian artists paint?'			
1892		begins school and receives weekly drawing lessons at home	On advice to seek further training in Melbourne, Preston and family move to Prahran. enrols with French instructor Madame Berthe Mouchette at Oberwyl Ladies College where she learns drawing, china painting and silkscreen techniques	born on 20 April 1892 in Neutral Bay, Sydney, the second of five children to Grace and Ernest Smith, both recent English immigrants
1893			enrols in National Gallery School under the instruction of painter Frederick McCubbin	
1894			returns to Adelaide to join her family; her father gravely ill	

	SELECTED WORLD AND ART EVENTS	GEORGIA O'KEEFFE	MARGARET PRESTON	GRACE COSSINGTON SMITH

1895

David McPherson, Preston's father, dies.

enrols at the School of Design, Painting and Technical Arts, Adelaide

nominated to join the South Australian Society of Artists

1896

re-enrols in the final term of the National Gallery School in Melbourne, where she is taught by Munich-trained Australian artist Bernard Hall

1897

boards at Westwood, a small independent school in Sydney's Point Piper that encouraged art education, and where her talent is first noted

1898

begins drawing lessons alongside her two sisters

begins watercolour lessons with Sarah Mann later in the year

1899

announces to a childhood friend, 'I am going to be an artist', later remembering, 'I don't really know where I got my artist idea ... I only know that by that time it was definitely settled in my mind'

returns to Adelaide to care for her mother

sets up a studio in the centre of the city and offers art classes in portraiture and still-life drawing

1901

The Commonwealth of Australia is established.

receives formal art education at Sacred Heart Academy boarding school, Madison, Wisconsin

Following a criticism of scale in one of her drawings, O'Keeffe decides, 'I would never, never draw anything too small'.

Ernest Cossington Smith is left in considerable debt after his business partner flees with the company's funds.

The Smith family sells their Neutral Bay house and moves to Thornleigh on the northern fringes of the city.

SELECTED WORLD AND ART EVENTS	GEORGIA O'KEEFFE	MARGARET PRESTON	GRACE COSSINGTON SMITH
1902 The Commonwealth Franchise Act 1902 is passed in Australia, granting women the right to vote in the 1903 election.	moves with her family to Williamsburg, Virginia		
1904	graduates from high school knowing she wishes to be an artist	Following the death of her mother, Preston travels to Munich, Naples, Genoa, Venice, Paris, Brittany, England, Scotland, and the Netherlands, with artist Bessie Davidson.	
1905	attends the Art Institute of Chicago, studying under John Vanderpoel	paints in Brittany and enrols in the recently opened academy La Grande Chaumière in Montparnasse exhibits paintings at the New Salon sees the sensational works of the Fauves at the Salon d'Automne and the Van Gogh retrospective in Paris	
1906	contracts typhoid fever and begins a long convalescence	travels to Ireland and Morocco before returning to South Australia via Naples	
1907 The first Australian Exhibition of Women's Work is held at the Melbourne Exhibition Building. Picasso paints *Les Demoiselles d'Avignon*.	attends Art Students League, New York City visits Alfred Stieglitz's gallery, known as '291' after its Fifth Avenue address	*Onions* 1905 enters the Art Gallery of South Australia collection, Preston's first sale to a state gallery. holds a joint exhibition with Bessie Davidson featuring artwork from their travels returns to teaching	

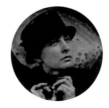

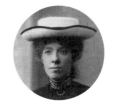

SELECTED WORLD AND ART EVENTS	GEORGIA O'KEEFFE	MARGARET PRESTON	GRACE COSSINGTON SMITH
1908	participates in a summer school at Lake George in upstate New York		enrols at Abbotsleigh School in Wahroonga, where her art practice is encouraged by the school's headmistress
1909 The first exhibitions of American painters are held at Alfred Stieglitz's gallery 291.	works as a freelance commercial artist in Chicago	accepts a teaching position at Presbyterian Girls College, Adelaide (1909–10)	
1910			begins drawing classes at Antonio Dattilo-Rubbo's atelier, Sydney
1911 Biologist and anthropologist Baldwin Spencer starts commissioning bark paintings from Arnhem Land, Northern Territory, Australia.	accepts her first teaching post at Chatham Episcopal Institute in Virginia	sees Australian Aboriginal art for the first time, through regular exhibitions of Spencer's barks at the South Australian Museum begins political involvement in the arts scene through public disagreement with the Society of Artists over retaining membership during travels	
1912	attends classes at the University of Virginia teaches art at the University of Virginia and at the Amarillo Public School, Texas	returns to Europe to reside in Paris and then London with her companion, artist Gladys Reynell begins studying Japanese prints through observation at the Museé Guimet	travels to England with her father and sister Mabel, where she attends Winchester Art School (1912–14)
1913 The International Exhibition of Modern Art, known as the Armory Show, New York, introduces European modern art to the United States.	acts as a summer teaching assistant to Alon Bement, University of Virginia (1913–16)	spends the summer painting at the Île de Noirmoutier, an island off the coast of Brittany moves to London and studies with American expatriate artist George Oberteuffer	visits Germany briefly, with her sister Mabel

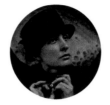

SELECTED WORLD AND ART EVENTS	GEORGIA O'KEEFFE	MARGARET PRESTON	GRACE COSSINGTON SMITH
1914 First exhibition of Picasso's work at 291. Australia enters World War I.	attends classes of Arthur Wesley Dow at Teachers College, Columbia University teaches at Columbia College, South Carolina joins the National Women's Party on behalf of women's suffrage and maintains membership for many decades after the right to vote is granted in 1920	participates in multiple exhibitions in London: the Society of Women Artists, the New English Art Club, and the Royal Academy travels to Ireland and then returns to London in October, one month after the war begins	returns to Australia in April moves with her family to Turramurra in Sydney's upper north shore, her primary residence throughout her career; Ernest builds her a studio in the garden re-enrols at Dattilo-Rubbo's atelier, where instruction now includes classes in oil painting
1915 ANZAC troops join the Gallipoli Campaign, Turkey (25 April 1915 until 9 January 1916), a defining moment of Australian nationhood.		takes students on a painting trip to Bonmahon, Ireland, where she paints still lifes, watercolours, and village scenes	paints *The Sock Knitter*, displayed the same year at the Royal Art Society, New South Wales, a painting later described as the first post-impressionist work exhibited by an Australian artist
1916	moves to Canyon, Texas to become head of the art department at West Texas State Normal College Ten charcoals are included in a group show at 291, her debut as a professional artist. O'Keeffe and Stieglitz begin corresponding. Her mother Ida dies of tuberculosis.	attends London's Camberwell School of Arts and Crafts to learn pottery exhibits at the New English Art Club starts an active publishing career, beginning with the article 'Australian artists at the Royal Academy' for the *Victorian Artists Society Journal*	exhibits works at the Royal Art Society volunteers as a commercial artist at the War Chest Flower Studios in Sydney, a fund-raising centre for the war effort
1917 The United States enters World War I.	stops briefly in Santa Fe, New Mexico holds first solo show at 291 on 3 April; travels to New York to see it Stieglitz begins his photographic portrait series of O'Keeffe. Stieglitz closes 291 due to financial difficulties.	meets William George Preston, an officer in the AIF; they marry two years later *Still Life* 1915 is reproduced in the London magazine *Colour*.	continues to exhibit work at the Royal Art Society, Sydney, until 1927 (aside from 1920, 1924 and 1926)

	SELECTED WORLD AND ART EVENTS	GEORGIA O'KEEFFE	MARGARET PRESTON	GRACE COSSINGTON SMITH
1918	World War I ends.	accepts Stieglitz's invitation to move to NYC with his financial support visits Stieglitz's family's summer residence at Lake George for the first time, the site of many paintings and a meeting place for their many artist and writer friends Her father, Francis, dies.	spends four months teaching war veterans basket weaving, pottery, monotypes, and batik during their rehabilitation at the Seale-Hayne Military Hospital in Devon	
1919	The Sydney artists Roy de Maistre (then Roi de Mestre) and Roland Wakelin hold their Colour in Art exhibition of 'syncromist' paintings, the first modernist art exhibition in Australia.		sails home to Australia with William (Bill) Preston, whom she marries on 31 December in Adelaide now financially secure, focuses on her art instead of teaching	paints the self portrait, *Study of a Head* submits work for exhibition to the Society of Artists and the Royal Art Society
1920	The 19th Amendment to the United States Constitution is ratified, allowing women to vote.		settles with Bill in Mosman, Sydney exhibits works produced in Europe as well as a new series of still lifes to great acclaim in Sydney establishes an active program of exhibiting at the Royal Art Society, the Society of Artists and later the Contemporary Art Group (from 1926)	The Smith family purchases the house they were renting in Turrumurra, Sydney, naming it Cossington. adds Cossington to her professional name, a suggestion from her mother, claiming her identity as a working artist
1921		Stieglitz has his first exhibition of photographs of O'Keeffe at the Anderson Galleries in New York.	gains support of influential publisher Sydney Ure Smith, also president of the Society of Artists who becomes a major supporter of her art and writing	completes many paintings of Sydney urban life
1922		An article on O'Keeffe's artwork by Paul Rosenfeld appears in *Vanity Fair*, gaining her a fashionable audience.		

SELECTED WORLD AND ART EVENTS	GEORGIA O'KEEFFE	MARGARET PRESTON	GRACE COSSINGTON SMITH

1923

Stieglitz organises the first solo exhibition of O'Keeffe's artwork, continuing these annually until his death in 1946.

advocates for a modern Australian national art, studying and seeking inspiration from Australian Aboriginal, Pacific Islander, and New Guinean art

establishes friendships with anthropologists Alfred Radcliffe-Brown, A.P. Elkin, and Frederick McCarthy

achieves success with colour woodblock prints that are recognised as a new form of Australian decorative art

publishes the essay 'Why I became a convert to modern art' for Ure Smith's *The Home* magazine

1924

marries Alfred Stieglitz on 11 December in a small private ceremony

O'Keeffe and Stieglitz exhibit their work together at Anderson Galleries.

begins to create large-scale flower paintings such as *Petunia No. 2*

lectures on modern art at the University of Sydney and on colour theory at Dattilo-Rubbo's studio, where Cossington Smith is among the students

holds successful exhibitions in Sydney and Adelaide

looks after her ageing and ailing parents, precluding participation in the Society of Artists annual exhibition

reads and transcribes *The New Science of Color* (1915) by American author Beatrice Irwin, a book that informs her subsequent colour practice

1925

F. Scott Fitzgerald publishes *The Great Gatsby*.

moves with Stieglitz into the Shelton Hotel, the first skyscraper residence in New York City

begins to paint images of the New York skyline

Stieglitz organises the exhibition Seven Americans at Anderson Galleries, including work by Arthur Dove, Marsden Hartley, John Marin, Charles Demuth, Paul Strand, Georgia O'Keeffe and himself.

designs an Aboriginal-art-inspired cover for *Art in Australia* and writes 'The Indigenous art of Australia', about the use of Aboriginal art motifs and colours for national art

journeys with her husband throughout Southeast Asia

exhibits work in the group show The Younger Group of Artists at Anthony Hordern's Gallery in Sydney

SELECTED WORLD AND ART EVENTS	GEORGIA O'KEEFFE	MARGARET PRESTON	GRACE COSSINGTON SMITH
1926	addresses the National Women's Party convention in Washington DC, where Constantin Brancusi praises O'Keeffe's paintings: 'There is no imitation of Europe here; it is a force, a liberating free force'	commences publishing travelogues in contemporary journals publishes a guide to woodblock printing techniques holds her first major solo exhibition of woodblock prints at Dunster Galleries, Adelaide	finishes studies at Dattilo-Rubbo's studio and enters a distinct and highly colouristic phase of her practice produces many paintings based on subjects from around her home in Turramurra, the Sydney Harbour Bridge constructions, landscapes and seascapes
1927	The Brooklyn Museum, New York, holds a survey of O'Keeffe's work. undergoes surgery to remove a breast tumour re-enters hospital for surgery again six months later and has a slow recovery from the second operation	publishes 'What is to be our national art' for the magazine *Undergrowth* spends six weeks travelling through the Northern Territory The Margaret Preston issue of *Art in Australia* is published, including her autobiographical essay 'From eggs to Electrolux', which tells of her conversion to modern art.	submits work to the Contemporary Group, established by Thea Proctor and Roland Wakelin the previous year works as a part-time art teacher at Turramurra College until 1928 and joins the Turramurra Wall Painters Group, founded by friend Ethel Anderson to encourage mural painting in Sydney
1928	The first flight across the Pacific from California to Queensland is successfully undertaken.	publishes 'Australian artists versus art', articulating her concern about Australian dependency on the British painting tradition and the impact of American internationalism exhibits across Australia and in London and delivers public lectures receives mastectomy for cancer treatment, recovers in New Caledonia and New Hebrides	holds first solo exhibition at Grosvenor Galleries, Sydney *Things on an Iron Tray on the Floor* c.1928 is reproduced in *Art in Australia*, illustrating an article by Roland Wakelin on the influence of Cézanne.

x

SELECTED WORLD AND ART EVENTS	GEORGIA O'KEEFFE	MARGARET PRESTON	GRACE COSSINGTON SMITH
1929 The stock market crashes in the United States, signalling the beginning of the Great Depression in the industrialised world. The first major exhibition of Australian Aboriginal art is held at the Museum of Victoria, Melbourne.	spends her first summer in New Mexico, inspiring paintings of architecture, crosses, cultural figures, flowers, and trees Stieglitz opens a new gallery at 509 Madison Avenue, New York, which he names An American Place.	holds solo exhibition at Grosvenor Galleries, Sydney *Margaret Preston Recent Paintings 1929* is published, featuring a colour portfolio and '92 aphorisms by Margaret Preston and others', which reveals her artistic orientation toward abstract values. on the invitation of the Trustees of the Art Gallery of New South Wales, paints her self portrait for the collection; the first woman and first modern artist to do so	
1930 After returning from a period of studying cubist theories in France, modernist artist Dorrit Black opens the Modern Art Centre in Sydney.	spends her second summer in New Mexico		*Landscape at Pentecost* and *The Bridge in Building* are singled out by reviewers of the Group of Seven show at Macquarie Galleries, Sydney.
1931 The first contemporary all Australian art exhibition is held at Roerich Museum, New York, including two paintings by Preston.	begins to paint skulls and bones		Her mother, Grace Smith, dies in April. accompanies her family to Thirroul on the coast south of Sydney in May and paints land and seascapes
1932 The Sydney Harbour Bridge opens.	travels in Gaspé area of Canada	moves to the bushland suburb of Berowra, 40 kilometres north of Sydney produces works based on the wildflowers of the area, and her style shifts to a more solid realism and subdued palette contributes paintings to Sydney Harbour Bridge celebrations, but later condemns the bridge as an example of 'Meccano' ideals	begins to hold solo exhibitions every three to four years at Macquarie Galleries, Sydney exhibits works at Dorrit Black's Modern Art Centre in Sydney has her first – and only – exhibition in London at Walker's Gallery in Bond Street, with Lionel and Frances Crawshaw

SELECTED WORLD AND ART EVENTS	GEORGIA O'KEEFFE	MARGARET PRESTON	GRACE COSSINGTON SMITH
1933 United States President Franklin D. Roosevelt inaugurates the Public Works of Art Project, a federal relief program for artists.		travels with her husband to the Pacific Islands for two months, following Gauguin's travels exhibits at Sedon Gallery, Melbourne	
1934	first visits Ghost Ranch, north of Abiquiú in New Mexico, and begins to paint the high desert land formations The Metropolitan Museum of Art purchases their first O'Keeffe painting.	travels with husband to China, Hong Kong, Seoul and Japan takes woodblock printing classes with the son of Hiroshige in Kyoto	
1935 The Works Progress Administration established for visual artists, writers, and musicians in the United States.	Whitney Museum of American Art opens the exhibition Abstract Painting in America, which includes five paintings by O'Keeffe. paints *Ram's Head, White Hollyhock–Hills*, her first image combining bones and landscape	lectures on 'Primitive craftwork of China, Japan, New Guinea etc' at the Society of Arts and Crafts	paints *The Lacquer Room*, which has since been described as a quintessential portrait of Sydney's interwar modernity
1936 The Museum of Modern Art, New York, opens Cubism and Abstract Art.		Harold Cazneaux produces a photographic essay on Preston at her home in Berowra, which is published in *The Australian Home Beautiful* in February 1937.	
1937		travels to the United States, South America and Mexico, following her interest in constructions of nationalism in the art of these countries, later publishing and lecturing on American Art and the New Deal exhibits in the Australian Pavilion of the Paris Exposition	

	SELECTED WORLD AND ART EVENTS	GEORGIA O'KEEFFE	MARGARET PRESTON	GRACE COSSINGTON SMITH
1938	150 Years of Australian Art exhibition in Sydney includes paintings by Cossington Smith and Preston. *Australian Aboriginal Decorative Art* by Frederick McCarthy becomes available to a mainstream audience.	receives honorary Doctor of Fine Arts degree from the College of William and Mary, Virginia, the first of many similar awards	becomes a founding member of the Australian Academy of Art lectures on her travels to Central and South America at the Society of Arts and Crafts, Sydney accepts a lecturing appointment at the Art Gallery of New South Wales, sponsored by the Carnegie Corporation, New York, and delivers five art history lectures	becomes head of the household, following the death of her father moves her studio into the main house, adjacent to her bedroom travels frequently to the countryside to paint with Helen Stewart, Enid Cambridge, and Treania Smith
1939	Picasso's painting *Guernica* 1937 shows in New York, Los Angeles, and Chicago. The *Herald* Exhibition of French and British Contemporary Art tours Australian cities. Major works by Cézanne, Van Gogh, Gauguin, Matisse and Picasso are seen in Australia for the first time. World War II breaks out. Australia joins after the invasion of Poland, declaring war on Germany on 3 September.	travels to Hawaii on commission from Dole Pineapple Company	visits Hungary, Poland, and Russia moves from Berowra back to Mosman, Sydney	
1940		purchases Rancho de los Burros house, Ghost Ranch	visits Aboriginal communities in Queensland, the Northern Territory, and Western Australia, with permission to travel to Aboriginal reserves to view rock art sites publishes 'Paintings in Arnhem land' in *Art and Australia*	volunteers as an air-raid warden and patrols the night streets in uniform Museums around Australia start collecting her work.

SELECTED WORLD AND ART EVENTS	GEORGIA O'KEEFFE	MARGARET PRESTON	GRACE COSSINGTON SMITH
1941 United States enters World War II after the Japanese attack Pearl Harbour. The Art of Australia 1788–1941 exhibition opens under the auspices of the Carnegie Corporation in Washington DC, inclusive of works by Preston and Cossington Smith, and tours to 29 museums in North America and Canada in 1941–45.	begins painting 240 kilometres west of Ghost Ranch at a site she calls the 'black place'	studies newly identified Aboriginal rock sites around the Sydney region travels to the spectacular rock sites of the Olary-Yunta region of South Australia forms part of the advisory committee for An Exhibition of Aboriginal Art and its Application, organised by Frederick McCarthy and the Australian Museum	
1942 A laboratory to develop the atomic bomb is set up at Los Alamos, New Mexico, some 50 kilometers from O'Keeffe's home at Ghost Ranch. Japanese submarines enter Sydney Harbour and torpedo an Australian naval vessel, killing 22 men.	campaigns for an equal rights amendment to the United States Constitution	publishes an essay on 'The orientation of art in the post-war Pacific' State galleries across Australia acquire her paintings.	
1943	holds her first retrospective exhibition (1915–1941) at the Art Institute of Chicago begins a new series based on animal pelvis bones		
1945 Japan surrenders after the United States Army Air Forces drop atomic bombs on Hiroshima and Nagasaki, ending World War II.	purchases an abandoned haçienda in Abiquiú on three acres of land	delivers a national radio talk for the ABC 'Australian artists speak' series	begins painting interiors

	SELECTED WORLD AND ART EVENTS	GEORGIA O'KEEFFE	MARGARET PRESTON	GRACE COSSINGTON SMITH
1946		Alfred Stieglitz dies on 13 July. O'Keeffe spends the majority of the next two years in New York settling his estate. A second O'Keeffe retrospective is held at the Museum of Modern Art, New York; the museum's first solo show to honour a woman.	includes paintings and monotypes in the UNESCO Exposition Internationale d'Art in Paris includes work in the Exhibition of Australian Women Painters at the Art Gallery of New South Wales in conjunction with the second international conference of the Australian Women's Charter	
1947	The House Committee on Un-American Activities black lists Hollywood writers, directors, and actors.		embarks on a 16, 000 km overland journey through Queensland, Central Australia, the Northern Territory and Western Australia by utility and plane to view Aboriginal art and rock painting and carving sites	becomes a member of the Society of Artists in Sydney
1948	The American–Australian Scientific Expedition to Arnhem Land is supported by the Australian Museum, the Institute of Anatomy in Canberra, the National Geographic Society and the Smithsonian Institute.	paints abstractions of her Abiquiú patio centered on the salita door		travels to England with sisters Mabel and Diddy
1949	*Life* magazine publishes 'Jackson Pollock: is he the greatest living painter in the United States?' Simone de Beauvoir publishes *The Second Sex*.	leaves New York to make New Mexico her permanent home	*Margaret Preston's Monotypes* is published, including an essay by Preston discussing the relationship between her process and Aboriginal art. becomes a member of the Australian UNESCO Committee for Visual Arts	travels onto Italy and then back to England
1950			travels through Europe and Morocco	

	SELECTED WORLD AND ART EVENTS	GEORGIA O'KEEFFE	MARGARET PRESTON	GRACE COSSINGTON SMITH
1951		begins to travel internationally, first to Mexico with writer Spud Johnson, where she meets artists Diego Rivera and Frida Kahlo in Mexico City and visits friends Rosa and Miguel Covarrubias		returns to Sydney
1952			guest judges the Mosman Art Prize and awards Grace Cossington Smith, stating her decision was based on art representative of Australia	receives Mosman Art Prize for *Gum Blossom and Drapery* 1952
1953		visits Europe for the first time, travelling to France, Germany, and Spain	holds her last major solo exhibition at Macquarie Galleries, opened by art historian Bernard Smith	Her sister, Diddy, has a stroke and is hospitalised for two years; she visits often.
1954			travels for six months to Europe and the Middle East	paints the first of her large interiors
1955	The Vietnam war is initiated by the United States Government, lasting until 1975.			cares for her sister Diddy at home
1956		travels to Peru for three months		
1957			at age 82, travels widely to destinations including Uganda, the Congo, Rhodesia, and South Africa, and makes her final trip, which is to India	
1958			delivers last lecture, 'Aboriginal paintings – Arnhem Land', at the Art Gallery of New South Wales	
1959		goes on the first of several trips around the world, visiting Japan, Hong Kong, India, Singapore, Southeast Asia, Egypt, Iran, Syria, Israel, and Rome		

SELECTED WORLD AND ART EVENTS	GEORGIA O'KEEFFE	MARGARET PRESTON	GRACE COSSINGTON SMITH

1960
The Australian Aboriginal Art exhibition curated by Tony Tuckson is the first of its kind to tour Australian state galleries (1960–61).

takes a six-week trip to Japan, Taiwan, Hong Kong, and other destinations in Asia and the Pacific Islands

The Art Gallery of New South Wales purchases *The Sock Knitter*.

1961
is made a life member of the New South Wales Society of Artists

1962
Australia joins the Vietnam War.

John Glenn Junior is the first American to orbit the earth.

Art historian Bernard Smith publishes *Australian Painting 1788–1960*, bringing public attention to Grace Cossington Smith.

receives a nomination to the prestigious American Academy of Arts and Letters

1963
Betty Friedan publishes *The Feminine Mystique*.

travels to Greece, Egypt, and the Near East

dies in Mosman Private Hospital, aged 88

1964
The Beatles tour Australia.

Macquarie Galleries holds solo exhibitions of her interior paintings in 1964, 1967 and 1968.

1966
creates the largest painting of her career, *Sky Above the Clouds IV*

1967
The Museum of Modern Art's Two Decades of American Painting tours to Melbourne and Sydney.

A referendum granting Aboriginal people the same constitutional rights as other Australians is successful.

Vogue magazine publishes an article about O'Keeffe describing her work as an antecedent to colourfield abstraction.

Daniel Thomas, the newly appointed curator at the Art Gallery of New South Wales, begins visiting Cossington Smith, and publishes the first major article on her work in *Art in Australia*.

'I have always wanted, and my aim had always been to express form in colour – colour within colour, vibrant with light'.

	SELECTED WORLD AND ART EVENTS	GEORGIA O'KEEFFE	MARGARET PRESTON	GRACE COSSINGTON SMITH
1968		*Life* magazine features O'Keeffe on the cover and an article 'Georgia O'Keeffe in New Mexico: stark visions of a pioneer painter'.		holds sell out exhibition at Macquarie Galleries
1970	Germaine Greer publishes *The Female Eunuch*.	A major retrospective is held at the Whitney Museum of American Art, New York.		
1971		loses her central vision due to Macular degeneration		
1972		completes her last unassisted oil painting, *The Beyond*		
1973	United States withdraws troops from Vietnam. Australian troops also withdraw. The Sydney Opera House opens.			The Art Gallery of New South Wales organises the first retrospective of her work, which travels to all Australian capital cities. awarded an Order of the British Empire for dedication and services to art
1974		travels to Morocco		
1976		Viking Press publishes *Georgia O'Keeffe*, a monograph that features 108 reproductions and autobiographical text. travels to Antigua		
1977		receives the Medal of Freedom from President Gerald R. Ford, the highest civilian award in the United States		

	SELECTED WORLD AND ART EVENTS	GEORGIA O'KEEFFE	MARGARET PRESTON	GRACE COSSINGTON SMITH
1978		Georgia O'Keeffe: a Portrait by Alfred Stieglitz opens at the Metropolitan Museum of Art, New York. O'Keeffe writes the catalogue that includes images not previously published.		after a long stay in hospital, moves to the Milton Nursing Home
1979		travels to Costa Rica and Guatemala		
1980		*Portrait of an Artist: a Biography of Georgia O'Keeffe* by Laurie Lisle is published.		
1982		returns to Hawaii Her large abstract sculpture is included in a show of American sculptors at the San Francisco Museum of Modern Art.		
1983		at age 96, makes her last international trip, to Costa Rica		receives an Order of Australia
1984				dies in Roseville on 20 December, aged 92
1985		receives the National Medal of Arts from President Ronald Reagan		
1986		dies on 6 March at St Vincent's Hospital in Santa Fe aged 98; her ashes are scattered over the landscape of northern New Mexico		

Images: Alfred Stieglitz *Georgia O'Keeffe* 1918 (detail), platinum print, 23.5 x 18.4 cm, Georgia O'Keeffe Museum, Santa Fe, gift of the Georgia O'Keeffe Foundation; **Margaret Preston aged 19**, 1894 (detail), photographer unknown, National Gallery of Australia, Canberra; **Grace Cossington Smith** c.1930-40 (detail), photographer unknown, Australian War Memorial, Canberra 8522207

Notes

Introduction

1 Margaret Preston quoted in Ann Stephen, Andrew McNamara, and Philip Goad (eds), *Modernism and Australia: Art, Design and Architecture 1917-1967*, Melbourne University Publishing, Melbourne, 2007, p. 67.

2 Georgia O'Keeffe, *Georgia O'Keeffe*, Viking Press, New York, NY, 1976, n.p.

3 Grace Cossington Smith, 'Artist's comment', in Mervyn Horton, *Present Day Art in Australia*, Ure Smith, Sydney, 1969, p. 203.

4 Georgia O'Keeffe quoted in Whitney Chadwick, *Women, Art, and Society*, Thames & Hudson, New York, NY, 1990, p. 303.

5 In the United States there is a tendency to use 'American' as synonymous with 'of the United States', ignoring the fact that many other peoples throughout North, South, and Central America rightfully also identify themselves as American. When used as an artistic period style, as in 'American Modernism', the term is admittedly confusing. In this context, we refer to the art of the United States. The irony, of course, is that one of the overriding points of this project is to think about modernism less in terms of nationalist bounds and more as a global confluence of ideas.

Georgia O'Keeffe
Ram's Head, Blue Morning Glory 1938

1 See Lesley Poling-Kempes, 'A call to place', in Barbara Buhler Lynes, Lesley Poling-Kempes and Frederick W. Turner, *Georgia O'Keeffe and New Mexico: A Sense of Place*, Princeton University Press, NJ, 2004, p. 78.

2 Artist's statement in Hunter Drohojowska-Philp, *Full Bloom: The Art and Life of Georgia O'Keeffe*, W.W. Norton & Co., New York, NY, 2004, p. 332.

3 Hunter Drohojowska-Philp, 2004, p. 336. This is part of O'Keeffe's artist statement in the exhibition brochure for her 1931 exhibition Georgia O'Keeffe: 33 New Paintings (New Mexico) at Alfred Stieglitz's gallery An American Place, 27 December 1931 – 31 January 1932.

4 Hunter Drohojowska-Philp, 2004, p. 380.

5 Hunter Drohojowska-Philp, 2004, p. 380.

6 Lewis Mumford quoted in Hunter Drohojowska-Philp, 2004, p. 363.

Margaret Preston
Implement Blue 1927

1 William Preston quoted in Humphrey McQueen, 'An enemy of the dull', *Hemisphere* (Sydney), vol. 20, no. 8, August 1976, p. 36.

Grace Cossington Smith
Sydney Harbour Bridge series 1928-30

1 Grace Cossington Smith recalled her great affection for the Sydney Harbour Bridge. See Drusilla Modjeska,

Stravinsky's Lunch, Picador, Sydney, 1999, p. 281.

2 Grace Cossington Smith in interview with Alan Roberts, quoted in Deborah Hart, *Grace Cossington Smith*, exh. cat., National Gallery of Australia, Canberra, 2005, p. 132.

3 Grace Cossington Smith quoted in Daniel Thomas, *Grace Cossington Smith*, exh. cat., Art Gallery of New South Wales, Sydney, 1973, p. 7.

4 Deborah Hart, 2005, p. 132.

5 Beatrice Irwin, *The New Science of Colour* (1915) William Rider and Son, London, 1923. Cossington Smith was interested in the transformative potential of colour from her student days. In *The Bridge in Building* her use of flame rose, orange and mauve reflects colours that Irwin thought of as 'spiritual stimulants'. I discuss the relevance of Irwin in greater depth in *Grace Cossington Smith*, 2005. Roy de Maistre quoted Irwin's description of colour as 'the very song of life' in the catalogue for the landmark Colour in Art exhibition.

6 Bruce James, *Grace Cossington Smith*, Craftsman House, Sydney, 1990, p. 67.

7 Bethia Foott, *Ethel and the Governors General*, Rainforest Publishing, Sydney, pp. 128–30, quoted in Deborah Hart, 2005, p. 28.

8 Cossington Smith suspected that the Society's president Sydney Ure Smith was responsible for the decision, and remembered being 'very downcast' about it. The painting was acquired by the National Gallery of Victoria in 1967.

9 Barry Pearce quoted in Deborah Hart, 2005, p. 133. The work was acquired by the Art Gallery of New South Wales in 1991.

10 *The Bridge in Building* was generously gifted to the National Gallery of Australia by Ellen Waugh in 2005.

The modern art of painting flowers: reinventing the still life

1 Margaret Preston, Aphorism no. 46, in '92 aphorisms by Margaret Preston and others', Sydney Ure Smith and Leon Gellert (eds), *Margaret Preston: Recent Paintings*, Art in Australia, Sydney, 1929, n.p.

2 Deborah Edwards and Rose Peel with Denise Mimmocchi, *Margaret Preston*, Thames & Hudson, Sydney, 2016, p. 7.

3 That said, Arthur Streeton and Tom Roberts along with a number of establishment artists such as Hans Heysen, Elioth Gruner and George Lambert also painted still lifes that were successful commercially, though the genre wasn't their primary interest.

4 Lionel Lindsay, 'Heysen's flower pieces', *Art in Australia* (Sydney), third series, no. 11, June 1925, n.p.

5 Norman Bryson, *Looking at the Overlooked: Four Essays on Still Life Painting*, Reaktion Books, London, 1990.

6 Maurice Denis, 'Cézanne', trans. Roger Fry, *The Burlington Magazine* (London), vol. 16, no. 82, January 1910, p. 214.

7 T.J. Clark, *Farewell to an Idea: Episodes from the History of Modernism*, Yale University Press, New Haven, CT/London, 1999, p. 10.

8 T.J. Clark, 'Origins of the present crisis', *New Left Review 2*, March–April 2002, p. 3, https://newleftreview.org/II/2/t-j-clark-origins-of-the-present-crisis, accessed 27 May 2016.

9 Romy Golan, preface, *Modernity and Nostalgia: Art and Politics in France Between the Wars*, Yale University Press, New Haven/London, 1995, p. x.

10 Thanks to Carolyn Kastner for bringing this to my attention.

11 Henry David Thoreau, journal entry, 22 October 1839, published in Odell Shepard (ed.), *The Heart of Thoreau's Journals*, Dover Publications, New York, NY, 1961, p. 9.

12 In the book accompanying the 2013–14 exhibition Modern Nature: Georgia O'Keeffe and Lake George, curator Erin B. Coe counters this prevailing view and provides a more nuanced and balanced reading of the artist's time spent at Lake George over the years. Erin B. Coe, Gwendolyn Owens and Bruce Robertson, *Modern Nature: Georgia O'Keeffe and Lake George*, Thames & Hudson, New York, NY, 2013.

13 The creative agency Burbank demonstrated in botany has been compared to that of an artist, due to his passion for perfecting form and selecting the perfect hues for his palette. See Erin B. Coe, '"Something so perfect": Georgia O'Keeffe and Lake George', in Coe, Owens and Robertson, 2013, p. 51; Randolph Griffey, 'Reconsidering the soil: the Stieglitz circle, the regionalists, and cultural eugenics in the twenties', in Teresa A. Carbone (ed.), *Youth and Beauty: Art of the American Twenties*, Skira Rizzoli, New York, NY, 2011; Jane S. Smith, *The Garden of Invention: Luther Burbank and the Business of Breeding Plants*, Penguin, New York, NY, 2009.

14 Bruce Robertson, '"The force that through the green fuse …": Georgia O'Keeffe and nature', in Coe, Owens and Robertson, 2013, p. 76.

15 Wanda M. Corn, *The Great American Thing: Modern Art and National Identity, 1915–1935*, University of California Press, Berkeley and Los Angeles, CA, 1999, p. 271.

16 The artist Peter Tyndall has pointed out that the horns in this painting appear more like that of a goat (often upturned) than a ram (usually curled back around the head) – bringing an interesting point to bear on O'Keeffe's emphasis in her skull pictures. Symbolic of Spanish and white pastoralism and their trophy aesthetic rather than Indigenous interests, her motifs could thus be construed as connecting her to the white history of the region rather than the Pueblo, Apache and Navajo peoples and desert cultures of the land itself. Carolyn Kastner points out that the effect that Tyndall describes may be a result of O'Keeffe flattening and foreshortening the spiral of the horns on the painted canvas, however the origin of the original skull which served as the model for this painting is ambiguous. Letter from Peter Tyndall to Linda Michael, 10 June 2016, Heide Museum of Modern Art archive. Email from Carolyn Kastner to Lesley Harding, 5 August 2016.

17 Wanda M. Corn, 1999, p. 279.

18 Georgia O'Keeffe, 'About myself', in *Georgia O'Keeffe: Exhibition of Oils and Pastels*, An American Place, New York, NY, 1939, quoted in 'Georgia O'Keeffe in her own words', *Tate Etc* (London), issue 37, summer 2016, p. 68.

19 Grace Cossington Smith in interview with Alan Roberts, 9 January 1970, quoted in Deborah Hart (ed.), *Grace Cossington Smith*, exh. cat., National Gallery of Australia, Canberra, 2005, p. 12.

20 Grace Cossington Smith quoted in Daniel Thomas, *Grace Cossington Smith*, exh. cat., Art Gallery of New South Wales, Sydney, 1973, p. 6.

21 Mary Eagle, 'The search for order between the wars', in Mary Eagle and John Jones, *A Story of Australian Painting*, Macmillan, Sydney, 1994, p. 162.

22 Ethel Anderson, 'Happy pictures', *The Sydney Morning Herald*, 11 August 1928, p. 11. It is telling of Cossington Smith's resolve that she continued on her path in the face of an oppositional but equally metaphoric review for the *Evening News* (Sydney), in which the art critic condemned one landscape as 'a lot of green frogs hanging out to dry', and another as 'a wheat elevator in the wilderness'. George Galway, 'Modernist again. Dodging true art', *The Evening News* (Sydney), 24 July 1928. For further discussion of the reception of this landmark exhibition, see Bruce James, *Grace Cossington Smith*, Craftsman House, Sydney, 1990 and Drusilla Modjeska, *Stravinsky's Lunch*, Picador, Sydney, 1999, p. 205.

23 Drusilla Modjeska, 1999, p. 287.

24 Bruce James, 1990, p. 90.

25 Bruce James, 1990, p. 90.

26 Arthur Dow, 'A note on Japanese art and on what the American artist may learn there', *The Knight Errant* (New York), vol. 1, no. 2, January 1893, pp. 114–15.

27 Margaret Preston, 'An Exhibition 1933', *Manuscripts* (Geelong), no. 4, February 1933, p. 45.

28 Thea Proctor and Margaret Preston, 'The gentle art of arranging flowers', *The Home* (Sydney), 1 June 1924, p. 39.

29 Margaret Preston quoted in Nora Cooper, 'Margaret Preston at home', *The Australian Home Beautiful* (Melbourne), 1 February 1937, pp. 31–32.

30 Grace Cossington Smith quoted in Drusilla Modjeska, 1999, p. 337.

31 The term is T.J. Clark's in 'Origins of the present crisis', 2002, p. 3.

Georgia O'Keeffe
The Black Iris 1926

1 For the critical discourse generated by Alfred Stieglitz and critics of his circle, see Barbara Buhler Lynes, *O'Keeffe, Stieglitz and the Critics: 1916–1929*, University of Chicago Press, Chicago/London, 1989. For the responses to the 1926 and 1927 exhibitions, see pp. 240–73.

2 On the role of feminine embodiment in O'Keeffe's works and their reciprocity with the putative masculine aesthetics of Dove and John Marin, which Stieglitz's stable of critics

crafted in the early 1920s, see Marcia Brennan, *Painting Gender, Constructing Theory: The Alfred Stieglitz Circle and American Formalist Aesthetics*, MIT Press, Cambridge, MS, 2001; on O'Keeffe's own developing stance toward her floral imagery over the decade of the 1920s, see Kathleen Pyne, *Modernism and the Feminine Voice: O'Keeffe and the Women of the Stieglitz Circle*, University of California Press, Berkeley/London, 2007; also Barbara Buhler Lynes, 'Georgia O'Keeffe and feminism: a problem of position', in Norma Broude and Mary D. Garrard (eds), *The Expanding Discourse*, Harper Collins; Icon Editions, New York, 1992, pp. 437–50.

3 Barbara Buhler Lynes, *Georgia O'Keeffe: Catalogue Raisonné*, Yale University Press, New Haven, CT, 1999, see nos 556–58 and 602–03, pp. 315–17, 351–52.

4 Statement in *Fifty Recent Paintings, by Georgia O'Keeffe*, exh. cat., The Intimate Gallery, New York, 11 February – 3 April 1926, n.p., reprinted in Barbara Buhler Lynes, 1989, p. 240.

5 It is widely acknowledged that this compositional strategy was learned from her training with Arthur Dow at Columbia College, in 1915; see Sarah Whitaker Peters, *Becoming O'Keeffe: The Early Years*, Abbeville Press, New York, 2001; Elizabeth Turner, *Georgia O'Keeffe: The Poetry of Things*, Phillips Collection, Washington, DC/Yale University Press, New Haven, CT, 1999; and Kathleen Pyne, 2007, pp. 245–29. On the commonplace of Dow's teaching among O'Keeffe's photographer peers at 291, which produced a similar effect in her work to that of these photographers, see Kathleen Pyne, 'Embodied intelligence in the Stieglitz circle', in Barbara Buhler Lynes and Jonathan Weinberg (eds), *Shared Intelligence: American Painting and the Photograph*, University of California Press, Berkeley/London, 2011, pp. 58–79.

6 For O'Keeffe's acknowledgement of the value of linear velocity to the effect of her compositions, see 'Notes on an interview with Frances O'Brien', typescript of an interview by Nancy Wall, taped 29 March 1986 – 2 May 1987, file #OB2300, Library, Georgia O'Keeffe Museum Research Centre.

Unveiling nature: landscape in the 'epoch of the Spiritual'

1 'The veil enveloping the spirit in matter is sometimes so thick that few men are generally able to discern it', Wassily Kandinsky, 'Sur la question de la forme' (*L'almanach du Blaue Reiter* 1912), translation quoted in Jean-Claude Lebensztejn, 'Passage: note on the ideology of early abstraction' in Terence Maloon (ed.), *Paths to Abstraction 1867–1917*, exh. cat., Art Gallery of New South Wales, Sydney, 2010, p. 38. The 'veil' or 'skin' of nature concealing spiritual realities was a concept often referred to by Kandinsky as well as his contemporaries Franz Marc, Piet Mondrian and Robert Delaunay.

2 Bruce James, *Grace Cossington Smith*, Craftsman House, Sydney, 1990, p. 67.

3 Grace Cossington Smith, 'Artist's comment', in Mervyn Horton, *Present Day Art in Australia*, Ure Smith, Sydney, 1969, p. 203.

4 In pursuing her dictum of painting 'colour vibrant with light' Cossington Smith said yellow, 'the colour of the sun', was her favourite pigment. Cossington Smith quoted in Daniel Thomas, *Grace Cossington Smith*, exh. cat., Art Gallery of New South Wales, Sydney, 1973, p. 7.

5 Georgia O'Keeffe to William Milliken, New York, 1 November 1930, in Jack Cowart and Juan Hamilton, with letters selected and annotated by Sarah Greenough, *Georgia O'Keeffe: Art and Letters*, National Gallery of Art, Washington, DC, 1987, p. 202.

6 D.H. Lawrence, 'Studies in classic American literature', 1923, quoted in Wanda M. Corn, *The Great American Thing: Modern Art and National Identity, 1915–1935*, University of California Press, Berkeley/London, 1999, p. 250.

7 Wanda M. Corn, 1990, p. 250. Artists in the Stieglitz circle who developed works from their connections with the landscape included John Marin, Charles Demuth, William Carlos Williams, and Alfred Stieglitz himself.

8 See Deborah Edwards, *Margaret Preston*, Art Gallery of New South Wales, Sydney, 2005, pp. 162–63, p. 174, and Deborah Edwards, with Rose Peel and Hetti Perkins, *Margaret Preston: The Brown Pot 1940, I Lived at Berowra 1941, Grey Day in the Ranges 1941, Australian Collection Focus Series No. 11*, Art Gallery of New South Wales, Sydney, 2002.

9 During the 1920s, Preston began her public campaign for a national art built on Aboriginal-inspired art forms. Her published articles on this subject included 'Arts and crafts: Aboriginal art artfully applied', *The Home* (Sydney), vol. 5, no. 4, December 1924, pp. 30–31; 'Australian artists versus art', *Art in Australia* (Sydney), third series, no. 25, December 1928, n.p.; 'The application of Aboriginal designs', *Art in Australia* (Sydney), third series, no. 31, March 1930, n.p.

10 Preston, too, was aware of the work of anthropologists including Frederick McCarthy, Michael Terry, and Bertha Strehlow, whose discoveries from expeditions during the 1930s added to the broadening awareness within white Australia of the spectacular scope of Aboriginal rock and cave paintings during this decade. See Deborah Edwards, 2005, p. 188.

11 Margaret Preston, 'An art in the beginning', in *Society of Artists' Book*, 1945–46, Ure Smith, Sydney, p. 19.

12 Margaret Preston, Carnegie lecture no. 4, 1938, transcript held in Art Gallery of New South Wales Library and Archive, Sydney.

13 Margaret Preston, 'An art in the beginning', 1945–46, p. 14.

14 Wassily Kandinsky quoted in Maurice Tuchman, *The Spiritual in Art: Abstract Painting 1890–1985*, Los Angeles County Museum of Art, Los Angeles, CA, and Abbeville Press, New York, NY, 1986, p. 11.

15 Elizabeth Johns, 'Landscape painting in America and Australia in an urban century', in Elizabeth Johns, Andrew Sayers, Elizabeth Mankin Kornhauser with Amy Ellis,

New Worlds from Old: 19th Century Australian & American Landscapes, exh. cat., National Gallery of Australia, Canberra and Wadsworth Atheneum, Hartford, CT, 1998, p. 23.

16 Georgia O'Keeffe, *Georgia O'Keeffe*, Viking Press, New York, NY, 1976, n.p. The idea that modern art aspired to the conditions of music was commonly repeated in sources known to the three painters. Each artist had also had direct experiences with the synaesthetic colour–music analogies. O'Keeffe experimented with the idea of painting musical form after she chanced upon a class by Alon Bement in 1912 where he was playing music and asked his students to paint what they heard. Preston had been introduced to the musical values of colour while working in London during the 1910s, and kept sketchbooks on colour–music analogies from around 1917. Cossington Smith had seen her student colleagues Roy de Maistre and Roland Wakelin's joint exhibition Colour in Art in Sydney in 1919, in which they exhibited their 'Colour Syncromy' abstractions.

17 Georgia O'Keeffe, 1976, n.p.

18 Ernest Fenollosa was a major intellectual force in American art in the late nineteenth and early twentieth centuries, during O'Keeffe's formative years as an artist. See Barbara Rose, 'O'Keeffe's trail', *New York Review of Books*, vol. 24, 31 March 1977, p. 30.

19 Arthur Wesley Dow, *Composition: A Series of Exercises in Art Structure for the Use of Students and Teachers*, Double Day, Duran and Co., New York, NY, c.1913, p. 35.

20 Georgia O'Keeffe, 1976, n.p. O'Keeffe here used Dow's phrase which she heard via her teacher Alon Bement at Columbia University Teachers College.

21 'The plains are very wonderful now – like green gold and yellow gold in red gold ... and the distance blue and pink and lavender strips and spots – May sound like a Dow canyon but really its wonderful – specially in the evening', Georgia O'Keeffe, letter to Anita Pollitzer, 30 October 1916, quoted in Clive Giboire (ed.), *Lovingly Georgia: The Complete Correspondence of Georgia O'Keeffe and Anita Pollitzer*, Simon and Schuster, New York, NY, 1990, p. 209. O'Keeffe remained indebted to Dow, citing him as her most significant formative influence: 'I think it was Arthur Dow who affected my start, who helped me find something of my own', interview with Katherine Kuh in *The Artist's Voice: Talks with Seventeen Artists*, Harper & Row, New York, NY/Evanston, IL, 1962, p. 189.

22 Margaret Preston, 'From eggs to Electrolux', *Art in Australia* (Sydney), third series, no. 22, December 1927, n.p.

23 Margaret Preston, 'From eggs to Electrolux', 1927, n.p.

24 Margaret Preston, Carnegie lecture in no. 2, 29 June 1938, transcript held in Art Gallery of New South Wales Library and Archive, Sydney.

25 Paul Strand quoted in Bonnie L. Grad, 'Georgia O'Keeffe's Lawrencean vision', *Archives of American Art Journal* (Washington), vol. 38, no. 3/4, 1998, p. 3.

26 Georgia O'Keeffe, 1976, n.p.

27 The phrase was used by Bruce James in relation to related works from this period. Bruce James, 1990, p. 20.

28 Matisse spoke of the 'will to rhythmic abstraction', see Jack Flam, *Matisse on Art*, University of California Press, Berkeley, CA/London, 1992, p. 272.

29 O'Keeffe would have first known of Bergson's work from the excerpts of his *Laughter* and influential *Creative Evolution* in *Camera Work* in 1911. For a detailed study of the influence of Lawrence, and broader vitalist theories on O'Keeffe, see Bonnie L. Grad, 1998.

30 O'Keeffe returned to 'the black place', as she named the landscape northwest of her home at Ghost Ranch, numerous times and eventually painted its forms from memory in her studio. Georgia O'Keeffe, 1976, n.p.

31 Henri Zerner, *Écrire l'histoire de l'art: Figures d'une discipline*, Gallimard, Paris, 1997, p. 103. Zerner referred to the examples of Kandinsky and Mondrian, who progressively shed representational elements of the landscape in their work to explore an abstract equivalent. My thanks to Peter Raissis for translating this passage from French.

32 Piet Mondrian quoted in Jean-Claude Lebensztejn, 2010, p. 38.

33 Grace Cossington Smith in interview with Hazel de Berg, 16 August 1965, National Library of Australia, Canberra.

34 Virginia Spate, 'Amazing Grace: thoughts inspired by the Grace Cossington Smith exhibition at the National Gallery of Australia, Canberra', *Art Monthly* (Canberra), no. 182, August 2005, p. 28.

35 Margaret Preston, 'Paintings in Arnhem Land', *Art in Australia* (Sydney), third series, no. 81, 25 November 1940, p. 63.

36 'Australian Artists Speak', Margaret Preston interviewed by Sydney Ure Smith, 2FC Radio, Sydney, 3 June 1945, transcript held in Art Gallery of New South Wales Library and Archive, Sydney.

37 Margaret Preston, 'Australian artists versus art', *Art in Australia* (Sydney), third series, no. 26, December 1928, n.p.

38 Georgia O'Keeffe, 1976, n.p.

39 The 'wonderful emptiness' was Georgia O'Keeffe quoted by Anita Pollitzer, 1950, quoted in Charles C. Eldredge, *Georgia O'Keeffe: American and Modern*, Yale University Press, New Haven, CT/London in association with InterCultra, Fort Worth, TX, the Georgia O'Keeffe Foundation, Abiquiú, NM, and the South Bank Centre, London, 1993, p. 196. O'Keeffe wrote of 'the Great American Thing' in Georgia O'Keeffe, 1976, n.p.

40 D.H. Lawrence referred to New Mexico as the 'Genuine America'. D.H. Lawrence, 'New Mexico', *Survey Graphic* (Pittsburgh), May 1931, quoted in Wanda M. Corn, 1999, p. 256.

41 Wanda M. Corn, 1999, pp. 272–84.

42 Barbara Rose provided the reading of O'Keeffe's skulls as 'part of an eternal nature'. See Barbara Rose, 1977, p. 31.

43 Georgia O'Keeffe to Maria Chabot, 17 November 1941, in Barbara Buhler Lynes and Ann Paden (eds), *Maria Chabot – Georgia O'Keeffe: Correspondence, 1941–1949*, University of New Mexico Press and Georgia O'Keeffe Museum, Santa Fe, NM, 2003, p. 12.

Grace Cossington Smith
Landscape at Pentecost 1929

1 *Landscape at Pentecost* is one of four contemporaneous
 works the same size: *The Gully* 1928, 110.5 x 82.5 cm, Kerry
 Stokes Collection, Perth; *The Curve of the Bridge* 1928–29,
 110.5 x 82.5 cm, Art Gallery of New South Wales, Sydney;
 The Bridge in-Curve 1930, 83.6 x 111.8 cm, National Gallery
 of Victoria, Melbourne. The artist returned to painting
 consistently larger works again in the late 1950s and 1960s.
2 The final dynamic composition differs remarkably from
 the artist's preliminary on-the-spot sketch of the subject
 (National Gallery of Australia, Canberra, 76:705.15.22).
 The pencil drawing is quite classical in its upright,
 balanced linearity.
3 Roland Wakelin, 'The modern art movement in Australia',
 Art in Australia (Sydney), December 1928, n.p.
4 Art historian Bruce Adams, who met and interviewed
 Grace Cossington Smith in 1973, provided the author
 with helpful insights, June 2016. Also see Bruce Adams,
 'Innovator in a garden studio', *Hemisphere* (Sydney),
 vol. 17, no. 6, June 1973, p. 7.
5 The use of vibrant colour shows not only the influence of
 Antonio Dattilo-Rubbo's school in Sydney but also the artist's
 admiration for Vincent van Gogh's emotional use of colour,
 for which her teacher affectionately referred to her as
 'Mrs Van Gogh'. As well as suggestions of the French
 moderns, Paul Cézanne, Paul Gauguin and Henri Matisse,
 there is an apparent awareness of British post-impressionists
 like Charles Ginner, Harold Gilman and Spencer Gore.
 Indeed Gore's road subject, *The Icknield Way* of 1912
 (acquired by the Art Gallery of New South Wales in 1962)
 bears an uncanny resemblance to *Landscape at Pentecost*.
6 Grace Cossington Smith, questionnaire for proposed book
 Australian Art of the Seventies, Encyclopedia Britannica, 1971.
 See Daniel Thomas, *Grace Cossington Smith*, exh. cat.,
 Art Gallery of New South Wales, Sydney, 1973, p. 6.

Margaret Preston
Blue Mountains Theme c.1941

1 Sydney Ure Smith, publisher of *Art in Australia*, *The Home*,
 and *Australia National Journal*, commissioned covers from
 Douglas Annand and Paul Haefliger in 1935, and an article
 by Ursula H. McConnel, 'Inspiration and design in Aboriginal
 art', *Art in Australia* (Sydney), vol. 59, 1935, pp. 49–68.
2 Margaret Preston, 'Aboriginal art', *Australia National
 Journal* (Sydney), vol. 2, no. 6, May 1941, p. 12.

Abstraction and the creation of national identity

1 As Leah Dickerman argues, abstraction was a radical idea that
 changed modern art. For a fuller discussion of how artists
 responded to the notion of abstraction theoretically and
 chronologically see Leah Dickerman, *Inventing Abstraction,
 1910–1925: How a Radical Idea Changed Modern Art*, Museum
 of Modern Art, New York, NY, 2013.
2 It is important to note that the discourse of abstraction was
 not linear or progressive and even Kandinsky expressed his
 skepticism of abandoning subject matter altogether in the
 first edition of *Concerning the Spiritual in Art*.
3 In 1911, Kandinsky's painting *Komposition V* ignited a
 transnational conversation on the question of painting
 without a subject. It was a bravura performance of ideas
 and intellectual control over a composition in emotionally
 expressive lines and brilliant colour, manifesting the unlimited
 potential of a limited abstract vocabulary, the same year he
 published *Concerning the Spiritual in Art*, trans. M.T.H. Sadler,
 Houghton Mifflin Company, Boston, MA/New York, NY, 1914.
4 Arthur Wesley Dow, *Composition: Understanding Line, Notan,
 and Colour* (1899), University of California Press, Berkeley,
 CA, 1977. O'Keeffe was introduced to Dow's theories in 1912
 when she was a student of Alon Bement at the University of
 Virginia who was a colleague of Dow's at Columbia University.
5 Clive Giboire, *Lovingly Georgia: The Complete Correspondence
 of Georgia O'Keeffe and Anita Pollitzer*, Simon and Schuster,
 New York, NY, 1990, p. 10. O'Keeffe describes reading Arthur
 Jerome Eddy, *Cubists and Post-Impressionism* (1914) that
 included reproductions of the work of Pablo Picasso, Wassily
 Kandinsky, and Arthur Dove. Georgia O'Keeffe's annotated
 copy of Beatrice Irwin's book *The New Science of Colour*,
 William Rider and Sons, London, 1916, is in the archives of
 the Georgia O'Keeffe Museum, a book so important to
 Grace Cossington Smith that she transcribed it, according
 to Deborah Hart (ed.), *Grace Cossington Smith*, exh. cat.,
 National Gallery of Australia, Canberra, 2005, p. 18.
6 Georgia O'Keeffe, *Some Memories of Drawings*, University of
 New Mexico Press, Albuquerque, NM, 1974, n.p.
7 For a description of the critical reception of the work see
 Deborah Hart, 2005, p. 32.
8 Georgia O'Keeffe, *Georgia O'Keeffe*, Viking Press,
 New York, NY, 1976, n.p.
9 Grace Cossington Smith in interview with Hazel de Berg,
 16 August 1965, quoted in Deborah Hart, 2005, p. 82.
10 Georgia O'Keeffe, 1976, n.p.
11 Georgia O'Keeffe quoted in Katharine Kuh, *The Artist's
 Voice: Talks with Seventeen Modern Artists*, Harper & Row,
 New York, NY, 1962, p. 190.
12 Ramona Sakiestewa, 'Katsinam: memories and reflections',
 in Barbara Buhler Lynes and Carolyn Kastner (eds), *Georgia
 O'Keeffe and New Mexico: Architecture, Katsinam and the Land*,
 exh. cat., Museum of New Mexico Press, Santa Fe, NM, 2012, p. 128.
13 Partha Mitter, 'Reflections on modern art and national identity
 in colonial India', in Kobena Mercer (ed.), *Cosmopolitan
 Modernisms*, MIT Press, Cambridge, MA, 2005, p. 39.
 Mitter suggests this shared interest among artists, writers
 and intellectuals who don't even know one another is an
 important part of a global contemporary discourse.

14 Ruth B. Phillips, 'Aesthetic primitivism revisited: the global diaspora of "primitive art" and the rise of Indigenous modernisms', *Journal of Art Historiography* (Birmingham), no. 12, June 2015, p. 6.
15 Ruth B. Phillips, 2015, p. 18.
16 Margaret Preston, 'What do we want for the New Year?' *Woman*, 5 January 1953, quoted in Art Gallery of New South Wales, 1 June 2016: http://www.artgallery.nsw.gov.au/sub/preston/artist_1950.html.
17 Ruth B. Phillips, 2015, pp. 9–10.

Margaret Preston
Aboriginal Landscape 1941

1 Margaret Preston, 'Aboriginal art artfully applied', originally published in *The Home* (Sydney), vol. 5, no. 5, December 1924, pp. 30–31.
2 Margaret Preston, 1924, p. 31.
3 Margaret Preston, 1924, p. 31.
4 Margaret Preston, 'Paintings in Arnhem Land', *Art and Australia* (Sydney), vol. 81, 25 November 1940, p. 62.
5 Margaret Preston, 'New development in Australian art', *Australia National Journal* (Sydney), vol. 2, no. 6, May 1941, p. 13.
6 Djon Mundine, 'Aboriginal Still Life', in Deborah Edwards, Rose Peel with Denise Mimmocchi, *Margaret Preston*, Art Gallery of New South Wales, Sydney, 2005, p. 194.

Grace Cossington Smith
Black Mountain c.1931

1 Ethel Anderson, a Sydney-based art writer and art patron, was the contact as wife of the New South Wales State Governor's secretary. She supported Cossington Smith's work, hosting a group exhibition of the new 'movement' which included work by Roland Wakelin and Cossington Smith at her home in 1931. See Bruce James, *Grace Cossington Smith*, Craftsman House, Sydney, 1990, p. 93.
2 Grace Cossington Smith in interview with Alan Roberts, 28 April 1970, quoted by Deborah Hart, *Grace Cossington Smith*, exh. cat., National Gallery of Australia, Canberra, 2005, p. 10.
3 Quoted by Deborah Hart, 2005, p. 30.
4 Deborah Hart, 2005, p. 97, note 82.
5 Beatrice Irwin quoted by Deborah Hart, p. 28.

Georgia O'Keeffe
Storm Cloud, Lake George 1923

1 Georgia O'Keeffe, *Georgia O'Keeffe*, Viking Press, New York, NY, 1976, n.p.
2 Charles C. Eldredge referred to O'Keeffe's Lake George views as 'exemplifying the distillation of form and force' in *Georgia O'Keeffe*, Harry N. Abrams, New York, NY,

in association with the National Museum of American Art, Smithsonian Institution, Washington, DC, 1991, p. 49.
3 Stieglitz wrote of walking out with O'Keeffe to the village when a storm hit: 'the Sky was black & the Lake black and near the horizon southward there was a dirty yellowish cloud. Georgia said she did not like the feeling – I thought it looked wonderful – it looked as if the day of Judgement had come'. Alfred Stieglitz, letter to Arthur Dove, 3 November 1923, quoted in Erin B. Coe, Gwendolyn Owens and Bruce Robertson, *Modern Nature: Georgia O'Keeffe and Lake George*, Thames & Hudson, New York, NY, 2013, p. 37.
4 In 1919 O'Keeffe was rowing with Stieglitz to Tea Island Bay at Lake George at the time of an unexpected storm. They saw a boat with two young men on board capsize. Stieglitz attempted to save them but only one could be rescued. Coe, Owens and Robertson, 2013, p. 36.

Grace Cossington Smith
Sea Wave 1931

1 This essay is largely based on an excerpt from the essay 'Landscapes of modernity' by Deborah Edwards published in Deborah Edwards and Denise Mimmocchi, *Sydney Moderns: Art for a New World*, exh. cat., Art Gallery of New South Wales, Sydney, 2013.

Georgia O'Keeffe
Blue Line 1919

1 Barbara Haskell, 'Georgia O'Keeffe, making the unknown – known', in Barbara Haskell (ed.), *Georgia O'Keeffe Abstraction*, Whitney Museum of American Art, New York, NY and Yale University Press, New Haven, CT/London, 2009, p. 13.
2 Lisa Mintz Messinger (ed.), *Steiglitz and His Artists: Matisse to O'Keeffe*, Metropolitan Museum of Art, New York, NY, 2011, p. 196.
3 Georgia O'Keeffe, *Georgia O'Keeffe*, Viking Press, New York, NY, 1976, n.p.

Grace Cossington Smith
The Window 1956

1 John Olsen, artist statement, *Contemporary Australian Paintings: Pacific Loan Exhibition*, exh. cat., Orient Line in collaboration with the National Gallery Society of New South Wales, Sydney, n.d. [1956], n.p.

Further reading

Georgia O'Keeffe

Barson, Tanya (ed.), *Georgia O'Keeffe*, exh. cat., Tate Publishing, London, 2016.

Berry, Michael, *Georgia O'Keeffe: Painter*, Chelsea House, New York, 1988.

Bry, Doris (ed.), *Georgia O'Keeffe: Some Memories of Drawings*, University of New Mexico Press, Albuquerque, 1974.

Coe, Erin B., Gwendolyn Owens and Bruce Robertson, *Modern Nature: Georgia O'Keeffe and Lake George*, Thames & Hudson, New York, 2013.

Giboire, Clive, *Lovingly Georgia: The Complete Correspondence of Georgia O'Keeffe and Anita Pollitzer*, Simon & Schuster, New York, 1990.

Greenough, Sarah, *My Faraway One: Selected Letters of Georgia O'Keeffe and Alfred Stieglitz*, Volume One, 1915–1933, Yale University Press, New Haven, 2011.

Haskell, Barbara (ed.), *Georgia O'Keeffe: Abstraction*, Yale University Press, New Haven and London, 2009.

Kandinsky, Wassily, *The Art of Spiritual Harmony*, trans., M.T.H. Sadler, Houghton Mifflin, Boston, 1914.

Kuh, Katharine, *The Artist's Voice: Talks with Seventeen Modern Artists*, Harper & Row, New York, 1962.

Lisle, Laurie, *Portrait of an Artist: A Biography of Georgia O'Keeffe*, Washington Square Press, New York, 1987.

Lynes, Barbara Buhler, *Georgia O'Keeffe: Catalogue Raisonné*, Yale University Press, New Haven, National Gallery of Art, Washington, Georgia O'Keeffe Foundation, Abiquiú, 1999.

Lynes, Barbara Buhler, *O'Keeffe, Stieglitz and the Critics, 1916–1929*, Ann Arbor, UMI Research Preston, Michigan, 1989.

Lynes, Barbara Buhler and Carolyn Kastner, *Georgia O'Keeffe in New Mexico: Architecture, Katsinam, and the Land*, exh. cat., Museum of New Mexico Press and Georgia O'Keeffe Museum, Santa Fe, 2012.

Lynes, Barbara Buhler and Agapita Judy Lopez, *Georgia O'Keeffe and her Houses: Ghost Ranch and Abiquiú*, Harry N. Abrams, New York, 2012.

Lynes, Barbara Buhler and Ann Paden (eds), *Maria Chabot – Georgia O'Keeffe: Correspondence, 1941–1949*, University of New Mexico Press, Albuquerque, 2003.

Lynes, Barbara Buhler, Lesley Poling-Kempes and Frederick W. Turner, *Georgia O'Keeffe and New Mexico: A Sense of Place*, exh. cat., Princeton University Press, Princeton, and Georgia O'Keeffe Museum, Santa Fe, 2004.

O'Keeffe, Georgia, *Georgia O'Keeffe*, Viking Press, New York, 1976. Reprint, Penguin Books, New York, 1985.

Peters, Sarah Whitaker, *Becoming O'Keeffe: The Early Years*, Abbeville Press, New York, 1991.

Pyne, Kathleen, *Modernism and the Feminine Voice: O'Keeffe and the Women of the Stieglitz Circle*, exh. cat., University of California Press, Berkeley, 2007.

Turner, Elizabeth Hutton, *Georgia O'Keeffe: The Poetry of Things*, Yale University Press, New Haven, 1999.

Udall, Sharyn R. Carr, *O'Keeffe, Kahlo: Places of Their Own*, Yale University Press, New Haven, 2000.

Margaret Preston

Butel, Elizabeth, *Margaret Preston: The Art of Constant Rearrangement*, Penguin, Melbourne, 1986.

Butler, Roger, *The Prints of Margaret Preston: A Catalogue Raisonné*, National Gallery of Australia, Canberra, 2005.

Edwards, Deborah and Rose Peel with Denise Mimmocchi, *Margaret Preston*, Art Gallery of New South Wales, Sydney, 2005. Reprint, Thames & Hudson, Sydney, 2016.

Harding, Lesley, *Margaret Preston: Recipes for Food and Art*, Miegunyah Press, Melbourne, 2016.

McQueen, Humphrey, 'An enemy of the dull', *Hemisphere* (Sydney), vol. 20, no. 8, August 1976.

Mimmocchi, Denise and Deborah Edwards, 'Margaret Preston', *Art and Australia* (Sydney), vol. 43, no. 1, spring 2005.

Missingham, Hal, 'Margaret Preston', *Art and Australia* (Sydney), vol. 1, no. 2, August 1963.

North, Ian (ed.), *The Art of Margaret Preston*, Art Gallery Board of South Australia, Adelaide, 1980.

Preston, Margaret, 'From Eggs to Electrolux', *Art in Australia* (Sydney), Margaret Preston number, third series, no. 22, December 1927, n.p.

Ure Smith, Sydney (ed.), *Margaret Preston's Monotypes*, Ure Smith, Sydney, 1949.

Ure Smith, Sydney and Leon Gellert (eds), *Margaret Preston: Recent Paintings*, Art in Australia, Sydney, 1929.

Grace Cossington Smith

Adams, Bruce, 'Innovator in a garden studio', *Hemisphere* (Canberra), vol. 17, no. 6, June 1973.

Hart, Deborah (ed.), *Grace Cossington Smith*, exh. cat., National Gallery of Australia, Canberra, 2005.

James, Bruce, *Grace Cossington Smith*, Craftsman House, Sydney. 1990.

James, Bruce, 'Grace Cossington Smith and photography', *Photofile*, no. 55, November 1998.

Modjeska, Drusilla, *Stravinsky's Lunch*, Picador, Sydney, 1999.

Sayers, Andrew, 'Grace Cossington Smith's sketchbooks', *Art and Australia* (Sydney), winter 1987.

Smith, Grace Cossington, interview with Hazel de Berg, 16 August 1965, recording, National Library of Australia, Canberra.

Thomas, Daniel, 'Grace Cossington Smith', *Art and Australia* (Sydney), vol. 4, no. 4, March 1967.

Thomas, Daniel, *Grace Cossington Smith*, exh. cat., Art Gallery of New South Wales, Sydney, 1973.

Thomas, Daniel, *Grace Cossington Smith: A Life From Drawings in the Collection of the National Gallery of Australia*, exh. cat., National Gallery of Australia, Canberra, 1993.

General

Ambrus, Caroline, *Australian Women Artists. First Fleet to 1945: History, Hearsay and Her Say*, Irrepressible Press, Canberra, 1992.

Bell, Clive, *Art*, Chatto and Windus, London, 1914.

Corn, Wanda M., *The Great American Thing: Modern Art and National Identity, 1915–1935*, University of California Press, Berkeley, 2000.

Dow, Arthur Wesley, *Composition: Understanding Line, Notan, and Colour* (1899), University of California Press, Berkeley, 1977.

Dickerman, Leah (ed.), *Inventing Abstraction, 1910–1925: How a Radical Idea Changed Modern Art*, Museum of Modern Art, New York, 2013.

Eagle, Mary, *Australian Modern Painting between the Wars 1914–1939*, Bay Books, Sydney, 1989.

Eddy, Arthur Jerome, *Cubists and Post-Impressionism*, A.C. McClurg, Chicago, 1914.

Edwards, Deborah and Denise Mimmocchi (eds), *Sydney Moderns: Art for a New World*, exh. cat., Art Gallery of New South Wales, Sydney, 2013.

Grishin, Sasha, *Australian Art: A History*, Miegunyah Press, Melbourne, 2015.

Irwin, Beatrice, *The New Science of Colour*, Union Lithograph Co., California, 1915.

McCaughey, Patrick, *Strange Country: Why Australian Painting Matters*, Miegunyah Press, Melbourne, 2014.

McQueen, Humphrey, *The Black Swan of Trespass: The Emergence of Modernist Painting in Australia to 1944*, Alternative Publishing Cooperative, Sydney, 1979.

Mercer, Kobena (ed.), *Cosmopolitan Modernisms*, MIT Press, Cambridge, 2005.

Phillips, Ruth B., 'Aesthetic primitivism revisited: the global diaspora of primitive art and the rise of Indigenous modernisms', *Journal of Art Historiography*, no. 12, June 2015.

Smith, Bernard, *Modernism's History: A Study in Twentieth-Century Art and Ideas*, Yale University Press, New Haven, 1988.

Smith, Terry, *Transformations in Australian Art: The Twentieth Century – Modernism and Aboriginality*, Craftsman House, Sydney, 2002.

Stephen, Ann, Philip Goad and Andrew McNamara (eds), *Modern Times: The Untold Story of Modernism in Australia*, Miegunyah Press, Melbourne, 2008.

Topliss, Helen, *Modernism and Feminism: Australian Women Artists 1900–1940*, Craftsman House, Sydney, 1996.

List of works

The works are arranged by artist, then chronologically and alphabetically by title.

Titles appear as inscribed by the artist, or when not inscribed, by the first exhibited title. Where the title is unknown, a descriptive title has been assigned and appears in parentheses.

The dates for works have been established by artist inscriptions. When not inscribed they have been attributed circa dates. Works with multiple or a span of dates are located by the first date.

Measurements are in centimetres (to the nearest millimetre), height precedes width. Works on paper dimensions are image sizes.

Works on paper are displayed in Brisbane and Sydney only.

Georgia O'Keeffe

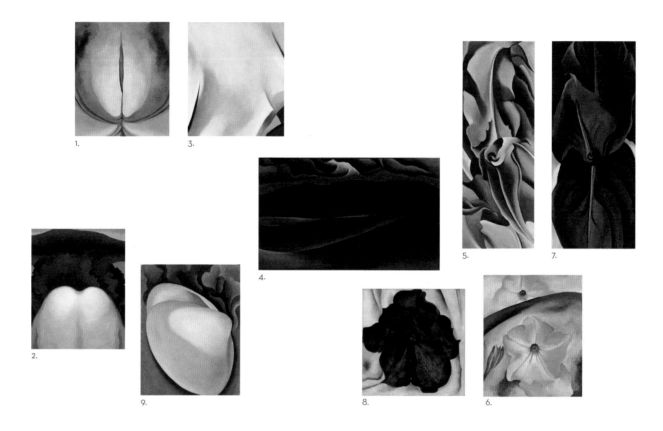

1. **Blue Line** 1919
 oil on canvas, 51.1 x 43.5 cm
 Georgia O'Keeffe Museum, Santa Fe
 Gift of the Burnett Foundation and
 the Georgia O'Keeffe Foundation 1997
 1997.04.004

2. **Series I, No. 10** 1919
 oil on canvas, 51.1 x 40.9 cm
 Georgia O'Keeffe Museum, Santa Fe
 Gift of the Georgia O'Keeffe
 Foundation 2006
 2006.05.086

3. **Series I, No. 12** 1920
 oil on canvas, 50.8 x 41.3 cm
 Georgia O'Keeffe Museum, Santa Fe
 Gift of the Burnett Foundation and
 the Georgia O'Keeffe Foundation 1997
 1997.05.013

4. **Storm Cloud, Lake George** 1923
 oil on canvas, 45.7 x 76.5 cm
 Georgia O'Keeffe Museum, Santa Fe
 Gift of the Burnett Foundation 2007
 2007.01.018

5. **Corn, No. 2** 1924
 oil on canvas, 69.2 x 25.4 cm
 Georgia O'Keeffe Museum, Santa Fe
 Gift of the Burnett Foundation and
 the Georgia O'Keeffe Foundation 1997
 1997.04.006

6. **Petunia No. 2** 1924
 oil on canvas, 91.4 x 76.2 cm
 Georgia O'Keeffe Museum, Santa Fe
 Gift of the Burnett Foundation and
 Gerald and Kathleen Peters 1996
 1996.03.002

7. **Canna Leaves** 1925
 oil on canvas, 66 x 27.9 cm
 Georgia O'Keeffe Museum, Santa Fe
 Gift of the Burnett Foundation 1997
 1997.06.011

8. **Untitled (Purple Petunia)** 1925
 oil on canvas, 18.4 x 18.4 cm
 Georgia O'Keeffe Museum, Santa Fe
 Gift of the Burnett Foundation 2007
 2007.06.021

9. **Tan Clam Shell with Seaweed** 1926
 oil on canvas, 22.9 x 17.8 cm
 Georgia O'Keeffe Museum, Santa Fe
 Gift of the Georgia O'Keeffe
 Foundation 2006
 2006.05.108

Georgia O'Keeffe

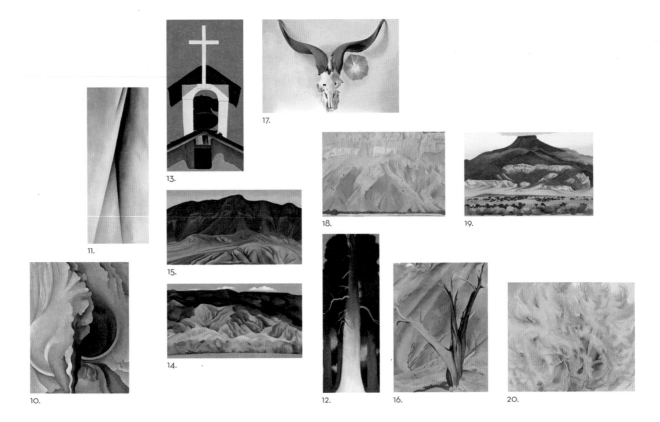

10. **The Black Iris** 1926
oil on canvas, 22.9 x 17.8 cm
Georgia O'Keeffe Museum, Santa Fe
Gift of the Burnett Foundation 2007
2007.01.019

11. **Abstraction White** 1927
oil on canvas, 86.4 x 35.6 cm
Georgia O'Keeffe Museum, Santa Fe
Gift of the Burnett Foundation 2007
2007.01.020

12. **Bear Lake, New Mexico** 1930
oil on canvas, 61 x 22.9 cm
Georgia O'Keeffe Museum, Santa Fe
Gift of the Burnett Foundation 2007
2007.01.022

13. **Church Steeple** 1930
oil on canvas, 76.2 x 40.6 cm
Georgia O'Keeffe Museum, Santa Fe
Gift of the Burnett Foundation 1997
1997.06.017

14. **Back of Marie's No. 4** 1931
oil on canvas, 40.6 x 76.2 cm
Georgia O'Keeffe Museum, Santa Fe
Gift of the Burnett Foundation 1997
1997.06.038

15. **Purple Hills Ghost Ranch –
2/Purple Hills No. II** 1934
oil on canvas on composition board,
41.3 x 76.8 cm
Georgia O'Keeffe Museum, Santa Fe
Gift of the Burnett Foundation 1997
1997.06.020

16. **Gerald's Tree I** 1937
oil on canvas, 101.6 x 76.5 cm
Georgia O'Keeffe Museum, Santa Fe
Gift of the Burnett Foundation 1997
1997.06.035

17. **Ram's Head, Blue Morning Glory** 1938
oil on canvas, 50.8 x 76.2 cm
Georgia O'Keeffe Museum, Santa Fe
Gift of the Burnett Foundation 2007
2007.01.024

18. **Untitled (Red and Yellow Cliffs)** 1940
oil on canvas, 61 x 91.4 cm
Georgia O'Keeffe Museum, Santa Fe
Gift of the Burnett Foundation 1997
1997.06.036

19. **Pedernal** 1941
oil on canvas, 48.3 x 76.8 cm
Georgia O'Keeffe Museum, Santa Fe
Gift of the Georgia O'Keeffe
Foundation 2006
2006.05.172

20. **Cottonwood Tree in Spring** 1943
oil on canvas, 76.2 x 91.4 cm
Georgia O'Keeffe Museum, Santa Fe
Gift of the Burnett Foundation 1997
1997.06.016

Georgia O'Keeffe

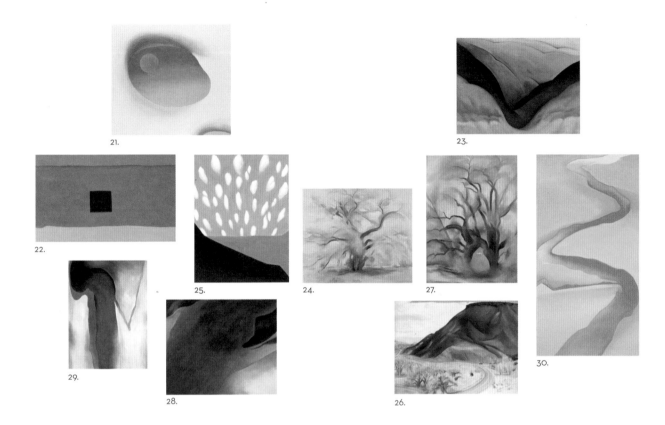

21.

23.

22.

25.

24.

27.

29.

28.

26.

30.

21. **Pelvis IV** 1944
oil on board, 91.4 x 101.6 cm
Georgia O'Keeffe Museum, Santa Fe
Gift of the Burnett Foundation 2007
2007.06.001

22. **In the Patio III** 1948
oil on canvas, 45.7 x 76.2 cm
Georgia O'Keeffe Museum, Santa Fe
Gift of the Georgia O'Keeffe Foundation 2006
2006.05.204

23. **Black Place, Grey and Pink** 1949
oil on canvas, 91.4 x 121.9 cm
Georgia O'Keeffe Museum, Santa Fe
Gift of the Burnett Foundation 1997
1997.06.030

24. **Cottonwoods Near Abiquiú** 1950
oil on canvas, 55.9 x 66 cm
Georgia O'Keeffe Museum, Santa Fe
Gift of the Georgia O'Keeffe Foundation 2006
2006.05.227

25. **In the Patio VIII** 1950
oil on canvas, 66 x 50.8 cm
Georgia O'Keeffe Museum, Santa Fe
Gift of the Burnett Foundation and
the Georgia O'Keeffe Foundation 1997
1997.05.008

26. **Mesa and Road East** 1952
oil on canvas, 66 x 91.4 cm
Georgia O'Keeffe Museum, Santa Fe
Gift of the Georgia O'Keeffe
Foundation 2006
2006.05.234

27. **Winter Cottonwoods East IV** 1954
oil on canvas, 101.6 x 76.2 cm
Georgia O'Keeffe Museum, Santa Fe
Gift of the Georgia O'Keeffe
Foundation 2006
2006.05.248

28. **Blue – A** 1959
oil on canvas, 76.2 x 91.4 cm
Georgia O'Keeffe Museum, Santa Fe
Gift of the Georgia O'Keeffe
Foundation 2006
2006.05.279

29. **Blue Black and Grey** 1960
oil on canvas, 101.6 x 76.2 cm
Georgia O'Keeffe Museum, Santa Fe
Gift of the Burnett Foundation 2007
2007.01.029

30. **Pink and Green** 1960
oil on canvas, 76.2 x 40.6 cm
Georgia O'Keeffe Museum, Santa Fe
Gift of the Burnett Foundation 1997
1997.06.018

Margaret Preston

32.

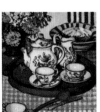

31.

33.

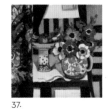

37.

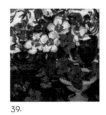

39.

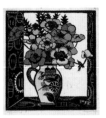

34.

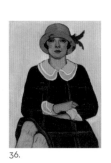

36.

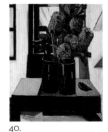

40.

35.

38.

31. **Still Life** 1915
oil on cardboard, 45.5 x 55 cm
Private collection

32. **Still Life** c.1915–16
oil on canvas
48.9 x 48.9 cm
Art Gallery of South Australia, Adelaide
Elder Bequest Fund 1940
0.1196

33. **Thea Proctor's Tea Party** 1924
oil on canvas on hardboard
55.9 x 45.7 cm
Art Gallery of New South Wales, Sydney
Purchased 1942
7215

34. **Anemones** 1925
woodcut, hand-coloured, 38.1 x 35.7 cm
Art Gallery of New South Wales, Sydney
Gift of Mrs Alison Brown 1968
DA15.1968

35. **Circular Quay** 1925
woodcut, hand-coloured, 24.7 x 24.4 cm
Art Gallery of New South Wales, Sydney
Purchased 1964
DA28.1964

36. **Flapper** 1925
oil on canvas, 77.3 x 58.5 cm
National Gallery of Australia, Canberra
Purchased with the assistance of the
Cooma-Monaro Snowy River Fund 1988
88.326

37. **Still Life** 1925
oil on canvas, 50.5 x 50 cm
National Gallery of Australia, Canberra
Purchased 1980
80.1090

38. **Sydney Heads (2)** 1925
woodcut, hand-coloured, 25.1 x 18.1 cm
Art Gallery of New South Wales, Sydney
Gift of Mrs Alison Brown 1968
DA16.1968

39. **White and Red Hibiscus** 1925
oil on canvas, 51.5 x 51 cm
Art Gallery of South Australia, Adelaide
A.R. Ragless Bequest Fund 1978
785P4

40. **Banksia** 1927
oil on canvas, 55.7 x 45.9 cm
National Gallery of Australia, Canberra
Purchased 1962
62.42

41. **Implement Blue** 1927
oil on canvas on hardboard, 42.5 x 43 cm
Art Gallery of New South Wales, Sydney
Gift of the artist 1960
OA7.1960

Margaret Preston

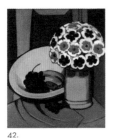

42.

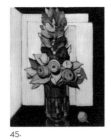

45.

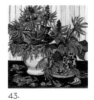

44.

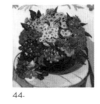

43.

47.

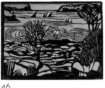

46.

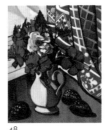

48.

49.

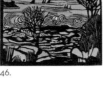

41.

50.

42. **Aboriginal Flowers** 1928
oil on canvas, 53.6 x 45.8 cm
Art Gallery of South Australia, Adelaide
Gift of the Art Gallery of South
Australia Foundation 1981
816P15

43. **Australian Coral Flowers** 1928
oil on canvas, 56 x 58 cm
National Gallery of Australia, Canberra
Gift of Andrew and Wendy Hamlin 1992
92.1376

44. **Australian Gum Blossom** 1928
oil on canvas, 55.5 x 55.5 cm
Art Gallery of New South Wales, Sydney
Purchased 1928
870

45. **Western Australian Gum Blossom**
1928
oil on canvas, 55.3 x 46 cm
Art Gallery of New South Wales, Sydney
Purchased 1978
93.1978

46. **Rocks and Waves** c.1929
woodcut, hand-coloured, 22.4 x 30.1 cm
Art Gallery of New South Wales, Sydney
Purchased 1976
141.1976

47. **Wheelflower** c.1929
woodcut, hand-coloured, 44 x 44.3 cm
Art Gallery of New South Wales, Sydney
Bequest of W.G. Preston, the artist's
widower 1977
204.1977

48. **Double Hibiscus** 1929
oil on canvas on composition board,
58.8 x 45.7 cm
National Gallery of Australia, Canberra
John B. Pye Bequest 1963
63.17

49. **NSW and West Australian Banksia**
1929
oil on canvas, 65.6 x 53.5 cm
Queensland Art Gallery, Brisbane
Purchased 1972
1.1248

50. **Self Portrait** 1930
oil on canvas, 61.3 x 51.1 cm
Art Gallery of New South Wales, Sydney
Gift of the artist at the request of
the Trustees 1930
937

Margaret Preston

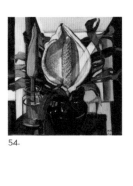

54.

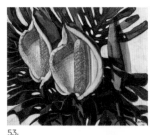

53.

52.

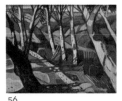

56.

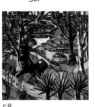

58.

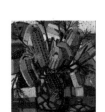

55.

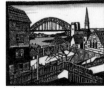

51b.

57.

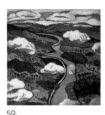

59.

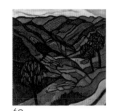

60.

51a. **Bridge from North Shore** c.1932
woodcut, hand-coloured, 20.3 x 24.5 cm
Queensland Art Gallery, Brisbane
Purchased 2003. Queensland Art
Gallery Foundation
2003.063

51b. **Sydney Bridge** c.1932
woodcut hand-coloured, 19.0 x 23.2 cm
Art Gallery of New South Wales, Sydney
Purchased 1964
DA30.164

52. **Australian Rock Lily** 1933
oil on canvas, 45.8 x 50.9 cm
Castlemaine Art Gallery & Historical
Museum, Victoria
Buda Collection

53. **Monstera Deliciosa** 1934
oil on canvas, 41.1 x 53.4cm
Bendigo Art Gallery, Victoria

54. **The Monstera Deliciosa** 1934
oil on canvas, 42.7 x 43.2 cm
Private collection

55. **The Brown Pot** 1940
oil on canvas, 51 x 45.8 cm
Art Gallery of New South Wales, Sydney
Purchased 1942
7223

56. **Aboriginal Landscape** 1941
oil on canvas, 40 x 52 cm
Art Gallery of South Australia, Adelaide
D. & J.T. Mortlock Bequest Fund 1982
821P3

57. **Blue Mountains Theme** c.1941
oil on canvas, 50.7 x 51.3 cm
Shepparton Art Museum, Victoria
Purchased with the assistance of the
Government Art Fund and Shepparton
City Council 1978
1978.99

58. **I Lived at Berowra** 1941
oil on canvas, 46.4 x 39.7 cm
Art Gallery of New South Wales, Sydney
Purchased 1941
7177

59. **Flying Over the Shoalhaven River**
1942
oil on canvas, 50.6 x 50.6 cm
National Gallery of Australia, Canberra
Purchased 1973
73.21

60. **Grey Day in the Ranges** 1942
oil on hardboard, 51 x 50.7 cm
Art Gallery of New South Wales, Sydney
Purchased 1942
7224

Grace Cossington Smith

61.
62.
63.
65.
64.
66.
67.
70.
69.
68.

61. **The Sock Knitter** 1915
oil on canvas, 61.8 x 51.2 cm
Art Gallery of New South Wales, Sydney
Purchased 1960
OA18.1960

62. **Study of a Head: Self-Portrait** 1916
oil on canvas on board, 28.6 x 23.4 cm
National Gallery of Australia, Canberra
Purchased with funds from the Marie
and Vida Breckenridge bequest 2010
2010.383

63. **Centre of a City** c.1925
oil on canvas on hardboard, 82.3 x 70 cm
Art Gallery of New South Wales, Sydney
Purchased with funds provided by
Susan Rothwell 2002
299.2002

64. **Pumpkin Leaves Drooping** 1926
oil on plywood, 61.2 x 44.2 cm
National Gallery of Australia, Canberra
Purchased 1969
69.157

65. **Arums Growing** c.1927
oil on cardboard, 48.6 x 38.5 cm
Art Gallery of New South Wales, Sydney
Dagmar Halas Bequest Fund 2016
257.2016

66. **Lily Growing in a Field by the Sea**
c.1927
oil on pulpboard, 37.9 x 25.7 cm
Private collection

67. **Trees** c.1927
oil on plywood, 91.5 x 74.3 cm
Newcastle Art Gallery, Newcastle
Purchased with assistance from the
Art Gallery and Conservatorium
Committee
1967.026

68. **Things on an Iron Tray on the Floor**
c.1928
oil on plywood, 54 x 69.5 cm
Art Gallery of New South Wales, Sydney
Purchased 1967
OA9.1967

69. **The Beach at Wamberal Lake**
1928–29
oil on cardboard, 41.8 x 35 cm
National Gallery of Australia, Canberra
Bequest of Lucy Swanton 1982
82.2361

70. **The Curve of the Bridge** 1928–29
oil on cardboard, 110.5 x 82.5 cm
Art Gallery of New South Wales, Sydney
Purchased with funds provided by the
Art Gallery Society of New South Wales
and James Fairfax AO 1991
1.1991

Grace Cossington Smith

71.

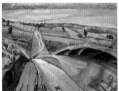

75.

77.

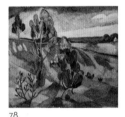

72.

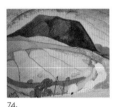

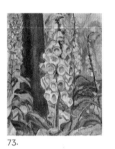

74.

76.

73.

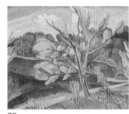

78.

79.

71. **The Bridge in Building** 1929
oil on pulpboard, 75 x 53 cm
National Gallery of Australia, Canberra
Gift of Ellen Waugh 2005
2005.239

72. **Landscape at Pentecost** 1929
oil on paperboard, 83.7 x 111.8 cm
Art Gallery of South Australia, Adelaide
South Australian Government Grant 1981
818P29

73. **Foxgloves Growing** 1929
oil on pulpboard, 47.4 x 37.8 cm
Private collection

74. **Black Mountain** c.1931
watercolour with gouache over pencil
35.6 x 42.3 cm
Sydney University Art Collection, Sydney
Donated by the Hon RP Meagher
through the Australian Government's
Cultural Gifts Program 2010
UA2010.114

75. **Bulli Pier, South Coast** 1931
oil on pulpboard, 41.5 x 40.5 cm
Private collection

76. **Poinsettias** 1931
oil on pulpboard, 73.7 x 59.7 cm
Art Gallery of South Australia, Adelaide
Ivor Francis Bequest Fund 1995
956P47

77. **Sea Wave** 1931
oil on pulpboard, 40.9 x 35 cm
Private collection

78. **Landscape at Pentecost** c.1932
oil on paperboard, 50 x 56.1 cm
Art Gallery of New South Wales, Sydney
Purchased 1964
OA2.1964

79. **Landscape with Flowering Peach**
1932
oil on board, 58.5 x 72.5 cm
Shepparton Art Museum, Victoria
Purchased 1976
1976.10

Grace Cossington Smith

83.

88.

87.

82.

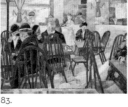

81.

80.

86.

84.

85.

80. **Yarralumla** 1932
oil on carboard, 46.3 x 35.9 cm
Newcastle Region Art Gallery,
New South Wales
1976.028

81. **Landscape with Jacaranda** c.1933
oil on board, 41 x 34.4 cm
Private collection

82. **Road with Two Horses** c.1933
oil on cardboard, 49.3 x 41.3 cm
National Gallery of Victoria, Melbourne
Purchased 1947
A15-1971

83. **The Lacquer Room** 1936
oil on paperboard on plywood
74 x 90.8 cm
Art Gallery of New South Wales, Sydney
Purchased 1967
OA10.1967

84. **Bonfire in the Bush** c.1937
oil on paperboard, 44.7 x 36.5 cm
Art Gallery of New South Wales, Sydney
Gift of Patrick White 1973
20.1973

85. **Bush at Evening** 1947
oil on hardboard, 61 x 45.7 cm
Art Gallery of New South Wales, Sydney
Purchased 1948
8125

86. **Gum Blossom and Drapery** 1952
oil on board, 40 x 53 cm
Mosman Art Gallery, Sydney

87. **Interior with Wardrobe Mirror** 1955
oil on canvas on paperboard
91.4 x 73.7 cm
Art Gallery of New South Wales, Sydney
Purchased 1967
OA11.1967

88. **The Window** 1956
oil on hardboard, 121.9 x 91.5 cm
Art Gallery of New South Wales, Sydney
Gift of Graham and Judy Martin
2014, assisted by the Australian
Masterpiece Fund
607.2014

Contributors

REBECCA COATES is a curator, writer and lecturer, and Director of SAM, Shepparton Art Museum, Victoria. She is also a fellow of the School of Culture and Communication, University of Melbourne.

DEBORAH EDWARDS was senior curator of Australian art, Art Gallery of New South Wales, Sydney, from 2000 to 2016. She has produced numerous exhibitions and books, including on artists Rosalie Gascoigne, Margaret Preston, and the Sydney Moderns. She is currently consultant curator at the Art Gallery of New South Wales.

LESLEY HARDING is a curator at Heide Museum of Modern Art, Melbourne, and co-curator of O'Keeffe, Preston, Cossington Smith: Making Modernism. Her most recent exhibition is Aleks Danko: My Fellow Aust-tra-aliens, co-curated with Glenn Barkley for Heide and the Museum of Contemporary Art, Sydney (2015-16). Her book *Margaret Preston: Recipes for Food and Art* will be published by the Miegunyah Press, Melbourne University Publishing in late 2016.

CODY HARTLEY is director of curatorial affairs at the Georgia O'Keeffe Museum in Santa Fe, New Mexico, overseeing exhibitions, collections, and conservation, and co-curator of O'Keeffe, Preston, Cossington Smith: Making Modernism. He holds a PhD in American Art History from the University of California, Santa Barbara.

CAROLYN KASTNER is the curator at the Georgia O'Keeffe Museum in Santa Fe, New Mexico, and co-curator of O'Keeffe, Preston, Cossington Smith: Making Modernism. She earned her PhD in American Art History at Stanford University. Her research, publications, and curatorial projects are focused on the diversity of American modernism.

BRUCE JAMES is a former art critic, arts broadcaster and writer. His monograph on Grace Cossington Smith, published by Craftsman House in 1990, remains the standard reference on this artist.

TRACEY LOCK is a curator in Australian art at the Art Gallery of South Australia, Adelaide. Her most recent exhibition and monograph is *Dorrit Black: Unseen Forces* (2014).

KYLA MCFARLANE is acting curatorial manager, Australian art at Queensland Art Gallery | Gallery of Modern Art, Brisbane. She has held curatorial positions at the Centre for Contemporary Photography and Monash University Museum of Art, both in Melbourne, and has curated and written extensively on visual art in Australasia.

ROBYN MARTIN-WEBER specialises in twentieth-century Australian art, particularly the Sydney Moderns such as Margaret Preston and Grace Cossington Smith. Her catalogue raisonné of Hector Gilliland was published by Craftsman House in 2000.

DENISE MIMMOCCHI is a curator in Australian art at the Art Gallery of New South Wales, Sydney, and co-curator of O'Keeffe, Preston, Cossington Smith: Making Modernism. Her most recent exhibition and publication *Sydney Moderns: Art for a New World* (2013) was jointly produced with Deborah Edwards. She curated and authored the publication *Australian Symbolism: The Art of Dreams* (2012) and has worked as assistant curator on major exhibitions including Margaret Preston, Robert Klippel and Rupert Bunny.

CARA PINCHBECK is a member of the Kamilaroi Aboriginal community and curator of Aboriginal and Torres Strait Islander art at the Art Gallery of New South Wales, Sydney.

KATHLEEN PYNE is emerita professor of Art History at the University of Notre Dame, Indiana. Her book, *Modernism and the Feminine Voice: O'Keeffe and the Women of the Stieglitz Circle*, was published by the University of California Press in 2007.

KIRA RANDOLPH holds a PhD in Art History from the University of Melbourne, focused on Australian Aboriginal art. Currently she manages online communications and requests for rights and reproductions of art at the Georgia O'Keeffe Museum in Santa Fe, New Mexico.

JASON SMITH is director of Geelong Gallery and co-curator of O'Keeffe, Preston, Cossington Smith: Making Modernism. He was previously curatorial manager, Australian art at the Queensland Art Gallery | Gallery of Modern Art; director and CEO of Heide Museum of Modern Art, Melbourne; director of Monash Gallery of Art, Melbourne and curator of Contemporary Art at the National Gallery of Victoria. He has individually and collaboratively curated over 40 solo, group and thematic exhibitions.

ANN STEPHEN is senior curator, University Art Gallery & University Art Collection, the University of Sydney. Her books include *On Looking at Looking: The Art and Politics of Ian Burn* (2006), the subject of her PhD from Queensland University of Technology; *Modernism & Australia: Documents on Art, Design and Architecture 1917-1967* (2006), and *Modern Times: The Untold Story of Modernism in Australia* (2008), both co-edited with Andrew McNamara and Philip Goad. All three were published by the Miegunyah Press, Melbourne University Publishing.